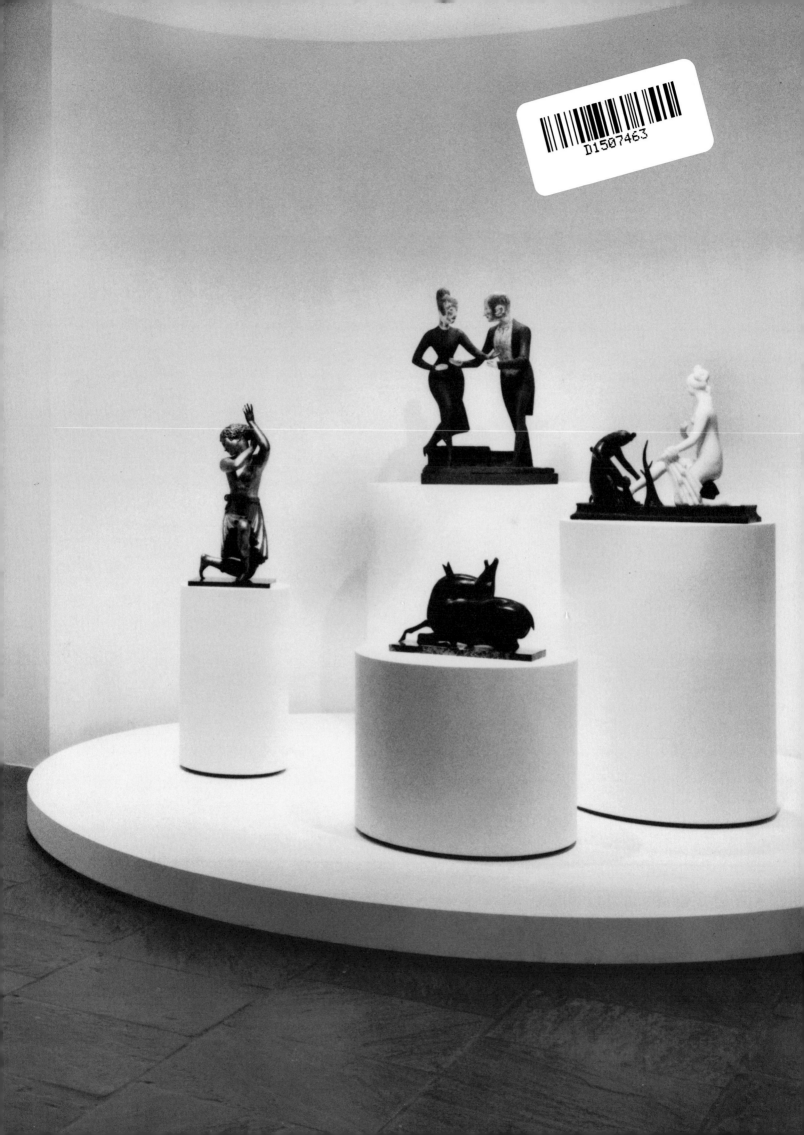

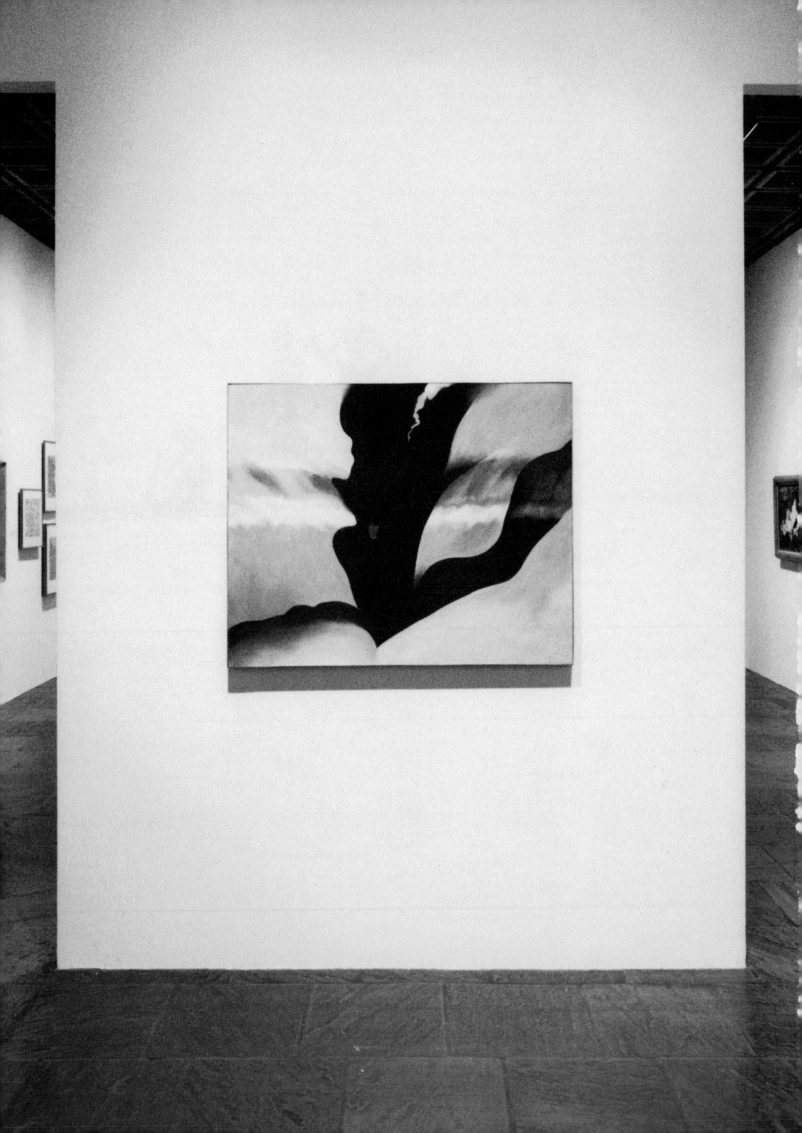

ART IN PLACE

FIFTEEN YEARS OF ACQUISITIONS

WHITNEY MUSEUM OF AMERICAN ART

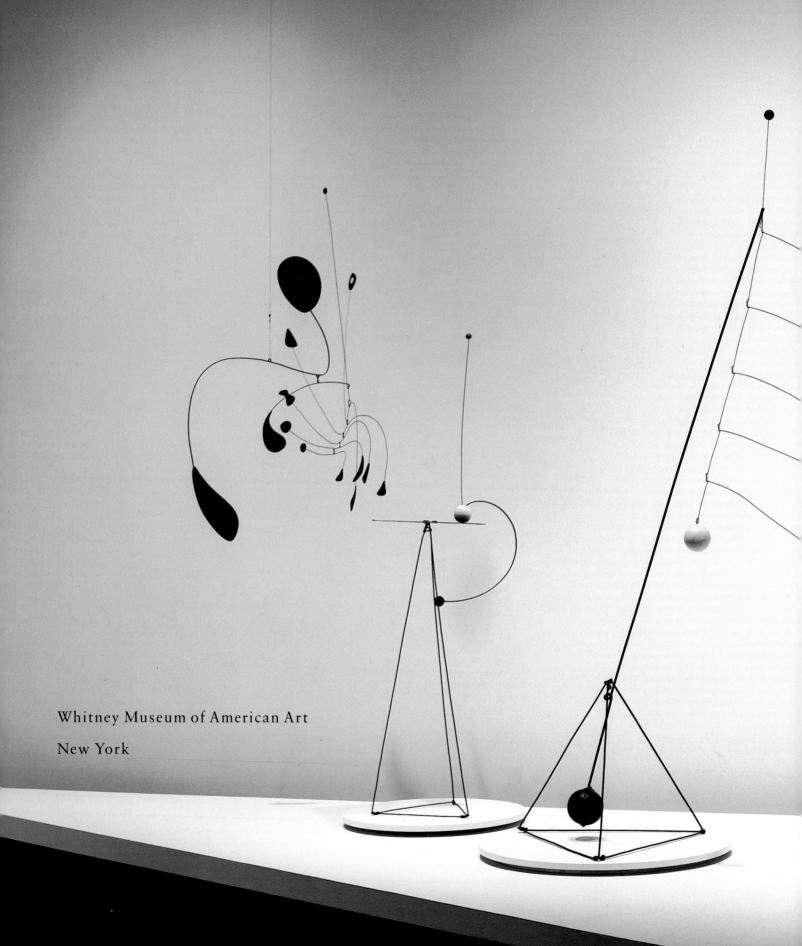

Whitney Museum of American Art

New York

ART IN PLACE
FIFTEEN YEARS OF ACQUISITIONS

Tom Armstrong

Susan C. Larsen

EXHIBITION SCHEDULE

Third floor
July 7, 1989–October 15, 1989

Fourth floor, Lobby Gallery
July 27, 1989–October 22, 1989

Lower Gallery
July 27, 1989–October 29, 1989

Cover
Installation view, left to right: Alex Katz, *The Red Smile*; Roy Lichtenstein, *Gold Fish Bowl*; Andy Warhol, *Ethel Scull 36 Times*; George Segal, *Walk, Don't Walk*.

Endleaf
Installation view of Elie Nadelman drawings and sculptures.

Frontispiece
Installation view of Georgia O'Keeffe, *Black Place Green*.

Title page
Installation view of Alexander Calder sculptures, left to right: *Hanging Spider, Little Ball with Counterweight, Calderberry Bush, Cage Within a Cage, Roxbury Flurry*.

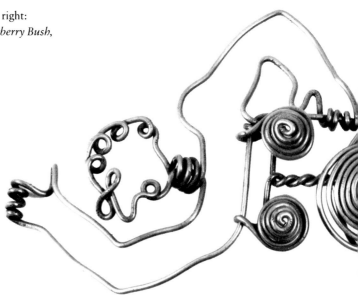

LIBRARY OF CONGRESS
CATALOGING-IN-PUBLICATION DATA

Art in place: fifteen years of acquisitions : essays / by Tom
 Armstrong, Susan C. Larsen.
 p. cm.
 Includes bibliographical references.
 ISBN 0-87427-066-9
 1. Art, American—Exhibitions. 2. Art, Modern—20th
century—United States—Exhibitions. 3. Whitney Museum of
American Art—Exhibitions. I. Armstrong, Tom. II. Larsen,
Susan C. III. Whitney Museum of American Art.
N6512.A73 1989 89-39743
709'.73'0747471–dc20 CIP

CONTENTS

ALEXANDER CALDER
Belt Buckle, 1935
Brass, 8 x 5 x ½ inches
Gift of Mrs. Marcel Duchamp
in memory of the artist 77.21

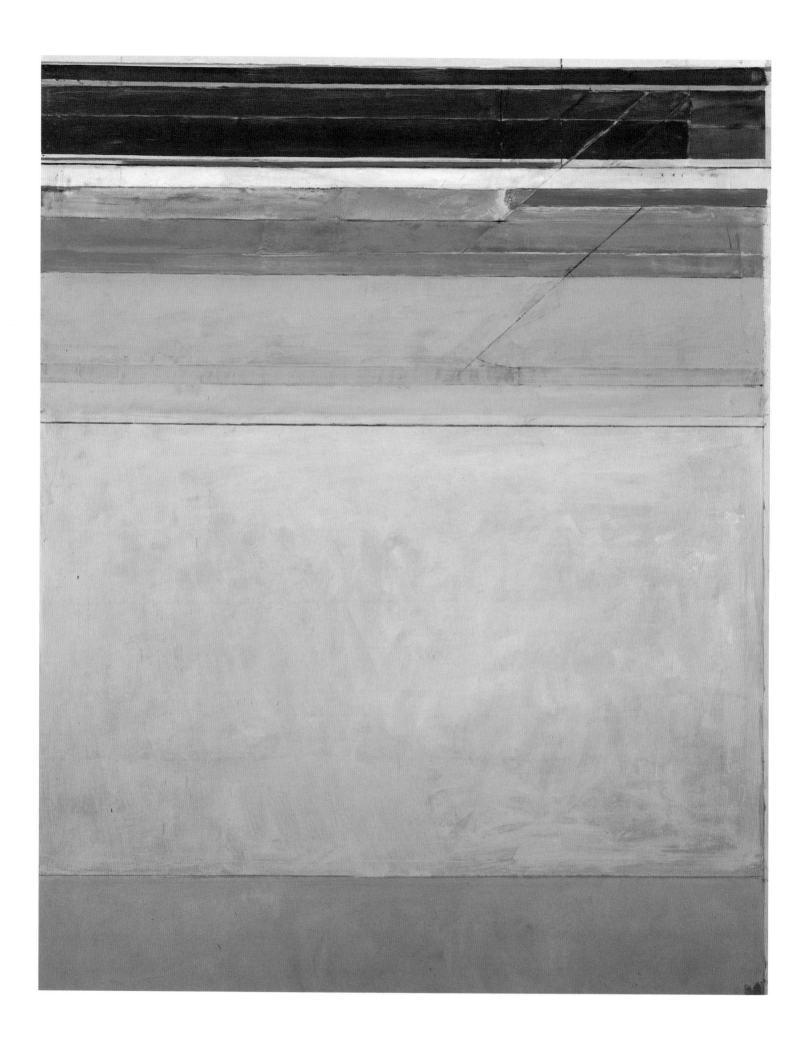

RICHARD DIEBENKORN
Ocean Park #125, 1980
Oil on canvas, 100 x 81 inches
Purchase, with funds from the Charles
Simon Purchase Fund, the Painting and
Sculpture Committee, and anonymous
donors, by exchange 80.36

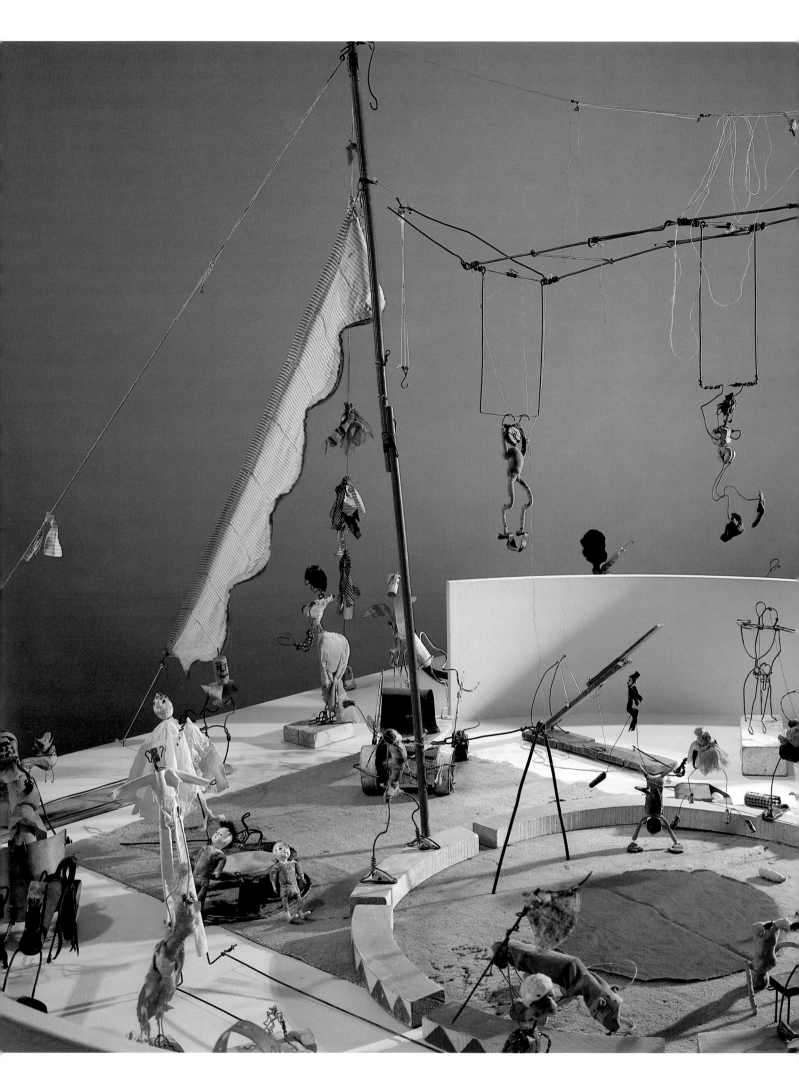

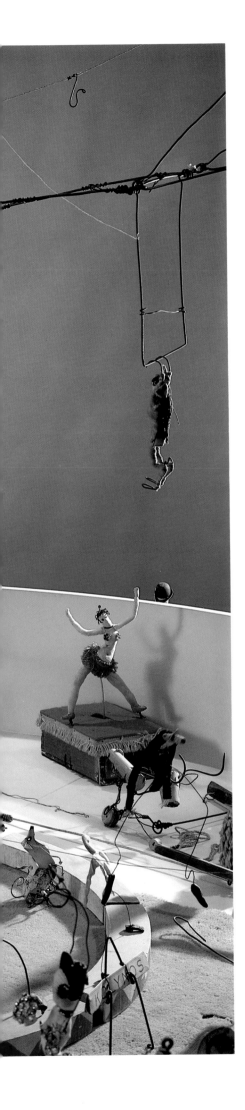

This book and accompanying exhibition are a testimony to the generosity of patrons of the Whitney Museum of American Art and the professional expertise of the staff. The paintings, sculptures, prints, and drawings attest to the loyal support that has built the Permanent Collection. It is the Trustees more than any other group who have continuously assisted the efforts of the staff. Their contribution to the Whitney Museum is exemplified by Emily Fisher Landau, who unfailingly responds to our need for help to make programs as beneficial to the public as possible. With *Art in Place: Fifteen Years of Acquisitions,* she enabled us to put our best foot forward.

The research for this publication has been supported by income from endowments established by Henry and Elaine Kaufman, The Lauder Foundation, the Andrew W. Mellon Foundation, Mrs. Donald A. Petrie, the Primerica Foundation, Charles Simon, and Nancy Brown Wellin. This is the first project on which I have worked together with Susan Larsen, newly appointed curator of the Permanent Collection. It has been a privilege to share the experience with Susan, who has brought new ideas, a fresh vision, and established scholarship to our endeavors. Our efforts on this book would not have been possible without the encouragement of Doris Palca, head, publications and sales, and the assistance of Anita Duquette, manager, rights and reproductions, both of whose tenures at the Whitney Museum have exceeded mine. It is a pleasure to work with them as colleagues and friends. Once again Sheila Schwartz, editor, has assisted me in expressing myself in writing. The details of this book have been coordinated by Stephanie Nealon, my assistant. No significant project at the Whitney Museum of American Art is possible without the participation of the entire staff; I am continually grateful to all of them for their loyalty and professional contribution to our work on behalf of American art.

TOM ARMSTRONG

Director

ALEXANDER CALDER
Calder's Circus, 1926–31 (detail)

9

LIST OF ARTISTS

The following list represents the artists whose works have been acquired by the Whitney Museum of American Art since 1974. Numbers refer to pages with reproductions.

STONES
are
our
Food

os mai 82-84

INTRODUCTION

When I became director of the Whitney Museum of American Art in 1974, my first priority was to determine the true nature of the institution: how it reflected the ambitions of the founder and the leadership which had guided it through its history, a period when American art had achieved international pre-eminence. It was the Permanent Collection of twentieth-century art that had attracted my attention when I was offered the job, and so I decided to attempt to unravel the mysteries of how it had been formed.

The permanent collection of a museum is an extension of the intellectual and aesthetic concerns of the institution's leaders. The Whitney Museum was totally supported by its founder, Gertrude Vanderbilt Whitney, from 1930 until 1942. Since her death, her daughter, Flora Whitney Miller, and then her granddaughter, Flora Miller Biddle, have played the major leadership roles as Trustees. Outside Trustees were not invited to join the Board until 1961. The professional leadership, until 1974, was always selected from long-term

CY TWOMBLY
Untitled (Stones Are Our Food to Gorky),
1982–84
Oil pastel, crayon, and graphite on paper,
44 1/8 x 30 1/8 inches
Gift of the artist 84.30

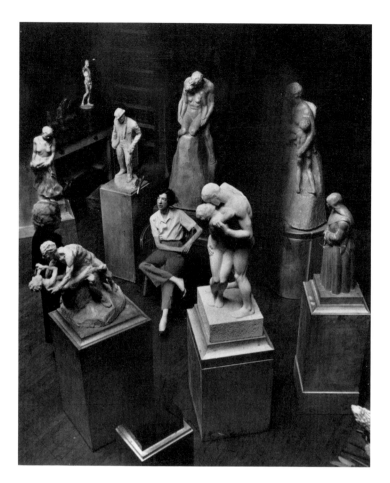

Gertrude Vanderbilt Whitney surrounded
by her own sculptures, 1939; Juliana Force
is at left.

staff members who perpetuated Mrs. Whitney's concerns, as reinforced by her daughter and granddaughter. For forty-four years, from 1930 until 1974, these circumstances assured that the Whitney Museum was guided by the spirit of its founder, who believed that the Museum's primary function was to assist American artists.

Born in 1875, Mrs. Whitney was the eldest child of the eldest son of the wealthiest family in the United States. After she married Harry Payne Whitney in 1896 and had three children, she began to feel a need to establish an identity outside the traditional roles of wife, mother, and socialite, and she turned to making art. In the first decade of the twentieth century, as she became more active in the art community in Greenwich Village, she realized that contemporary American artists were largely ignored by museums, galleries, and collectors and needed financial support and places to show their work in order to achieve recognition. One of her first known acts of patronage was in 1907, when she organized an exhibition for the Colony Club, a social club for ladies, of which she was a charter member. She included three paintings by Ernest Lawson, among them *Floating Ice*, a work she purchased the following year from the Macbeth Galleries exhibition of The Eight.

As an accomplished realist sculptor, Mrs. Whitney was primarily attracted to the aesthetic tradition established by Thomas Eakins and his successors at the Pennsylvania Academy of the Fine Arts and continued in New York by Robert Henri and The Eight. Today it is hard to imagine the public controversy caused by the exhibition of those seemingly innocuous paintings by The Eight. For the first time, a group of American artists chose to depict ordinary life as they saw it, rather than in the idealized, European-based style which dominated the art establishment. Mrs. Whitney bought four of the seven paintings sold from the historic show—the Lawson *Floating Ice*, *Laughing Child* by Henri, *Woman with Goose* by George Luks, and *Girl in Blue* by Everett Shinn. These purchases set the pattern for her future patronage, which focused on works by living artists, most often in the tradition of realism.

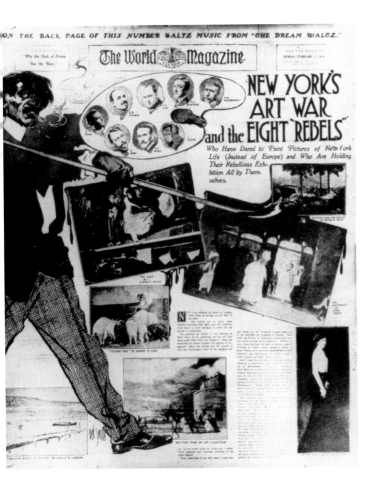

Cover of *The World Magazine*, February 2, 1908, reporting the exhibition of The Eight at the Macbeth Galleries, New York.

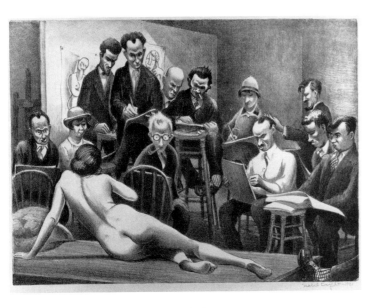

The Whitney Studio Club's life class as portrayed by Mabel Dwight, 1931. The fee was 20 cents a session. Among the artists depicted are: Jan Matulka (extreme right) and Edward Hopper (bald-headed man at center).

The 1913 Armory Show (to which Mrs. Whitney made a contribution for the decorations) was organized by American artists to bring European modernism, known here mainly through reproductions in books and journals, to the United States. This exhibition played a major role in the recognition of modernism in America; it also marked the genesis of The Museum of Modern Art, later founded by Mrs. Whitney's peer, Abby Aldrich Rockefeller, and six others. The histories of these two institutions—and their respective origins in American realism and European modernism—were best expressed in two fiftieth anniversary exhibitions in 1980: "Edward Hopper: The Art and the Artist" at the Whitney Museum of American Art and "Pablo Picasso: A Retrospective" at The Museum of Modern Art.

By 1914, Mrs. Whitney realized that the artists she knew needed a place to exhibit and meet socially to reinforce common concerns. She created the Whitney Studio at 8 West 8th Street, adjacent to her Macdougal Alley studio. It became the first formalized expression of her social service on behalf of artists. Many artists of the period, including Edward Hopper, Reginald Marsh, and John Sloan, had their first solo exhibitions at the Whitney Studio and its successor organizations, the Whitney Studio Club and Whitney Studio Galleries.

Mrs. Whitney's purchases and exhibitions of the works of living artists remained the primary public expressions of her patronage. By 1929, however, she felt that this type of patronage might no longer be needed because the number of commercial galleries willing to exhibit and sell the work of American artists had significantly increased. She sent Juliana Force, her assistant in all her art activities, to offer her collection to The Metropolitan Museum of Art. Mrs. Force had only a brief audience with Dr. Edward Robinson, director, who immediately rejected the idea of accepting a collection of twentieth-century American art; Mrs. Force did not even have the chance to reveal that Mrs. Whitney was planning to give an endowment with the collection. It was this rejection that led to the founding of the Whitney Museum of American Art in 1930.

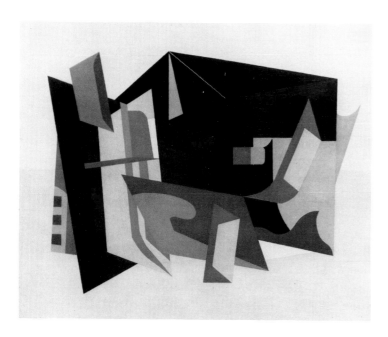

STUART DAVIS
Egg Beater No. 1, 1927
Oil on canvas, 29 ⅛ x 36 inches
Gift of Gertrude Vanderbilt Whitney 31.169

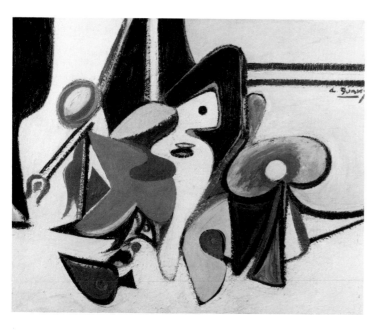

ARSHILE GORKY
Painting, 1936–37
Oil on canvas, 38 x 48 inches
Purchase 37.39

Between 1930 and 1931, when the Museum officially opened, Mrs. Whitney and Mrs. Force, who was appointed director, acquired an extraordinary group of American masterworks—in retrospect, a phenomenal accomplishment. In addition to *Early Sunday Morning* by Edward Hopper, *Dempsey and Firpo* by George Bellows, *Egg Beater No. 1* by Stuart Davis, and *Chinese Restaurant* by Max Weber, they purchased *My Egypt* by Charles Demuth, *Why Not Use the "L ?"* by Reginald Marsh, and *Interior* by Charles Sheeler.

The Museum's first Biennial exhibition of painting and sculpture was held in 1932. Paintings in that show included Grant Wood's *Daughters of Revolution*, Georgia O'Keeffe's *Farm House Window and Door*, and Ivan Le Lorraine Albright's *Room 203*, all of which were ignored in the ongoing acquisition program in favor of works that today we consider relatively minor. The reasons for this are as complicated as the personalities who ran the institution, but it is clear that since Mrs. Whitney had purchased works by some of these artists the previous year, she had decided not to increase their representation so soon thereafter. This was the first indication that the Museum would not purchase from strength. Until the 1970s, when policies dramatically changed, the Whitney Museum followed the principles of its founder—to help American artists by purchasing the works of as broad a group as possible and, except in rare instances, by avoiding collecting the works of individual artists in depth.

Purchases in the 1930s reflected loyalties to the realist artists for whom the Museum was a center of activity. A notable exception was the purchase of three works by O'Keeffe, including *White Calico Flower*, and *Painting* by Arshile Gorky, the latter purchased from the 1937 Annual exhibition. This abstract work, the first painting by the artist to be acquired by a museum, was an anomaly in the midst of a primarily realist collection. Avis Berman, author of the forthcoming book *Rebels on Eighth Street: Juliana Force and the Whitney Museum of American Art*, recounts the preamble to the purchase:

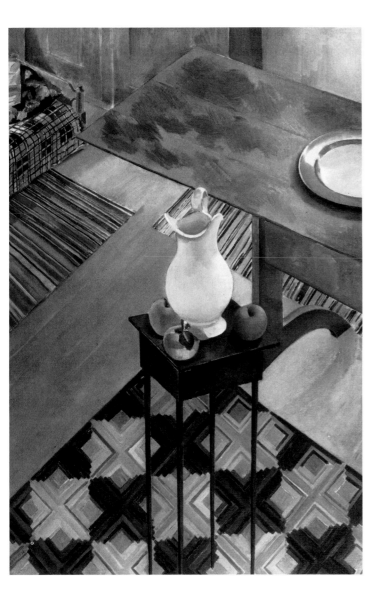

CHARLES SHEELER
Interior, 1926
Oil on canvas, 33 x 22 inches
Gift of Gertrude Vanderbilt Whitney 31.344

Lloyd Goodrich's first documented meeting with Arshile Gorky was on April 10, 1933, at a symposium on abstract art held at the Whitney Museum. There were four critics on the panel of the symposium, the most notable being Goodrich and Walter Pach. There were also many artists in the audience that evening, including Arshile Gorky. After the critics' discussion, there was a question and answer session with the audience. Gorky stood up and challenged the critics, saying, 'You must analyze abstract art the way you analyze a fugue by Bach,' and continued to speak for quite a bit of time. Lloyd, not understanding what Gorky was saying at that time and thinking he was being facetious, asked him to stop talking and to take his seat. Later, understanding what Gorky had meant, Lloyd would say, 'He was right. I was wrong. I should have never talked to an artist that way and I have always felt very badly about it.'

Lloyd soon came to respect Gorky and wanted his art represented in the Permanent Collection, which resulted in the purchase of *Painting*, a work associated with Gorky's paintings for the Public Works of Art Project, administered by Lloyd and Juliana Force.

Shortly after Mrs. Whitney's death in 1942, her children, who were concerned about the financial position of the Museum because it had been supported solely with her funds, decided that a merger with The Metropolitan Museum of Art might be desirable. The merger was announced in 1943, and eventually the negotiations evolved into the Three Museum Agreement of 1947, which included The Museum of Modern Art. According to the terms of the agreement, the Whitney Museum would limit its collecting activity and programs to American art of all periods, the Metropolitan to "classic art," and the Modern to European and American art of the present and recent past. In addition, the Whitney Museum would build and endow a wing at the Metropolitan to house its collection. The agreement was abandoned a year later, however, primarily because the Metropolitan would not agree to the separate identity and autonomy of the Whitney Museum and its staff.

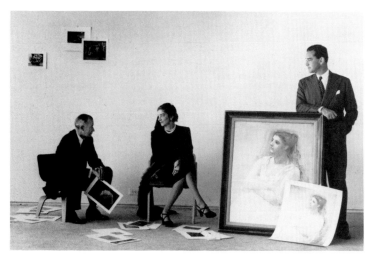

Left to right: Roland C. Redmond,
president of The Metropolitan Museum of
Art; Flora Whitney Miller, president of the
Whitney Museum of American Art; and
John Hay Whitney, president of The
Museum of Modern Art; at the signing of
the Three Museum Agreement, 1947.

© Arnold Newman

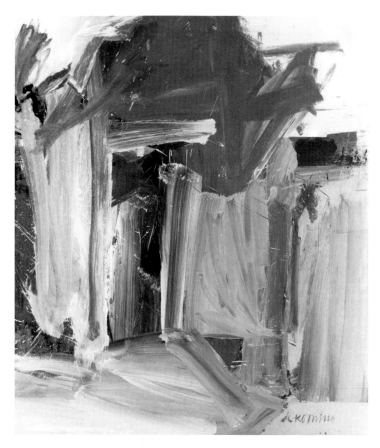

WILLEM DE KOONING
Door to the River, 1960
Oil on canvas, 80 x 70 inches
Purchase, with funds from the Friends of
the Whitney Museum of American Art 60.63

In 1948, the Museum began accept-
ing gifts and abandoned the policy of not giving one-
person shows to living artists. The first gift was from an
outside donor in 1949: Ben Shahn's *The Passion of Sacco
and Vanzetti*, given by Edith and Milton Lowenthal in
memory of Juliana Force, who had died the year before.

During the 1950s, the Museum
remained loyal to realist members of the art community,
and it also became increasingly necessary to use all avail-
able funds for operations. As a result, the leadership of the
Museum did not keep up with new developments. In 1959,
while Dorothy Miller was organizing "Sixteen Ameri-
cans" for The Museum of Modern Art, which included
the early work of Jasper Johns, Ellsworth Kelly, Robert
Rauschenberg, and Frank Stella, the Whitney Museum
was devoting attention to less innovative artists. Excep-
tions included the purchase in 1953 of Jackson Pollock's
Number 27, still the only painting by the artist in the Per-
manent Collection.

The first public support group for
the Museum, the Friends of the Whitney Museum of
American Art, was founded in 1956 to raise acquisition
funds through dues from its members. Early members
included David Solinger, president, and Hudson Walker,
Otto Spaeth, Harry N. Abrams, Seymour M. Knox, Mil-
ton Lowenthal, Roy R. Neuberger, Duncan Phillips, and
Nelson A. Rockefeller. Through its various acquisition
committees, the Friends were the primary source of acqui-
sitions for nearly twenty years—the largest collecting
effort on behalf of the Museum since Mrs. Whitney's
flurry of art purchases in 1930–31. In 1966 alone, the
Friends acquired Jasper Johns' *Studio* and Al Held's *The
Dowager Empress*, in each case, the first work by the art-
ist to enter the Permanent Collection, as well as Ellsworth
Kelly's *Green, Blue, Red* and Franz Kline's *Dahlia*. There
was still, however, little effort to recognize individual art-
ists by collecting their work in depth.

In 1970, the Museum received the
entire artistic estate of Edward Hopper, more than 2,500
objects, the largest gift in the Museum's history and the di-
rect result of Hopper's long association with the Museum—

BEN SHAHN
The Passion of Sacco and Vanzetti,
1931–32
Tempera on canvas, 84 ½ x 48 inches.
Gift of Edith and Milton Lowenthal in
memory of Juliana Force 49.22

from his first one-artist show at the Whitney Studio Club
in 1920 to the major retrospectives of 1950 and 1964.

In 1974, I became director, the first
without any previous association with the Museum, and
the Board of Trustees appointed a long-range planning
committee to determine the future course of the Museum.
The Planning Committee Report was prepared by a group
of outside advisers guided by Stephen Muller, president of
Johns Hopkins University and a Trustee. Adopted by the
Board of Trustees in 1978 after lengthy debate, it has since
been the basis for all the Museum's policies, including col-
lecting activity. The most significant recommendation
concerned the Permanent Collection:

*As a national museum with an international audience, the
Whitney Museum will move systematically and purpose-
fully toward the collection and exhibition of the best pos-
sible permanent collection of twentieth-century American
art. Specifically, this will involve acquisition of examples
of art in areas where the existing collection needs expan-
sion. The expansion of the permanent collection to form a
body of works of historical and qualitative importance
requires acquisition of art being produced and shown,
as well as strategic purchases and important gifts to fill
gaps in the collection.*

During the last fifteen years, using the Planning Commit-
tee Report as the guideline, we have appointed the first
curator of the Permanent Collection, established endowed
purchase funds and acquisitions committees with mem-
bers who regularly contribute funds, and emphasized, in
all aspects of Museum programs, the quality and strength
of the Permanent Collection. Available funds for acquisi-
tions have grown substantially from the less than $20,000
available annually in 1974.

The works in this book attest to
our attention and loyalty to the history and established
strengths of the Museum, to our acknowledgment of past
omissions, and our effort to recognize quality in our own
time. The Whitney Museum has played a unique role in
the history of twentieth-century American visual arts, and
I hope that our work has brought the institution closer to
the mainstream of the most accomplished creative activity.

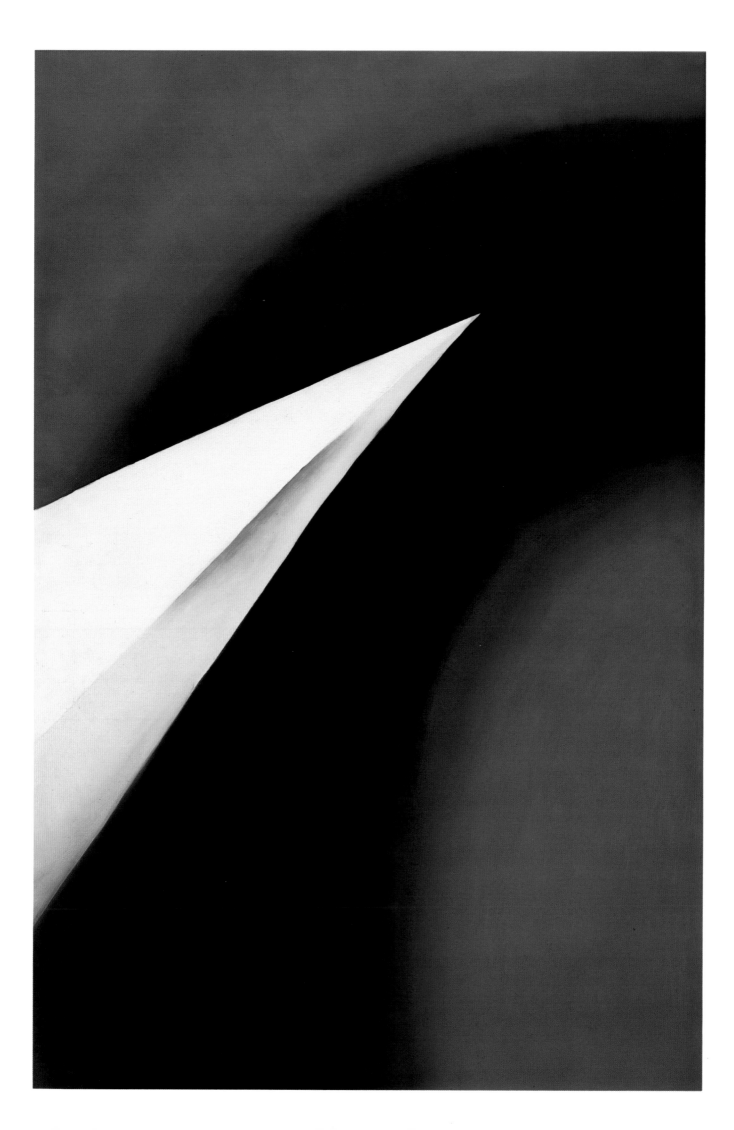

ANECDOTAL REMINISCENCES

A work of art carries with it myriad tales related to its acquisition by various owners, who are attracted to it for different and complex reasons. No one will ever fully comprehend what causes someone to fall under the spell of a particular object. The way in which these works subsequently enter public collections further reveals the vagaries of human nature, which museum directors attempt to understand but rarely are wont to describe.

Each work in this book could become the basis of a lengthy story about its creation and provenance. I have selected ten to discuss in terms of my personal relationships with the people associated with their acquisition by the Museum. These stories may seem extraneous, but they represent incidents in the daily life of a museum director that ultimately result in an object's permanent place in the institution. Perhaps these brief narratives will bring to life the phenomenon of collecting and add to the understanding of the individual work and its importance to the Whitney Museum.

GEORGIA O'KEEFFE
Black and White, 1930
Oil on canvas, 36 x 24 inches
50th Anniversary Gift of Mr. and Mrs.
R. Crosby Kemper 81.9

FRANK STELLA

Die Fahne Hoch, 1959

In the late 1960s and the early 1970s, Eugene and Barbara Schwartz were leaders of a small group of young collectors in New York City who recognized the importance of contemporary American art. Gene himself was a member of the Acquisitions Committee at the Whitney Museum during 1967–69 and 1973–74. At a party in 1967 at the apartment of art dealer Larry Rubin, they saw Frank Stella's *Die Fahne Hoch* (1959). Gene had already begun to think that he and Barbara should acquire an example of the first series of these Black paintings. He consulted that evening with another guest, his friend Bill Agee, curator at the Whitney Museum. "There is no question," said Agee, "*Die Fahne Hoch* is a masterpiece." Gene immediately began negotiations to purchase it.

On April 1, 1970, after learning that the Schwartzes had acquired *Die Fahne Hoch*, Jack Baur, director of the Whitney Museum, wrote to Gene: "I was immensely impressed by the quality of your painting, *Die Fahne Hoch*, in the Modern's Frank Stella exhibition. I thought it stood out head and shoulders above the other early black and white canvases. It has a kind of looming presence, hard to define but absolutely great. I do congratulate you and Barbara on your taste and perspicacity in getting it. I do not imagine that you would want to part with it, but if that time ever comes could I ask you to give a thought to the Whitney?"

Because of a rather unusual incident three years earlier, Gene Schwartz had already developed a deep respect for Jack Baur. At a meeting of the Acquisitions Committee in 1967, Gene had favored the acquisition of two Warhol works. Jack, however, doubted that the Museum should acquire any work by Warhol and certainly not two. As a result, only one was purchased (*Green Coca-Cola Bottles*, 1962) with funds from Committee member Charles Simon. Although the decision went against Gene, he remained enormously impressed by Jack's unyielding ideals and rigorous concerns about the nature of art.

For this reason, Baur's 1970 letter about *Die Fahne Hoch*, with its polite request to "give a thought to the Whitney," made a great impression on Gene. In 1975, after Jack's retirement, he called his friend B.H. Friedman, head of the Committee on the Collection, to ask if the Whitney Museum might be interested in a partial gift and purchase of the work. Friedman told Gene that it was beyond the Whitney's financial capacity but that he would inform the new director, Tom Armstrong, of the offer. I immediately responded that we had to have the painting and that I would make every effort possible to raise the money—more than the Museum had ever spent on a single object.

As an inexperienced art museum director, I went about raising the money in the only way I knew—in small sums from many acquaintances. The Trustees told me that this was too ambitious a task. The credit now indicates that the work was a gift of Mr. and Mrs. Eugene Schwartz, to whom we will always be grateful for their admiration of Jack Baur and loyalty to the Whitney Museum, as well as a purchase through the generosity of fourteen separate donors and the John I.H. Baur Purchase Fund, the first endowed purchase fund initiated by the Trustees and staff, which I had organized upon Jack's retirement the previous year.

Die Fahne Hoch, 1959
Enamel on canvas, 121½ x 73 inches
Gift of Mr. and Mrs. Eugene M. Schwartz
and purchase, with funds from the John
I.H. Baur Purchase Fund, the Charles and
Anita Blatt Fund, Peter M. Brant, B.H.
Friedman, the Gilman Foundation, Inc.,
Susan Morse Hilles, The Lauder
Foundation, Frances and Sydney Lewis,
the Albert A. List Fund, Philip Morris
Incorporated, Sandra Payson, Mr. and
Mrs. Albrecht Saalfield, Mrs. Percy Uris,
Warner Communications Inc., and the
National Endowment for the Arts 75.22

Overleaf
"Frank Stella: Prints 1967–1982," 1983.

ROBERT MORRIS

Untitled (L-Beams), 1965

Howard Lipman originally saw Robert Morris' *Untitled* (1965), two L-shaped pieces constructed of plywood, in an exhibition at the Green Gallery in 1965. By the time he decided to purchase the work in 1967, the Green Gallery, managed by the perceptive and dedicated Richard Bellamy and supported by Robert Scull, had closed, and Leo Castelli had begun to represent the artist. The pieces had been refabricated in fiberglass and given a different title, *Untitled, 1967, 2 L-Shaped Pieces.*

At that time, Howard and Jean Lipman were living in Cannondale, Connecticut, in an eighteenth-century house they had purchased thirty years earlier. Throughout their lives, the Lipmans have been involved in activities related to American art. They first became known through the collection of American folk art they had begun assembling in 1937. The entire collection was sold to Stephen Clark in 1950 and is now enjoyed by visitors to the New York State Historical Association in Cooperstown, New York. As the folk art left their home, the Lipmans became seriously involved with the art of their own time. Howard had been a professional sculptor for a brief period before becoming managing partner of the brokerage firm Neuberger & Berman, and he was particularly interested in encouraging contemporary American sculptors, who in the 1950s and 1960s were receiving virtually no attention from American museums or collectors.

In the mid-1960s, the Lipmans set up a foundation to acquire sculpture, especially pieces by younger artists, for the Whitney Museum, working directly and exclusively with the curatorial advice of Jack Baur (curator, 1952–58; associate director, 1958–68; director, 1968–74). In addition, they were assembling sculpture, in many cases by the same artists whose work they purchased for the Museum, for their own enjoyment. Howard quickly became known to many artists, including Morris. He purchased *Untitled, 1967, 2 L-Shaped Pieces,*

which he remembered crammed into the Green Gallery, and installed the work on the grounds of the Cannondale house. This remarkable place—in the middle of a historic area of Connecticut—soon achieved additional renown as the setting for works by Alexander Calder, George Rickey, and David Smith.

In 1970, it was becoming obvious that the fiberglass L-beams would not survive the harsh Connecticut climate. Robert Morris decided to have the piece refabricated by the Lippincott Foundry in North Haven, Connecticut, as three, instead of two, L-beams, this time in stainless steel and titled *Untitled (L-Beams)* with the original date of 1965. There are three authorized editions of the work. The one owned by the Lipmans was installed on their property from 1971 until 1976, when they gave it to the Whitney Museum. This version was included in the first retrospective of Morris' work, held at the Museum in 1970.

Howard Lipman became a Trustee of the Whitney Museum of American Art in 1969 and served as President (1974–77) and Chairman (1977–85). He and Jean purchased American sculpture when very few people other than Joseph Hirshhorn and Philip Johnson (who bought one of the versions of *Untitled [L-Beams]*) had similar enthusiasms. In the spirit of Mrs. Whitney's original patronage, the Lipmans acquired art unappreciated by others for the Whitney Museum and provided new vitality for the art community.

Howard and Jean Lipman are inextricably bound to the history of the Whitney Museum and the history of twentieth-century American art. Other than Gertrude Vanderbilt Whitney, they are the most important patrons of the Permanent Collection of the Museum.

Untitled (L-Beams), 1965
Stainless steel, 96 x 96 x 24 inches
Gift of Howard and Jean Lipman 76.29

Overleaf
"Robert Morris," 1970.

GEORGIA O'KEEFFE

Summer Days, 1936

At a dinner party at Howard and Jean Lipman's residence in Cannondale, Connecticut, during the summer of 1974, Louise Nevelson, Isamu Noguchi, and I discussed the fact that the Whitney Museum of American Art did not have a comprehensive collection of the work of Georgia O'Keeffe, whom they both knew as a friend. Louise wrote a letter of introduction to O'Keeffe for me later in August; I followed with a note to O'Keeffe explaining that I was anxious to improve her representation at the Museum, where in 1970 she had had the largest retrospective exhibition of her work, a major show that traveled to Chicago and San Francisco.

O'Keeffe extended an invitation for a visit. On November 11, I knocked at the door of the adobe house in Abiquiu, New Mexico, and Juan Hamilton ushered me into the living room, where I sat comforted by the presence of a friendly Calder mobile. In a few moments a diminutive woman entered the room; her black floor-length costume dramatized her white hair and the silver "OK" pin that Calder had designed for her.

The three of us talked for about an hour over mint tea, during which time O'Keeffe's conversation became caustic. She let me know repeatedly that she did not feel completely at ease with the Whitney Museum because we had not shown her proper attention. She informed me that a car had not been sent to bring her to the opening of her retrospective and that others paid regular homage to her, including Joe Hirshhorn, who visited each year on her birthday, bringing a cake. She added that the Stieglitz artists had never mixed socially with the artists in the Whitney Studio Club and that Lloyd Goodrich's installation of her retrospective had not pleased her.

When I thought it was appropriate, I told O'Keeffe that I had not come all the way to New Mexico to hear about her ill feelings for the Whitney Museum; that I was there following her gracious invitation, and I had hoped that we could become friends and

build upon the fact the Whitney Museum had acquired her work as early as 1931 and was the first major international museum to publish a scholarly catalogue of her accomplishments (for the 1970 exhibition) and that all this should be the basis of our relationship. Things became calmer.

In February 1977, I wrote to her with the news that we had acquired *It Was Blue and Green* as a bequest from Lawrence H. Bloedel, and I included a list of the six O'Keeffes now in the Permanent Collection. *It Was Blue and Green* had been our first choice in the division of the Bloedel collection between the Williams College Museum of Art and the Whitney Museum. She wrote back: "I am very pleased to hear you have acquired the painting *It Was Blue and Green*. It was one of the best of that series. As I read over the list of what you have, it isn't bad is it?"

In October 1980, I returned to Abiquiu to see *Black and White* (1930) and *White Patio with Red Door* (1960), which she offered to sell to the Museum. I had asked her to consider making *Summer Days* (1936) available to us, but there was no response. I was unable to raise the required funds for *Black and White* until the newly formed National Committee met in New York in February 1981. During the Committee's visit to artists' studios and galleries in SoHo, I asked Crosby Kemper, a member from Kansas City, Missouri, if he might be interested in joining a group of people to assist us in acquiring this work. He asked me how much it was. I told him what seemed to be the staggering cost of the painting and he said, "It's yours."

Summer Days, 1936
Oil on canvas, 36 x 30 inches
Promised gift of Calvin Klein P.4.83

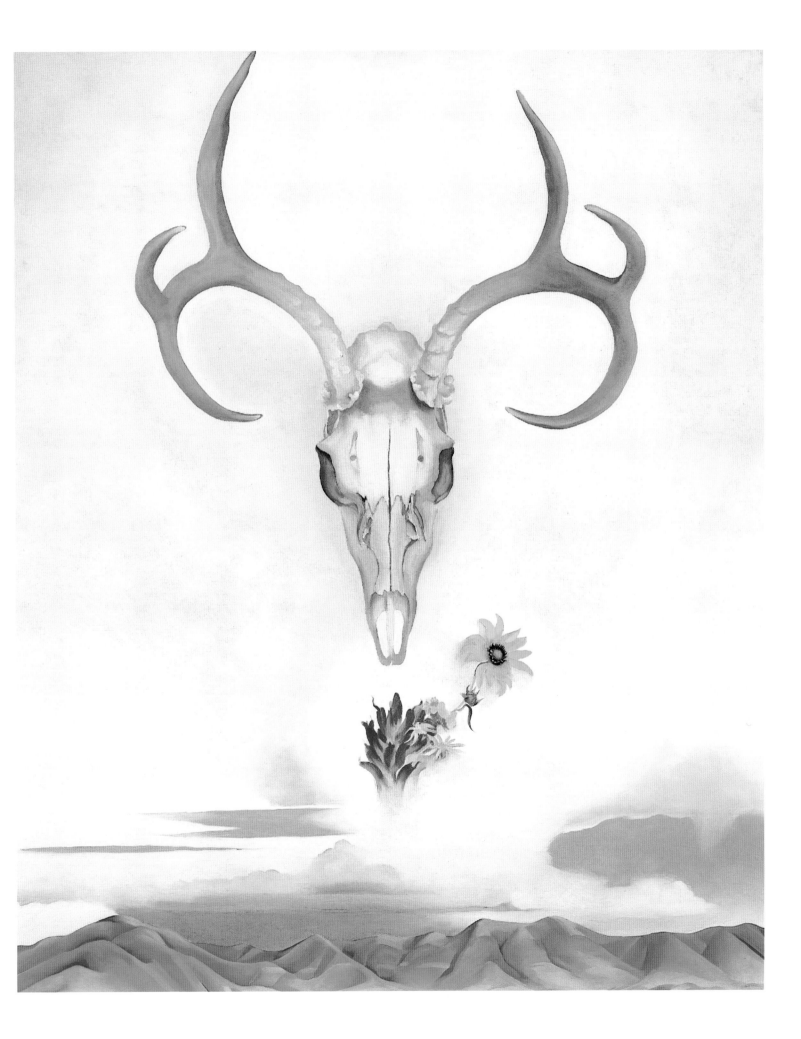

In May 1983, gallery owner Robert Miller called to tell me that he had just returned from Abiquiu with a client who had purchased *Summer Days*. My spirits sank. He then told me that in conjunction with the sale O'Keeffe, then almost ninety-six years old, had insisted that the work be a promised gift to the Whitney Museum of American Art and that, as part of the sales agreement, the donor give twenty-five percent of the work to the Whitney Museum immediately.

This was an extraordinarily magnanimous gesture by an artist who nearly nine years earlier had questioned the seriousness and dedication of the Whitney Museum. O'Keeffe's loyalty and her sense of admiration for the work we had accomplished since then was recognized in a characteristically private, quixotic manner.

In 1976, all of us at the Whitney Museum participated in an event unparalleled in our history. The retrospective exhibition of the work of Alexander Calder, which opened on October 14, 1976, and its publication, *Calder's Universe,* combined total involvement by the artist and overwhelming response by the public. During the installation, it was not unusual to see Calder walking along Madison Avenue holding a paintbrush, on his way to the Museum to touch up a piece in the show. The Whitney staff worked with him for over two years to prepare the book and exhibition, a process which he seemed to enjoy thoroughly. Appreciation and love for Calder were expressed at a gala dinner party on October 20 attended by his lifelong friends— famous people in all the arts—who sang the songs he and his wife, Louisa, had requested, and danced with the happiness of a very special occasion.

Georgia O'Keeffe surprised us with a visit to New York, a special effort to be with her friend Sandy Calder. When I had first met her two years earlier, she had berated me because she felt, the Museum had been inattentive to her at the time of her 1970 retrospective. Now, in 1976, she was staying at the Stanhope Hotel, and I arranged for the largest limousine I could find in New York City to bring her from the hotel to the Museum. I left a note for her on the back seat: "A little late, but still trying."

Calder died on November 11, 1976, less than a month after the opening, and we mourned him with the realization that the happiest Whitney Museum exhibition had become the memorial tribute to his genius. He died at the peak of his creative energies, the morning after a trip to Washington to make final arrangements for a commission. His family wanted all the activities planned in connection with the exhibition to proceed as scheduled so that the pleasure he had brought to us and to his audience would continue.

A memorial service was held at the Museum on December 6, 1976. Chairs were placed throughout the fourth floor gallery, and when the guests arrived they quietly moved them so as to surround Calder's family. The evening began with a Bach chaconne performed by violinist Alexander Schneider, and then James Johnson Sweeney, Saul Steinberg, Robert Osborn, and Arthur Miller paid tribute. Mr. Sweeney said, "Though the dancer has gone, the dance remains," and we looked up at the bright mobiles moving gracefully overhead.

ROY LICHTENSTEIN

Still Life with Crystal Bowl, 1973

In March 1970, on the eve of the first public offering of the stock of Best Products, the company Sydney and Frances Lewis founded in Richmond, Virginia, the Lewises entertained me for the first time in their home and we discussed our mutual enthusiasms for American art. This was the beginning of a friendship that ultimately brought them into the life of the Whitney Museum of American Art. In 1970, Sydney and Frances allowed me to show painting and sculpture from their collection at the College of William and Mary in Williamsburg, where I was associate director of the Abby Aldrich Rockefeller Folk Art Collection. They later became patrons of the Pennsylvania Academy of the Fine Arts while I was director, and in March 1976, two years after I became director of the Whitney Museum, they established the largest single purchase fund in the history of the Museum for the acquisition of works by living artists for the Permanent Collection; later that year Frances became a Trustee. The concept of patrons and the director working together to make acquisition decisions had been established by the relationship between Howard and Jean Lipman and Jack Baur. Together they had assembled a remarkable collection of sculpture and made it available to a wide audience; the Lewises regarded this as a guide for our own working relationship.

Frances and Sydney Lewis' admiration for American art of our times did not have a positive effect on their public life in the southern city where they lived, ran their business, and raised their children. In the conservative environment of Richmond, they seemed an anomaly. In many ways, the Lewises typified collectors of contemporary art throughout the United States who cannot find others within their communities to share their interests. Such patrons often turn to institutions in larger cities and then leaders in their own home towns realize the loss.

After the purchase fund was established, Sydney, Frances, and I began to acquire works we had seen and those suggested by the staff. The first object selected was *Ansonia* (1977) by Richard Estes. We spent many enjoyable Saturdays together in SoHo and often took trips to see artists, including Roy Lichtenstein and his wife, Dorothy, in Southampton. At this time, there was only one Lichtenstein work in the Permanent Collection, *Little Big Painting* (1965), purchased through the Friends of the Whitney Museum of American Art in 1966. The Lewises and I were particularly attracted to *Still Life with Crystal Bowl,* which the Lewises believed had been inspired by an illustration from a Best Products catalogue. Assisted by Leo Castelli, we made a special appeal to the artist, who agreed to make the painting available to the Museum.

In December 1979, Frances and Sydney asked me to have dinner with them at the Carlyle Hotel, where they had entertained artist friends on many occasions. During dinner they told me that they were negotiating with the Virginia Museum of Fine Arts to be the recipient of their various collections of painting, sculpture, and decorative arts and that, to avoid conflict of interest, they felt Frances should resign as a Trustee of the Whitney Museum. In the brief time the Lewises were associated with the Whitney Museum, they brought me, the staff, and the Trustees closer to the intrinsic value of art and to the dignity that abides in its creators.

Still Life with Crystal Bowl, 1973
Oil and magna on canvas, 52 x 42 inches
Purchase, with funds from Frances and
Sydney Lewis 77.64

Overleaf
Roy Lichtenstein, Southampton,
New York, 1973.

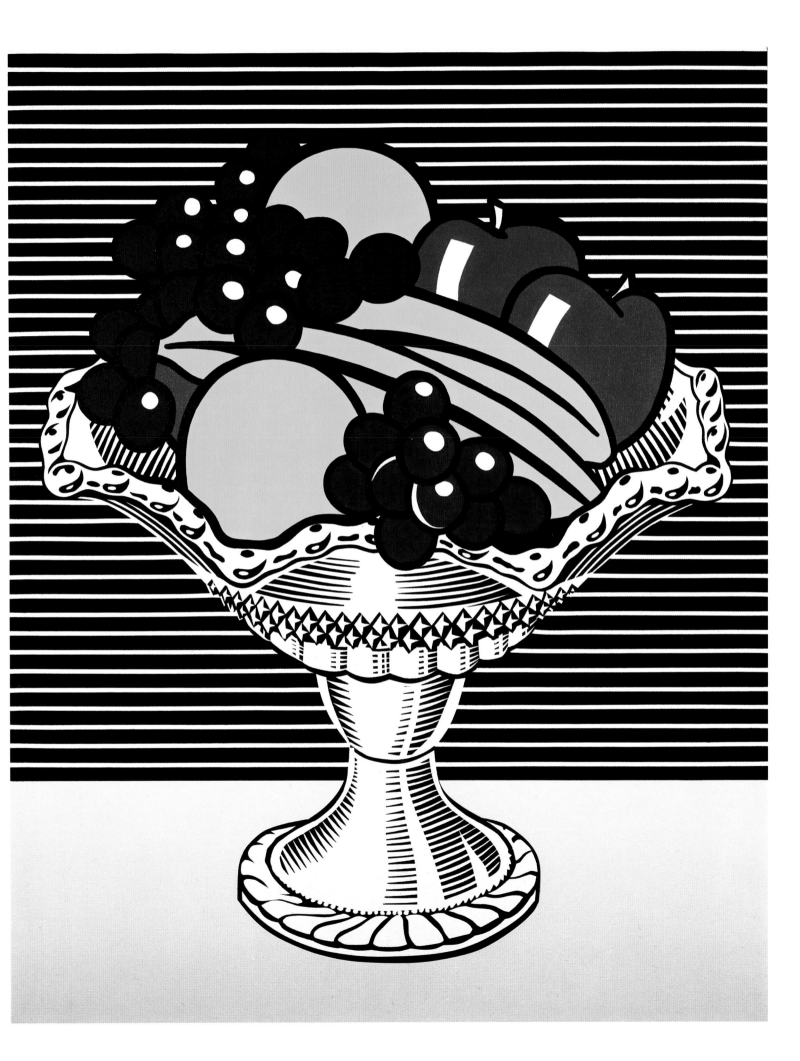

MAURICE PRENDERGAST

Summer's Day, 1916–18

In many ways, Lawrence H. Bloedel's respect for American art was expressed through a type of patronage exemplified by Gertrude Vanderbilt Whitney, founder of the Whitney Museum of American Art. They both assembled works they enjoyed, with curiosity and judgment and a fundamental respect for the artist as creator and innovator. Like Mrs. Whitney, Larry Bloedel often made a conscious, and characteristically understated, effort to encourage and support artists through the purchase of their work. He and his wife joined the Friends of the Whitney Museum of American Art in 1956, and later they became Benefactors, individually and through the Greylock Foundation, which they established in 1960 and named for the mountain they viewed each day from their home in Williamstown, Massachusetts. Larry served on the Acquisitions Committee during 1959–60, 1963–64, and 1970–71, and was a Trustee of the Museum from April 1975 until his death in November 1976.

Many years ago, Larry Bloedel decided that his collection should eventually be divided between the Williams College Museum of Art and the Whitney Museum. He planned to have the directors of the two institutions make the selections. Following his death, Whitney Museum curators and I visited the Bloedels' home in Williamstown and their apartment in New York to establish a list of priorities for additions to the Permanent Collection; the final list of 285 objects was arranged in order of the importance of each work to the Whitney Museum. On January 24, 1977, Patterson Sims, associate curator of the Permanent Collection, and I met in Williamstown with the executors of Larry Bloedel's estate and representatives of the Williams College Museum of Art. Franklin Robinson won the toss of the coin for Williams, and he and I then proceeded alternately to choose works for the two museums.

Frank went first, selecting a work not among our priorities. I then selected our first choice,

It Was Blue and Green by Georgia O'Keeffe. Our second selection was Maurice Prendergast's *Summer's Day*. Prendergast was among the famous group, The Eight, who showed at the Macbeth Galleries in 1908 and whom Mrs. Whitney supported more than any other patron. The first Prendergast painting entered the Permanent Collection in 1930, and in 1934 the Whitney Museum held a comprehensive memorial exhibition of his work.

In the division of the Bloedel Bequest we were able to obtain eight of the first ten works on our "most-wanted" list. The decision of what to select was coincident with the Planning Committee Report, accepted by the Board of Trustees a year later. The report established that the Museum must be guided primarily by considerations of quality and that our first priority was the Permanent Collection. Mrs. Whitney had founded the Museum following a long-term effort to help artists. She chose a director and curators who had developed strong, supportive relationships with artists. The Planning Committee Report announced a new ambition for the Whitney Museum: to base programs on considerations of excellence, exclusive of concerns for the well-being of artists. Our selections from the Bloedel Bequest were designed to strengthen historic concentrations of work by certain artists and build on our history of exhibitions and relationships with artists now considered of primary importance to the history of American art.

Larry Bloedel was a modest man who wanted to assist artists and play a role in positioning their work in history. He ultimately allowed us to decide how his patronage—the third largest single gift to the Permanent Collection in our history—could best contribute to the programs of the Whitney Museum. Through many conversations with him, long deliberations between me and the curatorial staff, and the luck of the draw, he now has a permanent place in the institution he felt represented American art better than any other.

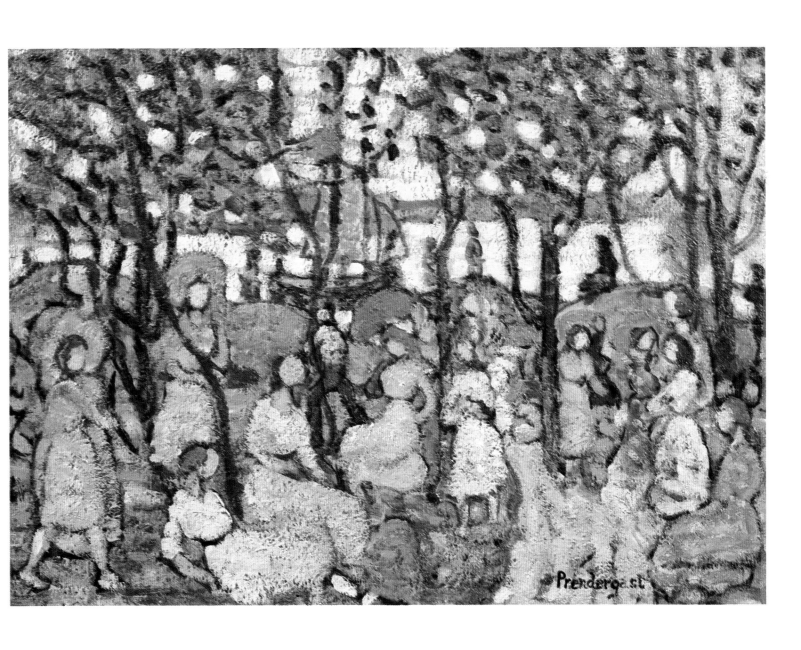

Summer's Day, 1916–18
Oil on canvas, 20¼ x 28¼ inches
Lawrence H. Bloedel Bequest 77.1.43

JASPER JOHNS

Three Flags, 1958

One of my first dilemmas as director was an ongoing misunderstanding with Emily and Burton Tremaine concerning the restoration of a Jasper Johns painting they had lent to the 1974 exhibition "American Pop Art." I had never met the Tremaines and was anxious to draw them closer to the Museum. I knew that they were allied with The Museum of Modern Art and that they had given a collection of works to the National Gallery of Art, but subsequently had a disagreement regarding the use of their gift. In November 1975, I wrote and asked the Tremaines if we could meet. Two months later, Howard Lipman and I visited them in an effort to try to settle our disagreements. We all realized that we shared the same long-term and intense interest in American art, which superseded the difficulties that had developed between us. They then lent, very generously, to the Jasper Johns exhibition, curated by David Whitney and presented at the Whitney Museum in 1978.

In January 1980, the Tremaines offered to sell the Whitney Museum a group of ten paintings, but the price was beyond our means. Later that spring, however, Arnold Glimcher of Pace Gallery offered the Museum right of first refusal on the Tremaines' *Three Flags* for $1 million. This was at the time not only the most ambitious acquisition for the Museum, but it was also the most expensive painting by a living American artist ever offered for sale. We were able to arrange for the purchase, the terms were agreed to in September, and voted upon by the Executive Committee at a meeting on September 17, 1980.

As we concluded the arrangements, I realized that *Three Flags* had been sold originally to the Tremaines by Leo Castelli. I wanted him to hear directly from me that we were purchasing it from Pace Gallery. I asked for an appointment to visit Leo in his home. I arrived, drinks were served, and I began talking about Johns, specifically about *Three Flags.* Mrs. Castelli asked

that we not discuss business. When she left the room I told Leo that we were buying the painting. He said that it was impossible, that we did not have the funding, and that he was certain it was going to a Japanese buyer. I told him that Arnold Glimcher had arranged for us to have first refusal, that the painting would be ours, and that I was proud to able to tell him so myself. Castelli remained incredulous, unable to believe the Whitney Museum could accomplish an acquisition of this magnitude.

During the last week in September, I was speaking in North Carolina at the Burroughs Wellcome Corporation and asked Flora Miller Biddle, then President of the Museum, and Brendan Gill, Trustee, to accompany me to Winston-Salem and Raleigh to enjoy public and private collections. While in Raleigh, I received a message from critic Grace Glueck that she knew about the purchase, had talked to Leo Castelli, and that she would announce it in *The New York Times* on September 27—nearly two weeks before the acquisition was to be presented to the full Board of Trustees at a meeting scheduled for October 8, 1980. When Flora and I heard that news of the acquisition would become public before the Trustees meeting, we returned to New York City to alert the Board, hoping that we had its confidence.

The acquisition of *Three Flags* by Jasper Johns was announced on the front page of *The New York Times* on the twenty-seventh. To the amazement of many, we had overcome the odds and purchased an internationally acclaimed masterpiece, with the assistance of four extraordinarily generous donors.

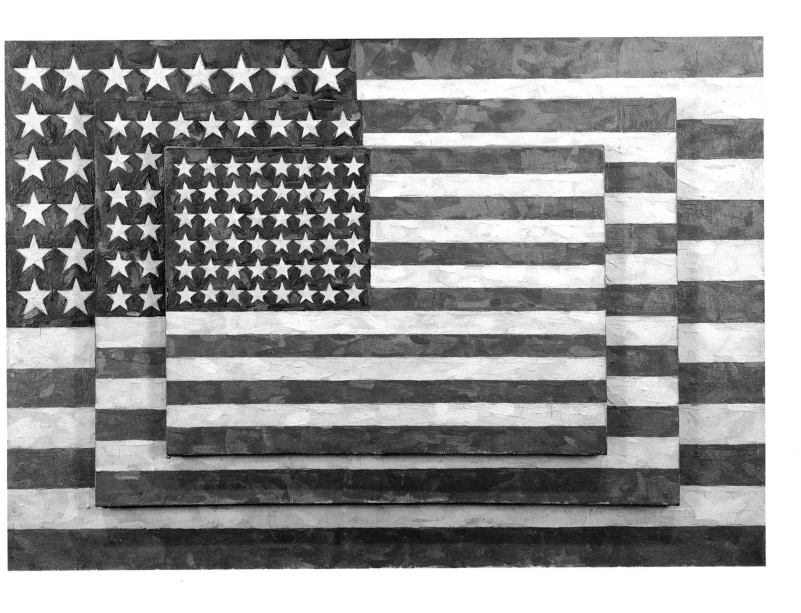

Three Flags, 1958
Encaustic on canvas, 30⅞ x 45½ x 5 inches
50th Anniversary Gift of the Gilman
Foundation, Inc., The Lauder Foundation,
A. Alfred Taubman, an anonymous donor,
and purchase 80.32

Overleaf
"Jasper Johns," opening reception, 1977.

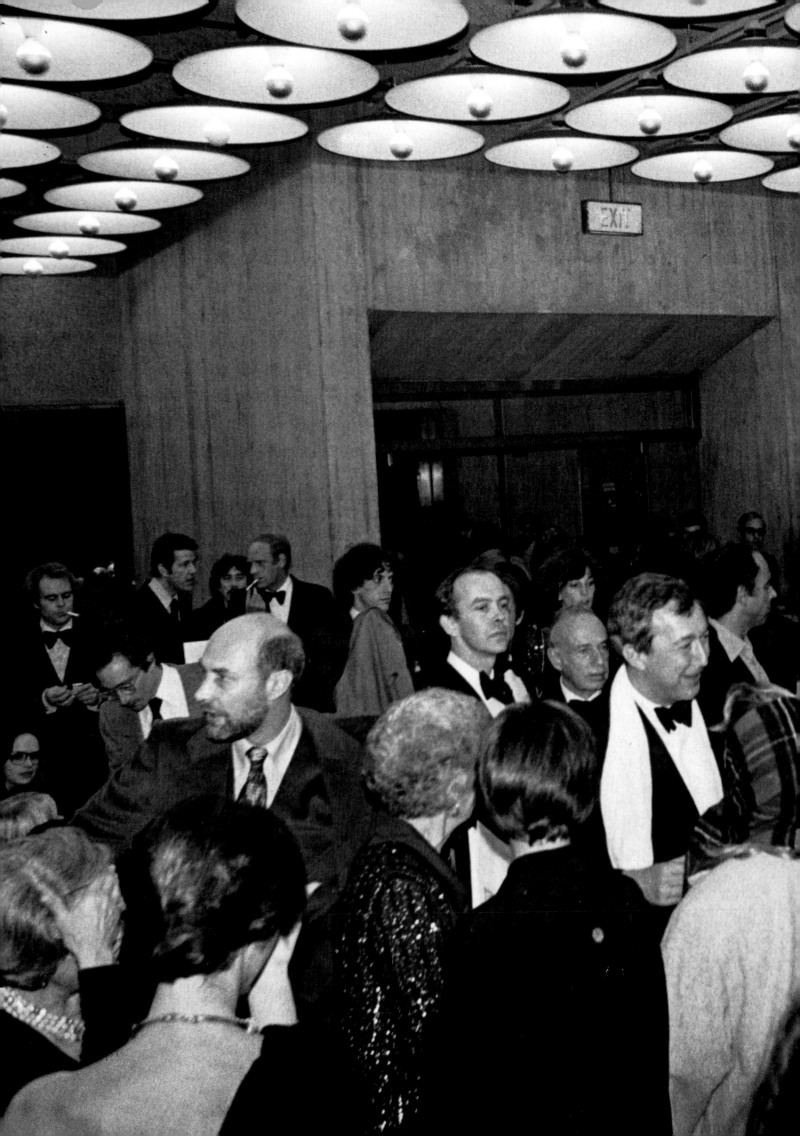

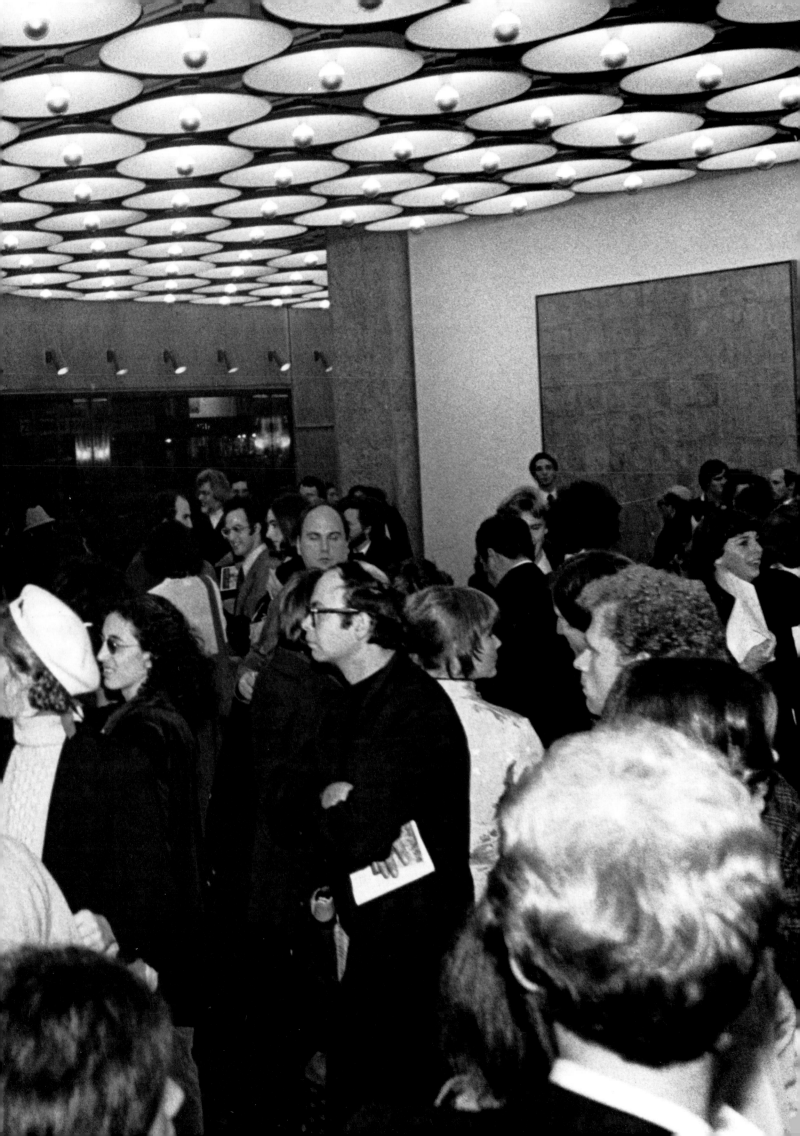

CLAES OLDENBURG

Soft Toilet, 1966

In my experience as a museum administrator, I have met few people who are constantly involved in the appreciation of twentieth-century American art through an ongoing, compulsive relationship with objects. Most important among these have been Edwin Bergman, Frances and Sydney Lewis, Howard Lipman, and Victor Ganz, all of them preoccupied with the search for new forms of expression. Howard Lipman had been chairman of the committee that selected me as director, and he inspired me with his patient teaching and vision of the Museum's future. When he retired and began spending most of his time out of New York, it was to Victor Ganz that I turned, as a friend and for his discerning judgment.

A member of the Drawing Committee since 1976, the Painting and Sculpture Committee since 1981, the Print Committee since 1984, and a Trustee between 1981 and his death in 1987, Victor came to the Whitney Museum with a lifelong experience in art. For over three decades he collected exclusively the work of Picasso, and then in 1961 he began to assemble the work of the generation of American artists that emerged after World War II—Johns, Rauschenberg, Oldenburg, and Stella—and of the next generation—Eva Hesse, Mel Bochner, and Dorothea Rockburne.

When in 1980 we were organizing the celebration of the fiftieth anniversary of the founding of the Whitney Museum of American Art, it was decided to approach collectors for gifts of specific objects rather than ask for a gift of their choice. This annoyed certain people but also assured that whatever we got would be exactly what we wanted. In the case of Sally and Victor Ganz, we felt it would be inappropriate to seek a work by an artist represented in-depth in their collection.

I had long admired Claes Oldenburg's *Soft Toilet*, which Victor delighted in showing visitors to their apartment. Sally and Victor had become intrigued by Oldenburg's work when they viewed the installation of the *Bedroom Ensemble* at the Sidney Janis Gallery early in 1964. When they saw *Soft Toilet* two years later at the same gallery, they bought it. The work was placed in the dining room of their apartment, designed by Robsjohn-Gibbings, which caused considerable concern to guests. Even Alfred Barr once discreetly asked Sally, "Is he really going to keep it there?"

In 1974, the Whitney Museum presented the first survey exhibition of Pop Art, "American Pop Art," curated by Lawrence Alloway, for which many masterpieces were borrowed from collections outside the United States. Soon after this exhibition I had the opportunity to see canvas versions of Oldenburg's "bathroom" pieces in Cologne and the cardboard version of the toilet in the Stöhrer Collection in Darmstadt. *Soft Toilet*, I felt, was a quintessential example of American Pop Art and would help the Museum document this moment in American art history—a moment represented so extensively in Europe but often rejected by American museums, perhaps because its themes were so close to the mundane realities of our culture. When I approached Victor and Sally about donating *Soft Toilet*, they immediately agreed.

It is a regrettable situation that there are so few people with the necessary knowledge, experience, generosity, and integrity to advise public institutions in the way Victor Ganz did. As a private collector he was motivated by a desire to assemble objects and understand them. As a patron he had one agenda in our long association, the Whitney Museum and its relationship to the art of our times.

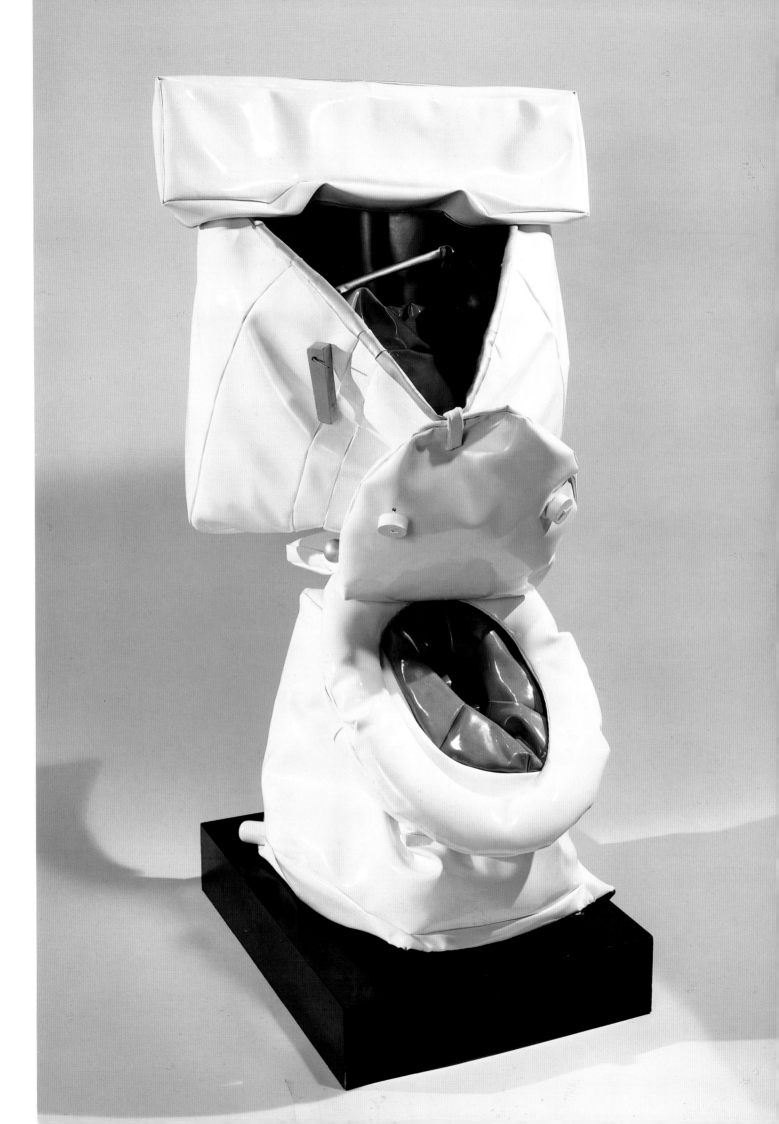

ALEXANDER CALDER

Calder's Circus, 1926–31

A work by Alexander Calder did not enter the Permanent Collection of the Whitney Museum of American Art until 1950. Since the 1960s, the Whitney Museum, through the continuous support of the artist by Howard and Jean Lipman, has assembled the most comprehensive collection of his work. The most famous example, *Calder's Circus,* was secured for the Permanent Collection in 1982, following a nationwide funding campaign.

Calder made his *Circus* in the 1920s. He gave performances for his friends and showed off for his future in-laws with a performance for them on the eve of his wedding. It represents the genesis of his introduction of movement into sculpture and is his most famous and beloved work. Because of the Lipmans' friendship with him and their many gifts to the Museum of his works, Calder placed the *Circus* on deposit with the Museum in 1970 and supervised its installation.

In 1976, Jean Lipman, with the assistance of Richard Marshall, curated "Calder's Universe," a grand and extraordinarily popular retrospective that involved Calder's total cooperation and participation and for which he reinstalled the *Circus* in the lobby of the Museum. Calder died three weeks after the exhibition opened, but *Calder's Circus* remained in the lobby, to the delight of tens of thousands of visitors to the Museum. In 1982, we learned that the ensemble would have to be sold by Calder's estate to settle taxes in France. Foreign museums, supported by government funds, particularly in France, had expressed interest in acquiring it at prices in excess of the first option price of $1.25 million offered only to the Whitney Museum. This option had to be exercised by May 31, 1982.

With very little time, the Trustees and staff organized a national effort to save *Calder's Circus.* Perhaps the most important meeting was an all-day session with the public relations staff of Ringling Bros. and Barnum & Bailey Circus, who organized a series of events to assist our campaign. On April 15, 1982, Ringling Bros. and Barnum & Bailey came to the Whitney Museum for a press conference attended by commissioner of cultural affairs Henry Geldzahler and Sonny Werblen, president of the Madison Square Garden Corporation. In his comments on this occasion, the late Irvin Feld, co-owner with his son Kenneth of Ringling Bros. and Barnum & Bailey Circus, said: "To let the *Circus* escape beyond our shores would be a cultural tragedy for all America."

In the audience that day was Seymour M. Klein, who had been a member of the Painting and Sculpture Committee since 1977. Seymour, through the Louis and Bessie Adler Foundation, Inc., of which he was president, had been extremely generous to the Museum over the years. Immediately following the press conference, he called to say that if Flora Miller Biddle and I would see him at his office at Shea & Gould he might be able to arrange to help us through the Robert Wood Johnson, Jr. Charitable Trust. We visited him, and after pleasantries were exchanged Seymour announced that he thought he could assist us with a gift of between $300,000 and $500,000. Flora and I were determined not to leave until we had secured the higher amount, which we did, but Seymour insisted we announce the gift immediately. I felt that this would undoubtedly hamper our ability to receive additional gifts and asked if we could discuss the details the following day. Very early the next morning, I called Seymour at his home to present the following proposition: would he request a gift from the Trust of one half of the necessary funding and give us three weeks to raise the remaining amount prior to the announcement of the gift? Seymour soon let me know that this arrangement would be satisfactory.

Activities over the next three weeks included clowns in Central Park soliciting funds, a poster contest for New York City school children, performances of circuses in backyards throughout the United States, articles in major publications, and Flora and I appearing as clowns in a benefit performance of Ringling Bros. and Barnum & Bailey Circus. We raised the necessary funds, and Seymour, through the Robert Wood Johnson, Jr. Charitable Trust, was the hero of our effort. He was joined by hundreds of others, perhaps the most cherished being a group of children in Texas who sent us the $3.75 they had raised from admission to their circus performance.

Overleaf
ALEXANDER CALDER
Calder's Circus, 1926–31
Mixed media, 54 x 94 ¼ x 94 ¼ inches overall
Purchase, with funds from a public fundraising campaign in May 1982. One half the funds were contributed by the Robert Wood Johnson Jr. Charitable Trust. Additional major donations were given by The Lauder Foundation, the Robert Lehman Foundation, Inc., the Howard and Jean Lipman Foundation, Inc., an anonymous donor, The T.M. Evans Foundation, Inc., MacAndrews & Forbes Group, Incorporated, the DeWitt Wallace Fund, Inc., Martin and Agneta Gruss, Anne Phillips, Mr. and Mrs. Laurance S. Rockefeller, the Simon Foundation, Inc., Marylou Whitney, Bankers Trust Company, Mr. and Mrs. Kenneth N. Dayton, Joel and Anne Ehrenkranz, Irvin and Kenneth Feld, Flora Whitney Miller. More than 500 individuals from 26 states and abroad also contributed to the campaign. 83.36.1-56

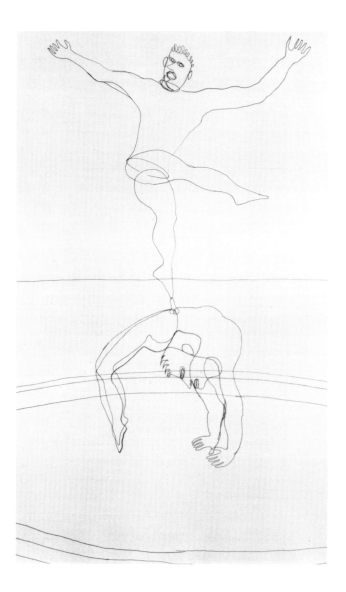

ALEXANDER CALDER
Two Acrobats, 1932 (detail)
Ink on paper, 21 ¼ x 29 ⅝ inches
Gift of Howard and Jean Lipman 80.50.1

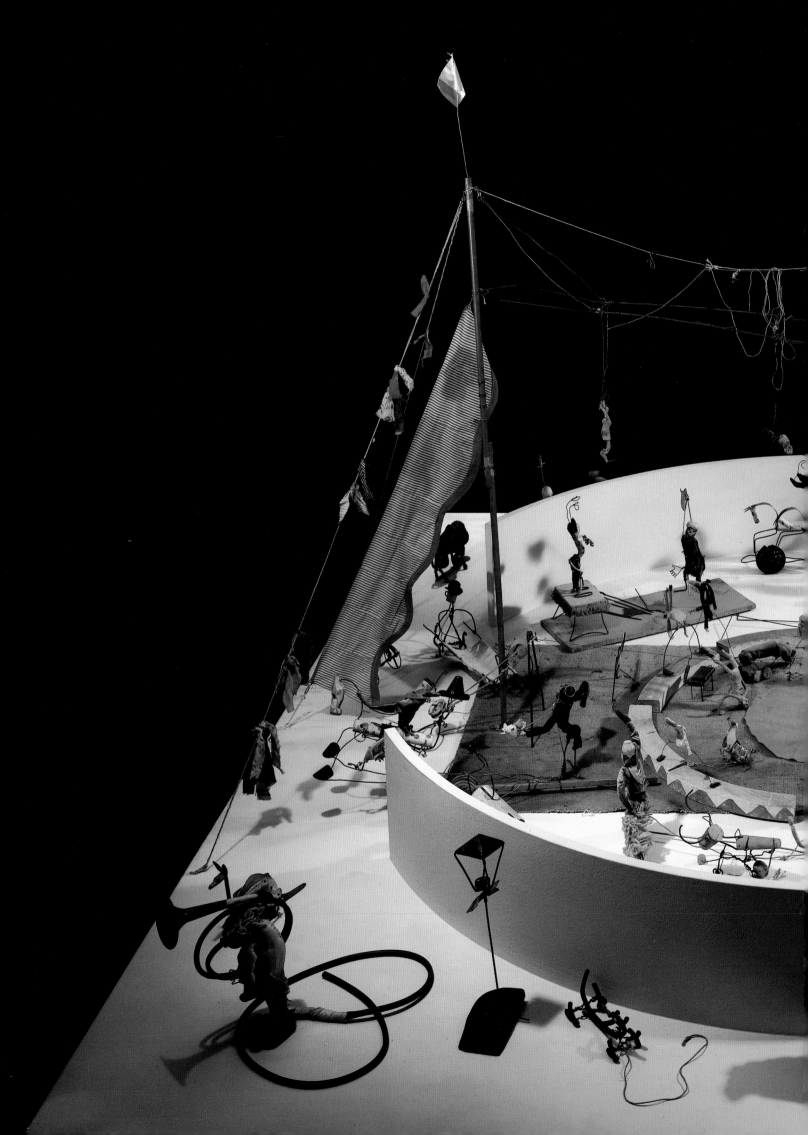

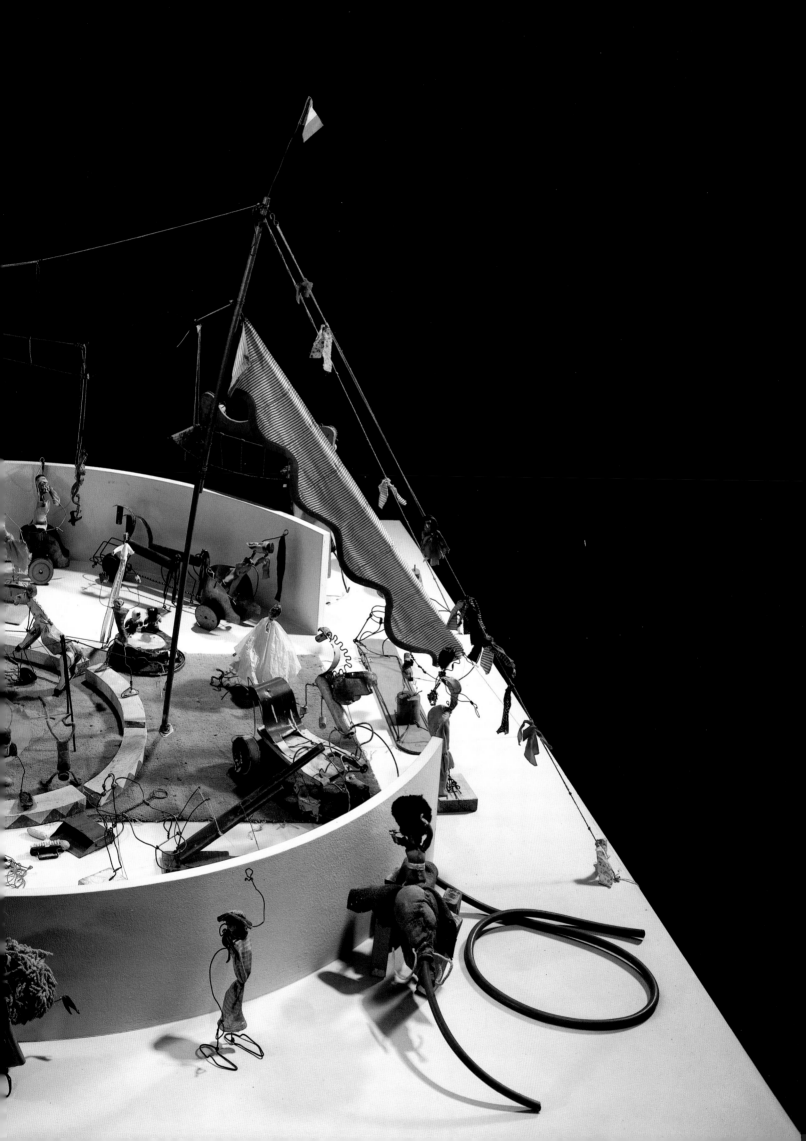

EDWARD HOPPER

A Woman in the Sun, 1961

When Lloyd Goodrich died in 1987, American art history lost a man who, more than anyone else, had witnessed and been a part of the history of twentieth-century American art. For our part, the Whitney Museum lost a consummate professional who had been associated with the institution for fifty-seven years, during which time he had become a preeminent scholar, making a lasting contribution to the understanding and enjoyment of American art.

Lloyd Goodrich was born in 1897, in Nutley, New Jersey. His best friend, in Nutley and during summers in Rhode Island, was Reginald Marsh. In an interview published in 1980, Lloyd vividly related his visit to the Armory Show in 1913 as a young man of sixteen and the arguments about the exhibition which he subsequently had with his father. In 1927, he became the associate editor of *The Arts*, which was then underwritten by Gertrude Vanderbilt Whitney. In March of that year, Lloyd published his first piece about Edward Hopper in conjunction with the first comprehensive one-artist exhibition of Hopper's work, at the Frank K.M. Rehn Gallery in New York. Sixty-two years ago, Lloyd Goodrich expressed as well as anyone has since the character of Hopper's work:

Hopper's austerity is . . . not the bloodless austerity of the would-be primitive, but the positive austerity of an artist who hates insincerity, false emotion, and superfluous decoration. . . . The vision expressed in his pictures is very much that of the average man, transformed into something more significant by the vision of the artist. The power which one feels in his work is all below the surface. . . . His sense of form is firm, sharp, spare; his color is not sensuously seductive, but it is always strong, clear, and ringing, and often of an invigorating brilliancy. . . . In Hopper's color, as in his drawing, there is an unfatigued, hard vigor that seems to me . . . as native to this country as his choice of subject matter or the spareness and austerity of his style.

Gertrude Vanderbilt Whitney gave Edward Hopper his first one-artist exhibition in 1920 at the Whitney Studio Club and presented his work again in 1922. In 1930, the same year Lloyd Goodrich became a researcher for the newly founded Whitney Museum, Mrs. Whitney purchased Hopper's *Early Sunday Morning*. Lloyd's association with Hopper, Mrs. Whitney, and the Whitney Museum led to a friendship between the artist and art historian that culminated in the greatest gift by an American artist to any museum. In 1968, Josephine Nivison Hopper, following plans made with her late husband, bequeathed to the Museum Hopper's entire artistic estate —now the heart of the Permanent Collection. Lloyd's greatest legacy is the Hopper Bequest, which his tenacious admiration for the artist, building on Mrs. Whitney's early support, brought to the Museum.

I have had to correct the perception that with the Hopper Bequest the Museum can adequately explain Hopper's achievement, for we cannot properly present the culmination of his talent. Lloyd Goodrich, late in life, played a final role in improving the Museum's representation of Hopper. His older sister, Frances, collected works by artists she had known and admired through Lloyd's enthusiasm. In 1984, Frances and her husband, Albert Hackett, made a partial and promised gift of Hopper's *A Woman in the Sun* (1961). This masterwork, which exemplifies the qualities Lloyd found in Hopper's art, was given to the Whitney Museum in honor of Lloyd and his wife, Edith, who encouraged and assisted every phase of his work. It will forever associate Hopper, the greatest American realist painter of the twentieth century, the Goodriches, and the generosity of a loyal family to the Whitney Museum.

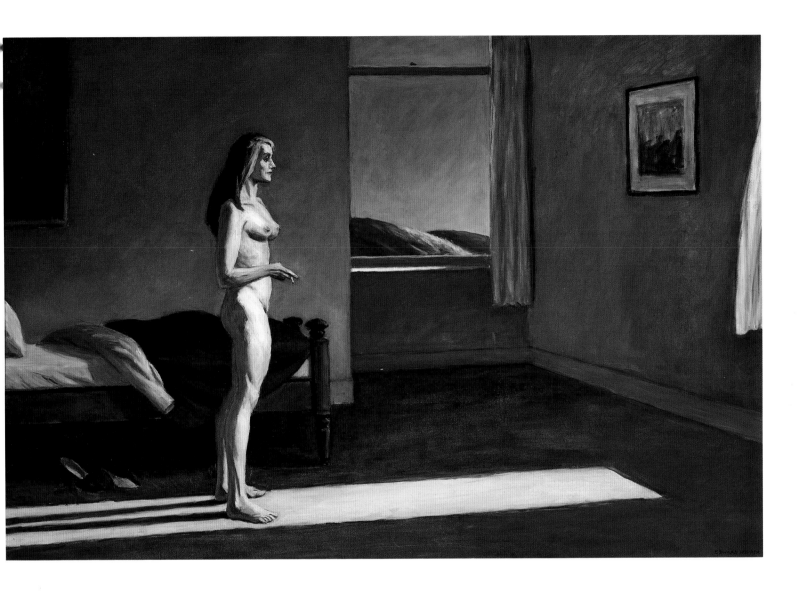

A Woman in the Sun, 1961
Oil on canvas, 40 x 60 inches
50th Anniversary Gift of Mr. and Mrs.
Albert Hackett in honor of Edith and
Lloyd Goodrich 84.31

Overleaf
"Edward Hopper: The Art and The Artist,"
1980–81.

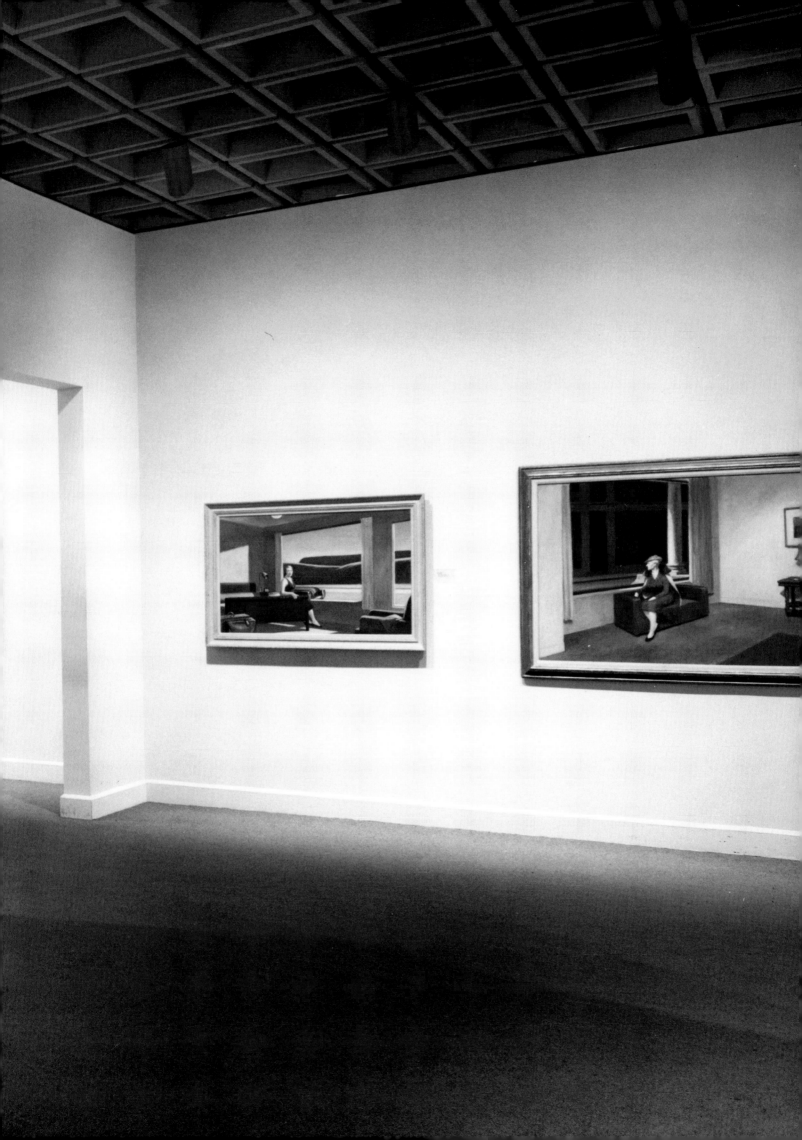

ELIE NADELMAN

Tango, c. 1919

A paragraph in the minutes of the April 3, 1973, Board of Trustees meeting reads: "Mr. Baur reported a telephone conversation with Lincoln Kirstein concerning the Nadelman *Tango* in the [Edith Halpert estate] sale, for which the Museum had intended to bid. Mr. Kirstein suggested that, instead, he would anonymously bequeath to the Museum his own finer and earlier version of *Tango* in memory of Mrs. Whitney and Mrs. Force. . . ."

In his letter of transfer to Jack Baur, Lincoln Kirstein wrote: "This is the first of two versions of *Tango;* I bought it from Mrs. Nadelman in 1950. . . . Mrs. Halpert bought hers much later; she split it in an attempt to sell the man and woman individually. Since the gesso was peeling, she had it rather coarsely repainted—mine is faded and flaked, but I think it is what Nadelman would like. . . . It gives my wife and myself such pleasure to think that *Tango* would be at the Whitney, for Nadelman was associated with the Studio Club from the start and a friend." The gift was published in the 1972–73 *Whitney Review.* In September 1976, Lincoln Kirstein withdrew the gift: "I know now that my circumstances are so altered that I am not in a position to do this any longer. My first obligation is to the School of American Ballet and our fulfillment to the Ford Foundation in regard to matching grants makes me have to dispose of my pictures and sculpture in favor of the school." The Museum did not contest because of the purposes of the reassignment.

Jack Baur organized the first important Nadelman retrospective, presented at the Whitney Museum in 1975. At the time, we owned one Nadelman, the bronze relief *Spring,* and it was clear that the lack of representative work by this early modernist marked a great deficiency in the Permanent Collection. Nadelman had his first show in New York in 1915 with Alfred Stieglitz. Mrs. Whitney knew of him and he was friendly with many artists who regularly attended the Whitney Studio Club. The gift of *Tango,* his greatest wood sculp-ture, was a significant addition to the Permanent Collection and the withdrawal seemed an irreplaceable loss. It became obvious that every effort should be made to acquire a masterwork by this artist who, with Gaston Lachaise, was the most accomplished American sculptor of the earlier twentieth century.

In late spring 1987, we learned that five Nadelmans, given to the School of the American Ballet by Lincoln Kirstein, were going to be sold, and we made efforts to purchase *Tango* directly. The School, however, decided to auction all five works at Christie's.

The Planning Committee Report had stated that the Museum should collect only twentieth-century works. To acquire *Tango,* we sold at Sotheby's a group of important nineteenth-century works from the Permanent Collection. One had been given in memory of Juliana Force and another in memory of Jack Baur. Funds created from their sale would continue to carry these credits.

On December 4, 1987, the Whitney Museum was the underbidder for *Tango.* Immediately after the sale, we were told that Berry-Hill Galleries had purchased the work for inventory. When I informed the Trustees that we had lost *Tango,* Bill Woodside, president, heartily encouraged me to attempt to buy it. On January 15, 1988, the sculpture originally promised to the Whitney Museum fifteen years earlier entered the Permanent Collection.

Tango, c. 1919
Painted wood and gesso, three units,
35⅞ x 26 x 13⅞ inches overall
Purchase, with funds from the Mr. and
Mrs. Arthur G. Altschul Purchase Fund,
the Joan and Lester Avnet Purchase Fund,
the Edgar William and Bernice Chrysler
Garbisch Purchase Fund, the Mrs. Robert
C. Graham Purchase Fund in honor of John
I.H. Baur, the Mrs. Percy Uris Purchase
Fund, and the Henry Schnakenberg
Purchase Fund in honor of Juliana Force 88.1a-c

Overleaf
"The Sculpture and Drawings of Elie Nadelman," 1975.

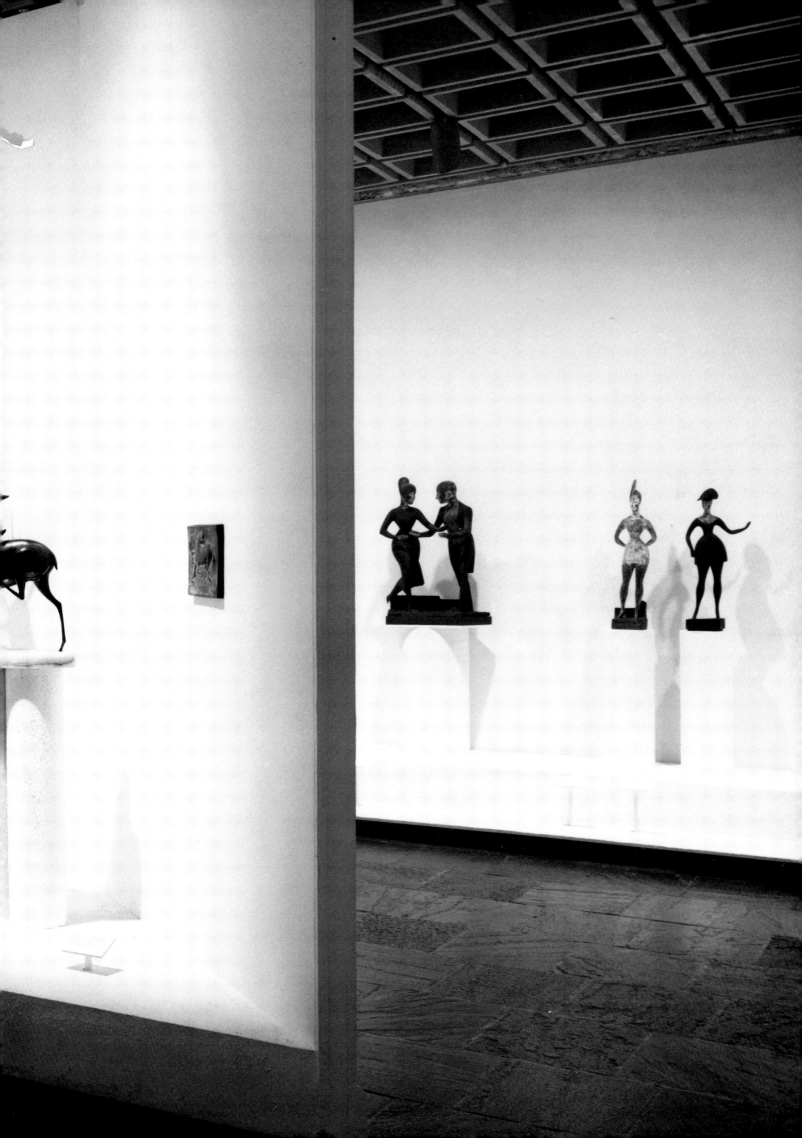

ACQUISITION COMMITTEES 1974–1989

PAINTING AND SCULPTURE COMMITTEE

Mrs. Robert M. Benjamin

Edwin A. Bergman

Mrs. Richard Black

Peter M. Brant

Eli Broad

Joanne L. Cassullo

Jack E. Chachkes

Richard M. Danziger

Charles B. Diker

Asher B. Edelman

Mrs. Thomas M. Evans

Arthur Fleischer, Jr.

B.H. Friedman

Victor W. Ganz

Faith G. Golding

Sondra Gilman Gonzalez-Falla

John Halpern

Susan Morse Hilles

Morton L. Janklow

Sidney S. Kahn

Martin E. Kantor

Elaine Kaufman

Henry Kaufman

Gilbert H. Kinney

Seymour M. Klein

Berthe Kolin

Emily Fisher Landau

Leonard A. Lauder

Raymond J. Learsy

Sydney Lewis

Robert K. Lifton

Howard Lipman

Constance B. Mellon

Robert M. Meltzer

Mrs. Nicholas Millhouse

Adrian Mnuchin

Sandra Payson

Sandra L. Price

Hannelore Schulhof

Paul J. Schupf

Eugene M. Schwartz

Ethel Redner Scull

Robert Sosnick

A. Alfred Taubman

Mrs. Nathaniel Usdan

George H. Waterman III

Mrs. Paul L. Wattis

Nancy Brown Wellin

Leslie H. Wexner

Mrs. Robert Woods

Richard S. Zeisler

Thomas N. Armstrong III, *ex officio*

Flora Miller Biddle, *ex officio*

William S. Woodside, *ex officio*

DONORS OF WORKS IN THE EXHIBITION

Louis and Bessie Adler Foundation, Inc., Seymour M. Klein, President

Mr. and Mrs. Arthur G. Altschul Purchase Fund

The American Art Foundation

Associated American Artists

The Lily Auchincloss Foundation

Sally Avery

Joan and Lester Avnet Purchase Fund

Richard Brown Baker

Bankers Trust Company

John I.H. Baur Purchase Fund

Grace Belt Endowed Purchase Fund

Mrs. Robert M. Benjamin

Mr. and Mrs. Edwin A. Bergman

Flora Miller Biddle

Charles and Anita Blatt Fund

James Block

Lawrence H. Bloedel Bequest

Peter M. Brant

Sandy and Peter M. Brant

Eli and Edythe L. Broad

Eli Broad Family Foundation

Brown Foundation, Inc.

Burroughs Wellcome Purchase Fund

Alexander Calder

Louisa Calder

Leo Castelli

Toiny and Leo Castelli

Mr. and Mrs. Wilfred P. Cohen

Wilfred P. and Rose J. Cohen Purchase Fund

Timothy Collins

The Crawford Foundation

Neelon Crawford

Dana Foundation, Incorporated

Peggy and Richard Danziger

Mr. and Mrs. Kenneth N. Dayton

Gertrude W. Dennis

Seth and Gertrude W. Dennis

Willem de Kooning

DeWitt Wallace Fund, Inc.

Beth and James DeWoody

Edward R. Downe, Jr.

Edward R. Downe, Jr. Purchase Fund

Drawing Committee

Norman Dubrow

Mrs. Marcel Duchamp

Joel and Anne Ehrenkranz

Julia B. Engel Purchase Fund

Equitable Life Assurance Society of the United States Purchase Fund

The T.M. Evans Foundation, Inc.

Mr. and Mrs. Thomas M. Evans Purchase Fund

Irvin and Kenneth Feld

Lucille and Walter Fillin

Vain and Harry Fish Foundation, Inc.

M. Anthony Fisher Purchase Fund

Mr. and Mrs. M. Anthony Fisher Purchase Fund

Xavier Fourcade

Abby and B.H. Friedman

B.H. Friedman

Friends of the Whitney Museum of American Art

The family of Victor Ganz

Mr. and Mrs. Victor W. Ganz

Edgar William and Bernice Chrysler Garbisch Purchase Fund

Gilman Foundation, Inc.

Sondra and Charles Gilman, Jr. Foundation, Inc.

Edith and Lloyd Goodrich

Mrs. Robert C. Graham Purchase Fund

Martin and Agneta Gruss

Agnes Gund

Mr. and Mrs. Albert Hackett

The Edith Gregor Halpert Foundation

The Hearst Corporation

Susan Morse Hilles

Historic Art Associates of the Whitney Museum of American Art

Vivian Horan

Mr. and Mrs. Leonard J. Horwich

Mr. and Mrs. Michael H. Irving

Mr. and Mrs. Morton L. Janklow

Philip Johnson

Robert Wood Johnson, Jr. Charitable Trust

Sidney S. Kahn

Mr. and Mrs. R. Crosby Kemper

Calvin Klein

Knoll International

Mrs. Oscar Kolin

Mr. and Mrs. Oscar Kolin

Mr. and Mrs. Samuel M. Kootz

Sherry and Alan Koppel

The Lachaise Foundation

Emily Fisher Landau

The Lauder Foundation

Mr. and Mrs. Leonard A. Lauder

Raymond J. Learsy

Mr. and Mrs. Raymond J. Learsy

Robert Lehman Foundation, Inc.

Lemberg Foundation, Inc.

Frances and Sydney Lewis

Howard and Jean Lipman

Howard and Jean Lipman
Foundation, Inc.

Albert A. List Fund

The List Purchase Fund

Mrs. H. Gates Lloyd

Mr. and Mrs. Richard D. Lombard

MacAndrews & Forbes Group,
Incorporated

Dr. and Mrs. Barnett Malbin

Lydia Winston Malbin

Felicia Meyer Marsh

Felicia Meyer Marsh Purchase Fund

Mrs. William A. Marsteller

Mr. and Mrs. William A. Marsteller

Neysa McMein Purchase Award

Mr. and Mrs. Robert M. Meltzer

Flora Whitney Miller

Mrs. Nicholas Millhouse

The Mnuchin Foundation

Fred Mueller

Mr. and Mrs. E. Jan Nadelman

National Endowment for the Arts

Painting and Sculpture Committee

Mrs. Muriel D. Palitz

Joan Whitney Payson Bequest

Sandra Payson

Philip Morris Incorporated

Anne Phillips

Richard Pousette-Dart

Print Committee

Print Purchase Fund

Mrs. John B. Putnam Bequest

Rita Reinhardt

Judge Steven D. Robinson

Sara Roby Foundation

Mr. and Mrs. David Rockefeller

Mr. and Mrs. Laurance S. Rockefeller

Richard and Dorothy Rodgers Fund

Mrs. Theodore Roszak

Theodore Roszak Estate

The Mark Rothko Foundation, Inc.

Mr. and Mrs. Albrecht Saalfield

Henry Schnakenberg Purchase Fund

Hannelore Schulhof

Mr. and Mrs. Eugene M. Schwartz

Ethel Redner Scull

Mr. and Mrs. Robert C. Scull

Daisy V. Shapiro Bequest

Katherine Schmidt Shubert
Purchase Fund

Charles Simon

Charles Simon Purchase Fund

Friends of Charles Simon from
Salomon Brothers

Simon Foundation

Benjamin Sonnenberg

Mr. and Mrs. George D. Stoddard

Philip and Lynn Straus

David J. Supino

Helen S. Tankersley

A. Alfred Taubman

Alan H. Temple

Cy Twombly

Mrs. Percy Uris

Mrs. Percy Uris Bequest

Mrs. Percy Uris Purchase Fund

Mrs. Louise Varèse

Chauncey L. Waddell

Andy Warhol

Warner Communications Inc.

Mr. and Mrs. Benjamin Weiss

Marylou Whitney

Christopher Wilmarth

Robert W. Wilson

Lydia and Harry Lewis Winston
Collection

The Norman and Rosita Winston
Foundation, Inc.

Penny and Mike Winton

Louise and Joe Wissert

The Woodward Foundation

Claire B. Zeisler

Richard S. Zeisler

Jerome Zipkin

The children of William Zorach

EARLY AMERICAN MODERNISM

CHARLES DEMUTH
Red Gladioli, 1928
Watercolor on paper, 22 x 28 inches
Promised gift of Mr. and Mrs. Laurance
S. Rockefeller P.1.87

When the Whitney Museum of American Art opened its doors in 1931, its collection contained a core of masterworks of twentieth-century American art assembled by the Museum's founder, Gertrude Vanderbilt Whitney. She was assisted by director Juliana Force and many of the artists who had taken part in the activities of the Whitney Studio and its successors, the Whitney Studio Club and Whitney Studio Galleries, from 1914 on. The collection, with fine examples of works by George Bellows, Alexander Brook, Guy Pène du Bois, William Glackens, Edward Hopper, Rockwell Kent, Reginald Marsh, and others, celebrated realism as the characteristic expression of American life. The enduring tradition of realism, broadly interpreted, was also supported in the Museum's collection through a small, select number of nineteenth-century masterworks by Mary Cassatt, Thomas Eakins, Albert Pinkham Ryder, and John La Farge. Among the modernists active in New York at that time, only Oscar Bluemner, Stuart Davis, and Jan Matulka were represented by more than one work.

OSCAR BLUEMNER
Study for *Expression of a Silktown*
(Paterson Centre), 1914
Charcoal on paper, 29 1/8 x 39 5/8 inches sight
Purchase, with funds from the Wilfred P.
and Rose J. Cohen Purchase Fund, the
Katherine Schmidt Shubert Purchase Fund,
the Mrs. Percy Uris Purchase Fund, The
Norman and Rosita Winston Foundation,
Inc., and the Drawing Committee 89.1

Since the Planning Committee Report on the future of the Museum was approved by the Board of Trustees in 1978, the Museum's collecting activity has been directed toward the creation of a broader and more comprehensive presentation of early twentieth-century art, one that includes realism, various forms of abstraction, and the work of individual artists who made an original synthesis of several traditions. To bring the Permanent Collection into better balance, we have acquired a number of important and characteristic works by early American modernists, especially those by artists in the Stieglitz circle and artists who were active during the years just before and after the Armory Show of 1913.

There has always been a strong emphasis on sculpture at the Whitney Museum, perhaps because our founder was herself an active, exhibiting sculptor. Mrs. Whitney's generation of American sculptors was often torn between an admiration for classicism, with its idealized beauty and tradition of direct carving, and the beckoning freedoms of modernism, with its unsettling, fragmented forms and alternative methods of construction. One of Mrs. Whitney's contemporaries who understood this very well was Polish-born Elie Nadelman, whose sculptures, drawings, and prints we have collected with growing commitment and enthusiasm in recent years.

Nadelman's *Tango* (c. 1919) is the elegant embodiment of a pleasure-loving era in American life. Its smoothed contours and precise forms express Nadelman's admiration for Greco-Roman classicism, while his affectionate handling of cherry wood reveals his fond regard for the natural materials so important to this avid collector of American folk sculpture.

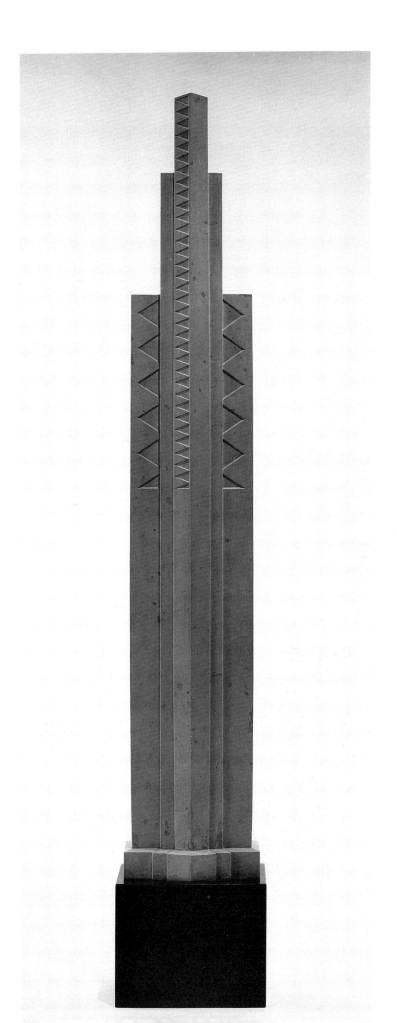

JOHN STORRS
Forms in Space #1, c. 1924
Marble, 76¾ x 12⅝ x 8⅝ inches
50th Anniversary Gift of Mr. and Mrs. B.H. Friedman in honor of Gertrude Vanderbilt Whitney, Flora Whitney Miller, and Flora Miller Biddle 84.37

65

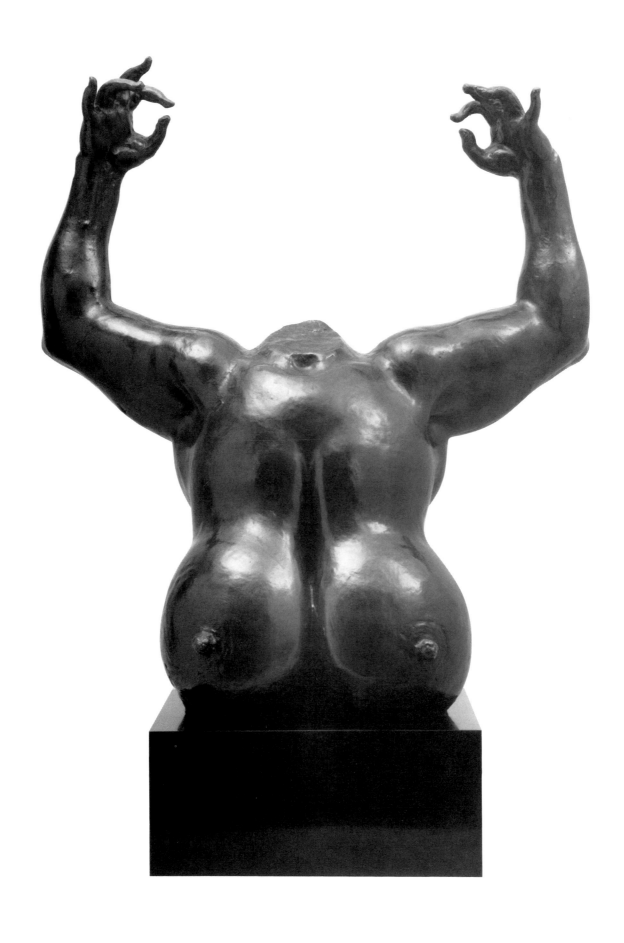

GASTON LACHAISE
Torso with Arms Raised, 1935
Bronze, 36¼ x 32¼ x 16½ inches
50th Anniversary Gift of The Lachaise
Foundation 80.8

As a young man living in Paris during the first decade of the century, Nadelman developed a curvilinear geometry of abstract form, quite possibly in advance of the angular geometries of Cubism. When he moved to New York in 1914, he seemed to be the leading spokesman for a synthesis of classicism and abstraction in American sculpture. His innovative art challenged American audiences to come to terms with the artistic vocabulary of the twentieth century while gaining a new appreciation for their national artistic heritage. Today, the issues brought forth in Nadelman's art and career seem to parallel our own desire to juxtapose, if not reconcile, forms derived from older artistic traditions with those of modernism.

In *Sur la Plage* (1916), Nadelman creates a tableau involving two female figures, a bowing servant in bronze and a marble goddess who offers her softly stylized limb to be bathed. The significant differences in the scale of these figures may represent a homage to the hierarchies often found in antique art, but they also admit a degree of dreamlike fantasy that would characterize much of later twentieth-century art. In Nadelman's bronze sculptures *Dancing Figure* (c. 1916–18) and *Wounded Stag* (c. 1915) a fictional world of antiquity comes to life amidst the clear influence of abstraction.

Nadelman's graceful drawing *Head of a Woman with Hat* (c. 1923–25) is composed of repeated curves and half-circles, clearly related to the geometric concepts he employed in the creation of his sculpture. A retrospective exhibition of Nadelman's work at the Whitney Museum in 1975 demonstrated the truly fascinating issues involved in his art and career, many of which we are confronting in the art and architecture of our own time.

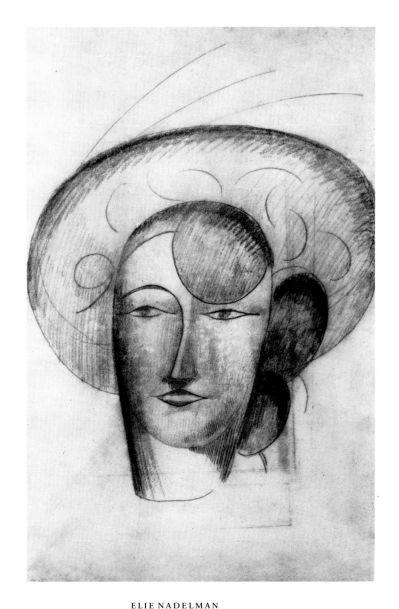

ELIE NADELMAN
Head of a Woman with Hat, c. 1923–25
Graphite on tracing vellum, 16½ x 10¼ inches
Purchase, with funds from the Lily Auchincloss Foundation, Vivian Horan, The List Purchase Fund, the Neysa McMein Purchase Award, Mr. and Mrs. William A. Marsteller, the Richard and Dorothy Rodgers Fund, and the Drawing Committee 83.34

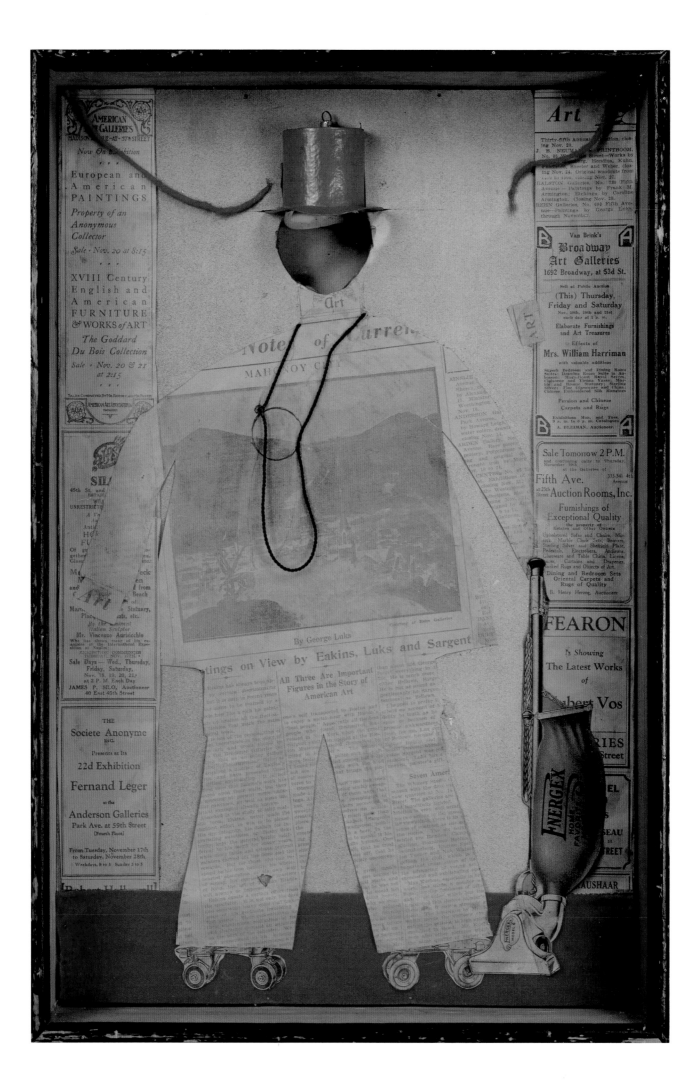

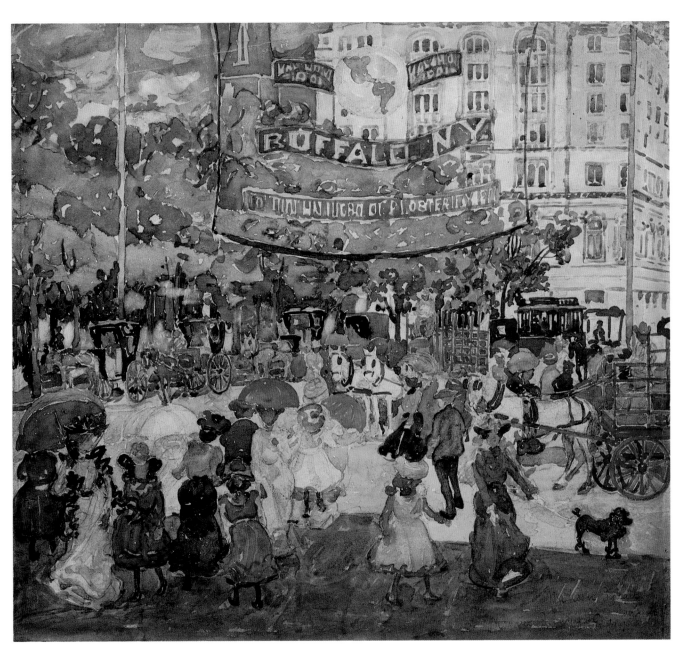

MAURICE PRENDERGAST
Madison Square, c. 1901
Watercolor on paper, 15 x 16½ inches
Joan Whitney Payson Bequest 76.14

ARTHUR G. DOVE
The Critic, 1925
Collage, 19¾ x 13½ x 3⅝ inches
Purchase, with funds from the Historic Art
Associates of the Whitney Museum of
American Art, Mr. and Mrs. Morton
L. Janklow, the Howard and Jean Lipman
Foundation, Inc., and Hannelore Schulhof
76.9

A notable group of bronze sculptures and drawings by Gaston Lachaise has recently augmented the Museum's extensive holdings of this artist's work. Two exceptionally early bronzes, *Woman Arranging Hair* and *Woman with Arms Akimbo,* both of 1910–12, have a fluidity of form and an animal vitality that clearly express the sculptor's pleasure in their creation. In Lachaise's later *Standing Figure* (1927), the outline is much more contained, but the swirling drapery recalls the exuberance of the earlier works. The latest sculpture in this group, *Torso with Arms Raised* of 1935, is a startling and overtly erotic work whose fragmentation only enhances its dramatic ability to engage our emotions and examine our private feelings about human sexuality.

Artists of the Stieglitz circle have figured in Whitney Museum exhibitions since the 1930s, but their work was not collected in depth or with the commitment that their enormous influence upon early twentieth-century American art deserves. We are very fortunate to have acquired five major paintings and two drawings by Georgia O'Keeffe during the past fifteen years. These span the emotional spectrum of her work, from the lush and lyrical *Flower Abstraction* of 1924 to the angular geometries of *Black and White* of 1930. An O'Keeffe retrospective, curated by Lloyd Goodrich and Doris Bry at the Whitney Museum in 1970, added to our understanding of her long career, and the 1981 show of O'Keeffes in our collection, curated by Patterson Sims, demonstrated how our holdings of her works have grown. In recent years, O'Keeffe's earliest works have attracted the attention of historians and critics; they have found such compositions as our *Drawing No. 8* of 1915, with its rhapsodic evocation of cosmic and biological forces, to be among the most original American contributions to twentieth-century art.

Arthur Dove's wonderfully irreverent assemblage *The Critic* (1925) presents an energetic creature known to many artists—a peripatetic empty-headed critic who moves swiftly through exhibitions on roller skates, gleaning what he can with his vacuum cleaner. He sports a clouded monocle and wears "ART" on his sleeve. This work is an icon of the period and one with specific references to the conservative critic Forbes Watson, who wrote many an unfriendly review of Dove and other artists associated with Alfred Stieglitz.

The watercolors of Charles Demuth, another important figure represented by Stieglitz, are among the most revered of early twentieth-century works on paper. The sensuous beauty of Demuth's *Red Gladioli* (1928) is so intense that it suggests a thoroughly eroticized vision of life. These works were shown, along with some of Demuth's more explicitly erotic paintings, within the larger context of the artist's oeuvre in the Museum's recent Demuth retrospective, curated by Barbara Haskell in 1987. Demuth's achievements in watercolor built upon the traditions established by such early twentieth-century masters of the medium as Maurice Prendergast. Our *Madison Square* of c. 1901 enables us to see how purposeful and wide-ranging a colorist Prendergast was. The delicate technique he employed so rigorously in his paintings comes from the direct experience of the light and color that so vividly describe these expansive watercolors.

To identify and study the major figures in American art of the early twentieth century, the Museum has acquired works that reveal the scope of the artists' creations and tell us about their lives and aspirations. We know, of course, that the landscape, architecture, and cultural heritage of New Mexico was important to Georgia O'Keeffe, but she also encouraged friends to visit the Southwest as a contrast to their experiences of life in big cities. Marsden Hartley's *Landscape, New Mexico* (1919–20) is as much a document of his own rugged, solid character as it is of the majestic openness of New Mexico. It provides a valuable opportunity to see how personality and environment contribute to a work of art and how an artist's essential concerns find expression in the most diverse of circumstances. American modernist Jan Matulka also journeyed to the Southwest early in this century, where he created a startling group of drawings such as our *Hopi Snake Dance, Number 1* of 1917–18, a work in which the geometric forms of Cubism interface with native geometries in Hopi costumes. It is a fascinating parallel to earlier European adaptations from the art of Africa and Oceania.

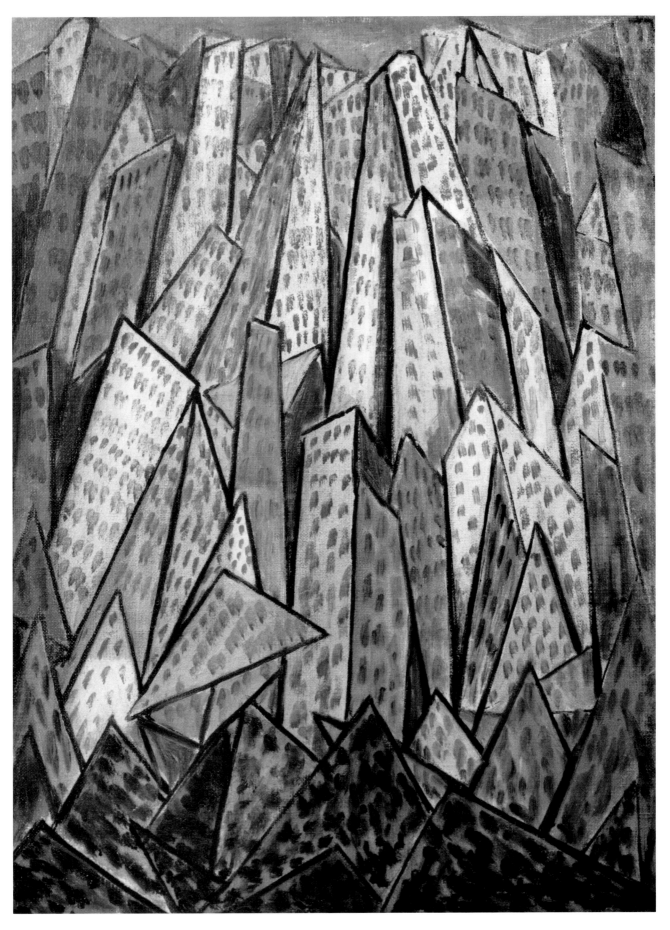

ABRAHAM WALKOWITZ
Cityscape, c. 1915
Oil on canvas, 25 x 18 inches
Purchase, with funds from Philip Morris Incorporated 76.11

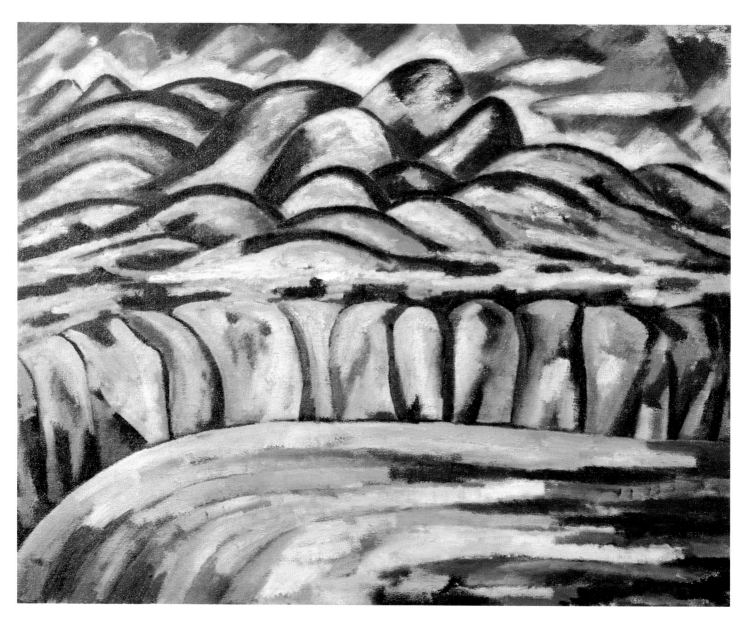

MARSDEN HARTLEY
Landscape, New Mexico, 1919–20
Oil on canvas, 28 x 36 inches
Purchase, with funds from Frances and
Sydney Lewis 77.23

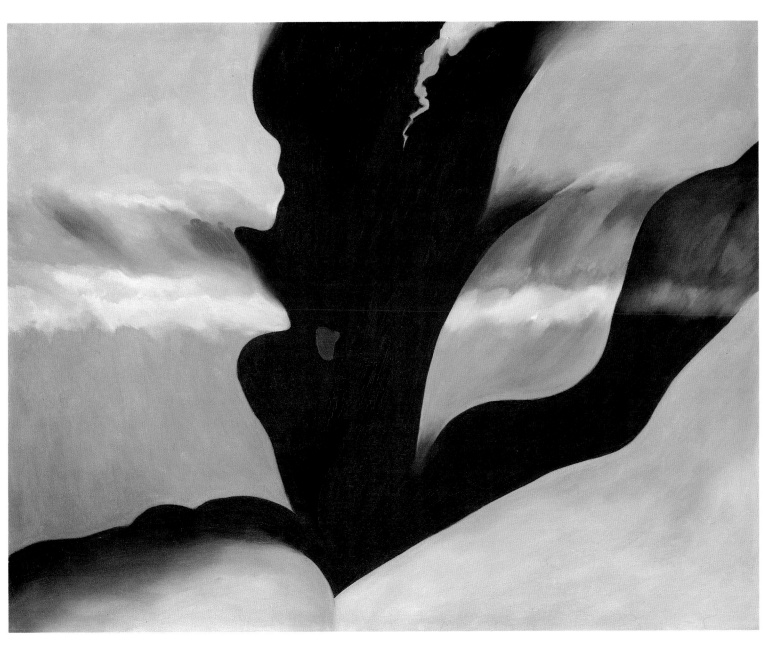

GEORGIA O'KEEFFE
Black Place Green 1949
Oil on canvas, 38 x 48 inches
Promised 50th Anniversary Gift of Mr.
and Mrs. Richard D. Lombard P.17.79

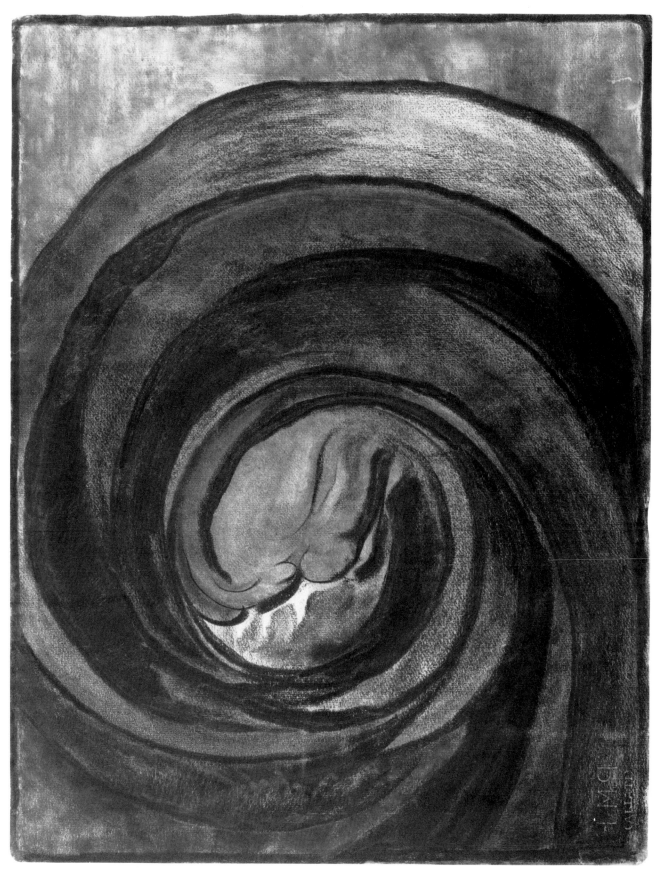

GEORGIA O'KEEFFE
Drawing No. 8, 1915
Charcoal on paper mounted on cardboard,
24¼ x 18⅞ inches
Purchase, with funds from the Mr. and
Mrs. Arthur G. Altschul Purchase Fund 85.52

The broadly supportive and at times eclectic patterns of collecting that characterized the early years of the Whitney Museum have in some respects worked to the advantage of our Permanent Collection. Mrs. Whitney's commitment to living American artists led her to reach out to many who were less well known in her lifetime but who are now quite highly regarded. Our collection thus contains several important paintings by Oscar Bluemner, some of these acquired early in the history of the Museum. To this group, we have recently added a large and very finely detailed drawing in charcoal, Study for *Expression of a Silktown (Paterson Centre)* (1914), which reveals the architectonic character of Bluemner's draftmanship and how it functioned as the structural counterpoint to the intense expressionist color in his paintings.

As our understanding of the art and the careers of early American modernists has grown, we have become more aware of the diversity of styles, the important role of individual personalities, and the complexity of the artistic and social issues confronted by this generation of American artists. We can begin to understand how individuals as different as Nadelman, O'Keeffe, Dove, and Bluemner could have been active in the same community of artists while working according to widely varying principles. The challenge of European modernism and the political upheavals of the early twentieth century were reflected in American life and in American art even while our artists tried, sometimes successfully, to maintain our national artistic character and our traditional commitment to realism. Only now that we comprehend the complexity of the achievements of early twentieth-century American modernists can we see how great were their aspirations for the new century.

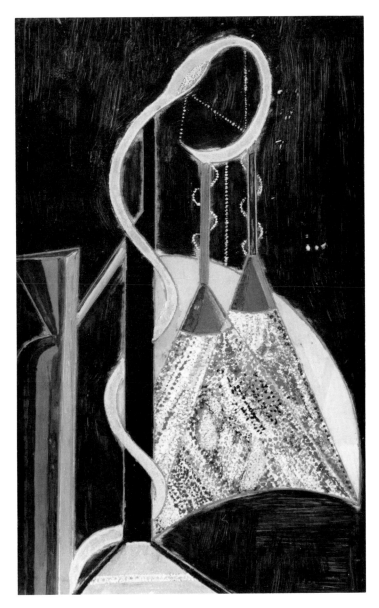

JOSEPH STELLA
Untitled, c. 1919
Oil and wire on glass, 13 5/16 x 8 1/2 inches
Daisy V. Shapiro Bequest 85.29

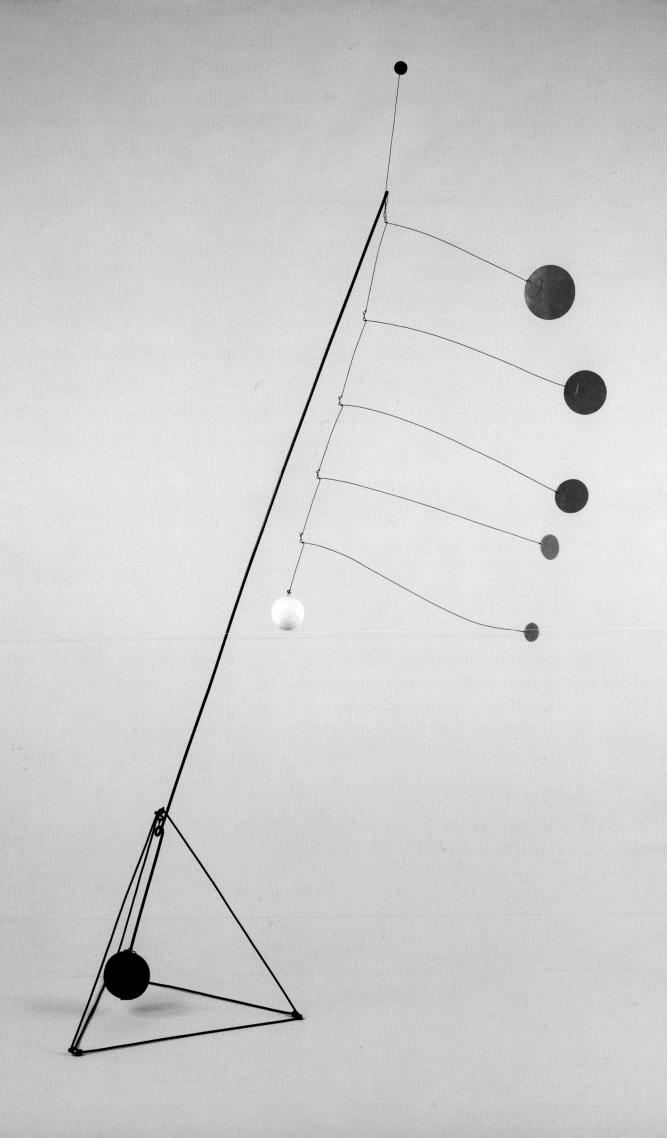

GEOMETRIC AND BIOMORPHIC ABSTRACTION

ALEXANDER CALDER
Calderberry Bush, 1932
Painted steel rod, wire, wood, and sheet
aluminum, dimensions variable,
approximately 88½ x 33 x 47½ inches
Purchase, with funds from the Mrs. Percy
Uris Purchase Fund 86.49

A second wave of American contact with European modernism occurred from the late 1920s to World War II, once again challenging the primary claim of realism on the American artistic imagination. A new generation of Americans, most of them too young to have seen the Armory Show of 1913, were attracted to late Synthetic Cubism, Contructivism, Neoplasticism, and abstract Surrealism. Americans of this generation often used the formal elements and pictorial syntax of these styles and movements in freer combinations and with less concern for the orthodoxies of theory than their European counterparts.

During the years after World War I and before the severe economic effects of the Great Depression were evident, American artists Alexander Calder, Stuart Davis, Jan Matulka, Isamu Noguchi, Theodore Roszak, and many others frequently went to Europe; some even attached themselves to European artist groups, forming strong bonds of friendship based on shared aesthetic, social, and political ideals. As the political climate

in Europe grew unstable, many gifted émigrés came to the United States, where they soon began to play significant roles in this country's artistic development.

Recent scholarship and our own collecting activity over the past fifteen years have focused on the active dialogue between the partisans of realism and those of abstraction, a dialogue that made this period such an important turning point in the history of American art. The acquisition of significant works of abstract and non-objective art from the late 1920s to the mid-1940s has challenged us to see this period of American art anew, as the strong realist base of our Permanent Collection is viewed in a broader context.

Perhaps no other American modernist has won our esteem so completely as Alexander Calder. Our Permanent Collection now contains more than a hundred works by this important, indeed beloved American artist. *Calder's Circus* (1926–31) is what remains of the many performances he staged of acrobats, clowns, and caged lions, accompanied by extemporaneous narratives that delighted his audiences, private and public, for almost forty years. The story of the Museum's acquisition of *Calder's Circus* through a public fund-raising campaign in May 1982, recounted in Tom Armstrong's introduction, is one of the most delightful and inspiring chapters in the history of the Whitney Museum.

Alexander Calder's role as a pioneer American modernist has also been emphasized in recent years. We can see the rigorous qualities of abstraction in the elegant simplicity and warmth of *Calderberry Bush* (1932), a work poised on the edge of complete non-objectivity, yet with clearly stated references to the structural beauties of nature. Calder moved easily between geometric abstraction and the biomorphic forms he evolved from his buoyant appreciation for nature's forces, physical laws, and gentle, yet insistent patterns of movement.

The graceful mobile *Roxbury Flurry* (c. 1948) traverses the boundary between abstraction and representation as it becomes the physical embodiment of a gentle winter snow hovering and falling around Calder's Connecticut studio and home. In 1976, the year of the artist's death, the Whitney Museum staged the major exhibition "Calder's Universe," curated by Jean Lipman, which presented a vast panorama of his creative work in many media. A well-focused historical exhibition, "Alexander Calder: Sculpture of the Nineteen Thirties," curated by Richard Marshall in 1987, focused on Calder's early work in Paris, which established him as the important American sculptor of his generation. International acclaim for Calder's art continues to grow, an acclaim based as much on the work's intellectual rigor as on the emotional lyricism that touches so many of us, regardless of age, sophistication, or expectations.

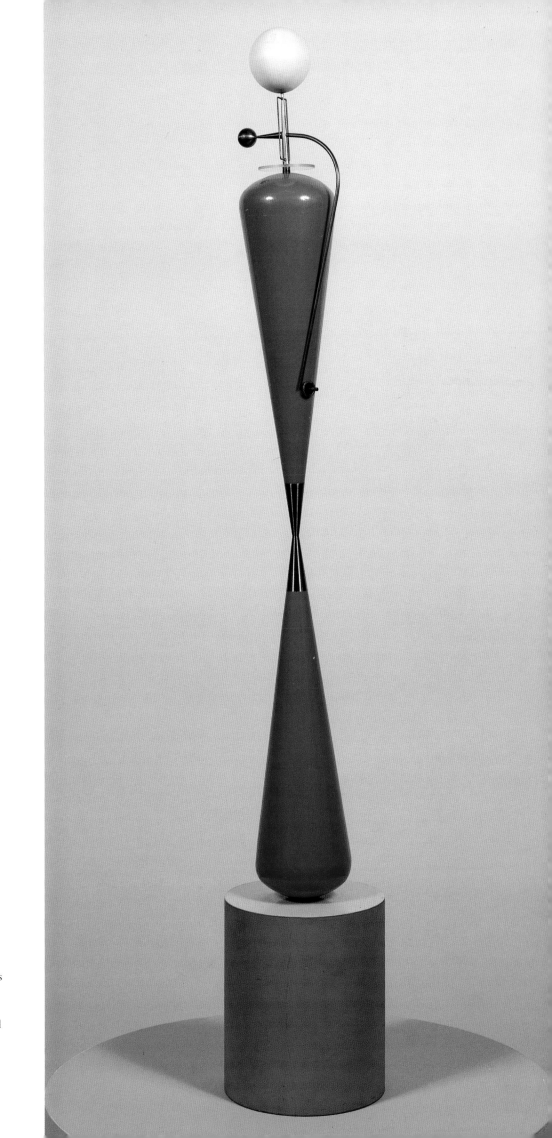

THEODORE ROSZAK
Bi-Polar in Red, 1940
Metal, plastic, and wood, 54 x 9 x 9 inches
including base
Purchase, with funds from the Burroughs
Wellcome Purchase Fund and the National
Endowment for the Arts 79.6

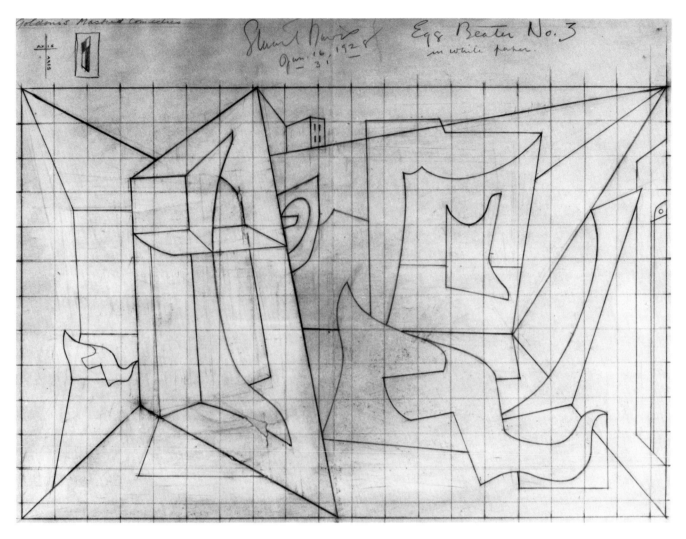

STUART DAVIS
Study for *Egg Beater No. 3*, 1928
Graphite and colored pencil on paper,
17 x 21 ⅛ inches
Purchase, with funds from the Charles
Simon Purchase Fund 80.46

STUART DAVIS
Theater on the Beach, 1931
Lithograph: sheet, 15¹³/₁₆ x 22⅝ inches;
image, 11 x 15 inches
Purchase, with funds from Mr. and Mrs.
Samuel M. Kootz 77.75

STUART DAVIS
Barber Shop Chord, 1931
Lithograph: sheet, 20³/₁₆ x 26 inches;
image, 14 x 19 inches
Purchase, with funds from Philip Morris
Incorporated 77.84

Stuart Davis was the most influential modernist American painter of this period. His groundbreaking Eggbeater paintings of 1927–28 were among the most abstract of his entire career. In a series of drawings and paintings, he patiently transformed a tabletop still life. *Eggbeater No. 1*, acquired in 1931, has long been a significant part of our Permanent Collection. Therefore, the acquisition of a drawing, Study for *Eggbeater No. 3*, provides a welcome opportunity to document the evolution of Davis' series.

It is fascinating to contrast the analytical abstraction of Davis' paintings and drawings of the late 1920s with the figuration of American themes he introduced in the 1930s, as in our recently acquired group of 1931 lithographs: *Barber Shop Chord, Sixth Avenue El, Theater on the Beach,* and *Two Figures and El*. In his mature work, Davis would achieve a brilliant synthesis of abstract form based on Cubism with the depiction of the specific cultural and emotional tenor of twentieth-century American life. He also played an important part in the artistic and intellectual development of the New York School. Through his work, many younger artists learned to use and transform Synthetic Cubism into a new and surprising American idiom.

Stuart Davis enjoyed the company and camaraderie of several younger artists in New York. Two of them, Arshile Gorky and Ad Reinhardt, set out in quite different directions, and each would make a distinctly personal contribution to the emerging New York School. Gorky's *Nighttime, Enigma, Nostalgia* (c. 1931–32) is one of a group of ambitious Surrealist-inspired drawings on the same theme. This work, one of the most fully realized of the series, is an early indication of the emotional power of Gorky's restless, sophisticated spirit. In a dreamlike composition, he integrated a firmly drawn geometric framework with areas of pure improvisation, reveling in the rich contradictions suggested by his mixture of pictorial traditions and languages.

Ad Reinhardt, a neighbor and friend of Stuart Davis during the 1930s, developed his own synthetic idiom of abstract form. Reinhardt's *Number 30* of 1938 is a beautifully resolved painting, strong in color and solidly composed. It is the cornerstone of the Museum's holdings of Reinhardt's early work, a collection that includes several fine gouaches, among them two vibrant abstract studies of the 1939 New York World's Fair.

With the advent of the Depression, American artists banded together for emotional, economic, and intellectual support. Among the founders of American Abstract Artists (AAA), formed late in 1936, was Burgoyne Diller, who had been producing advanced and uncompromising non-objective canvases since the early 1930s. The Whitney Museum is fortunate to have acquired *First Theme* (1933–34), which demonstrates the structural character of Diller's work, his early and unusually original reinterpretation of Constructivist and Neoplastic forms. Diller became supervisor of the WPA/FAP Mural Division in New York during the 1930s and encouraged the employment of many other American modernists.

ARSHILE GORKY
Nighttime, Enigma and Nostalgia,
c. 1931–32
Ink on paper, 24 x 31 inches
50th Anniversary Gift of Mr. and Mrs.
Edwin A. Bergman 80.54

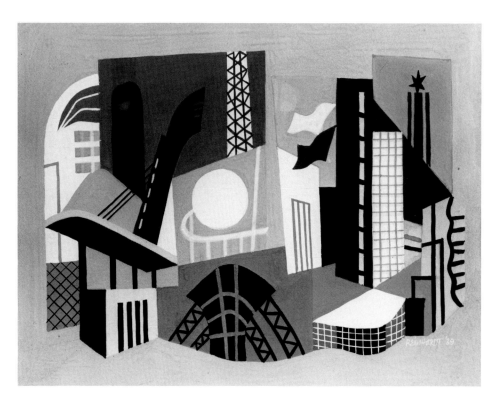

AD REINHARDT
Untitled (N.Y. World's Fair), 1939
Gouache on cardboard, 10 x 13¼ inches
50th Anniversary Gift of Rita Reinhardt
79.55

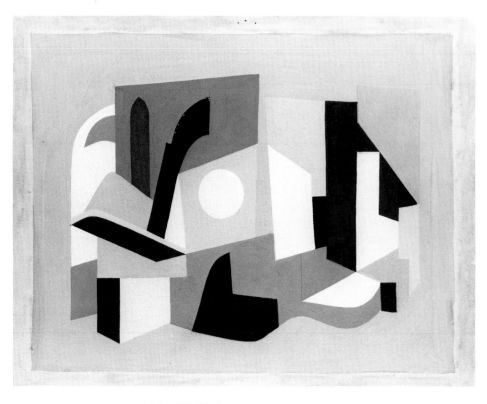

AD REINHARDT
Untitled (N.Y. World's Fair), 1939
Gouache on cardboard, 10 x 13 inches
50th Anniversary Gift of Rita Reinhardt
79.56

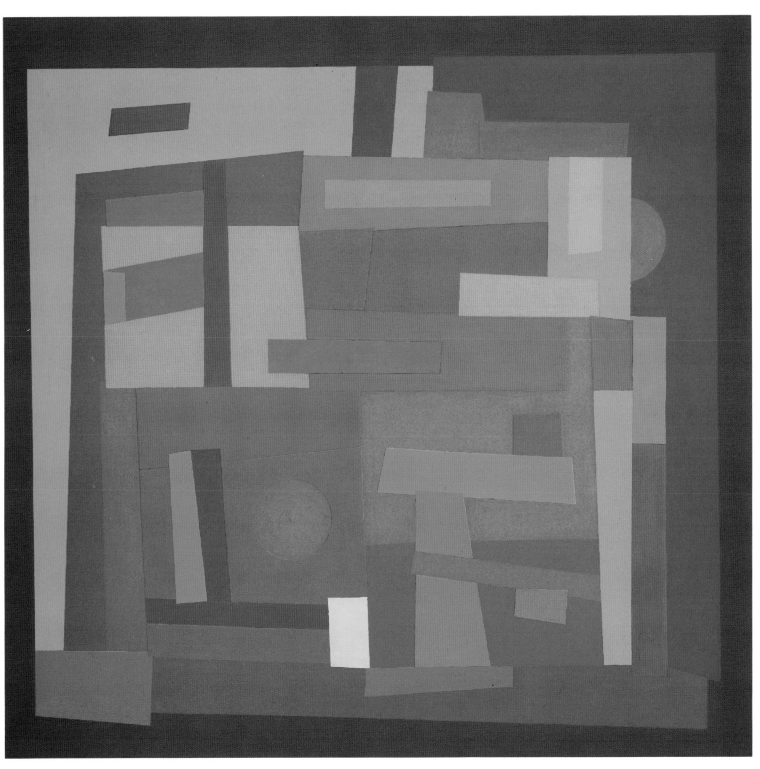

AD REINHARDT
Number 30, 1938
Oil on canvas, 40½ x 42½ inches
Promised gift of Rita Reinhardt P.31.77

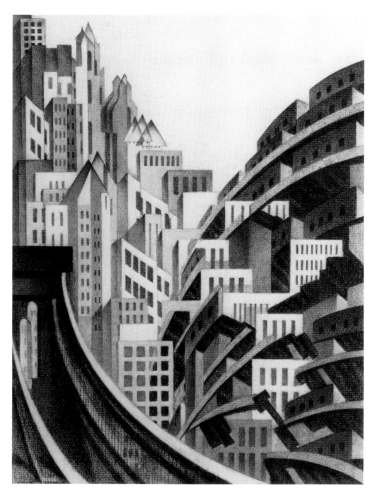

LOUIS LOZOWICK
New York, c. 1923
Carbon pencil on paper, 12½ x 10 inches
Purchase, with funds from the Richard and
Dorothy Rodgers Fund 77.15

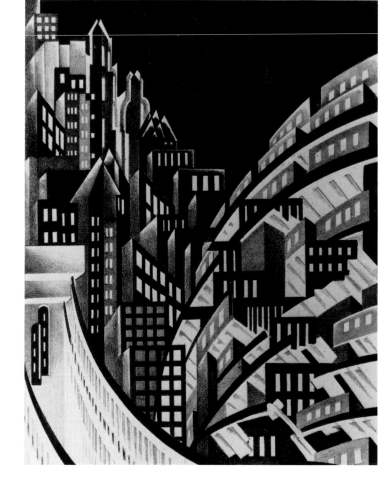

LOUIS LOZOWICK
New York, 1925
Lithograph: sheet, 15⅛ x 11⅜ inches;
image, 11⁹⁄₁₆ x 9 inches
Purchase, with funds from the John
I.H. Baur Purchase Fund 77.12

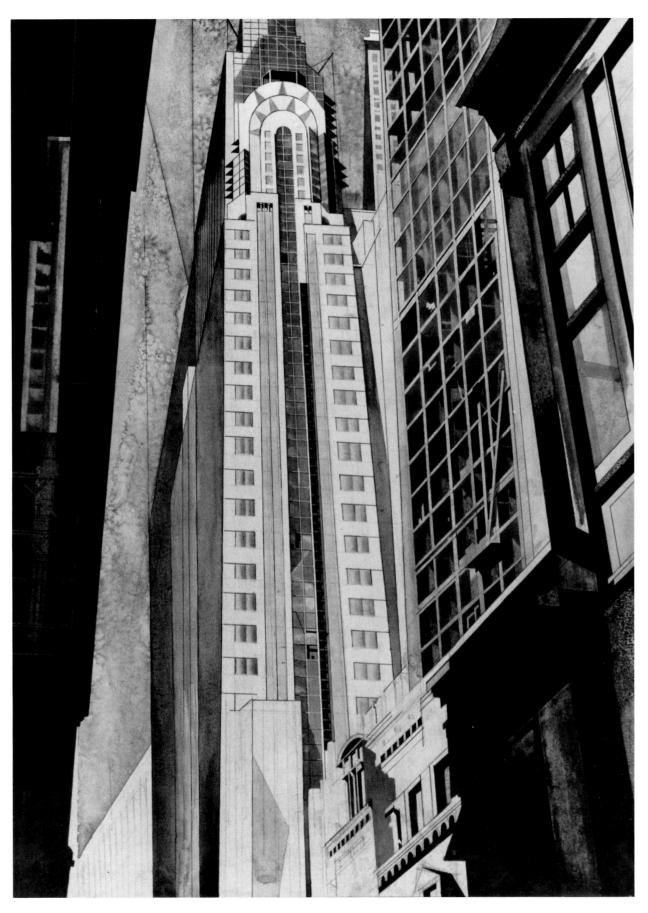

EARLE HORTER
The Chrysler Building Under Construction, 1931
Ink and watercolor on paper, 20¼ x 14¾ inches
Purchase, with funds from Mrs. William A. Marsteller 78.17

BURGOYNE DILLER
First Theme, 1933–34
Oil on canvas, 30¹⁄₁₆ x 30¹⁄₁₆ inches
Purchase, with funds from Emily Fisher
Landau 85.44

CHARLES BIEDERMAN
New York, February 1936, 1936
Gouache on composition board,
29¹⁵⁄₁₆ x 21³⁄₁₆ inches
Purchase, with funds from the Drawing
Committee 85.57

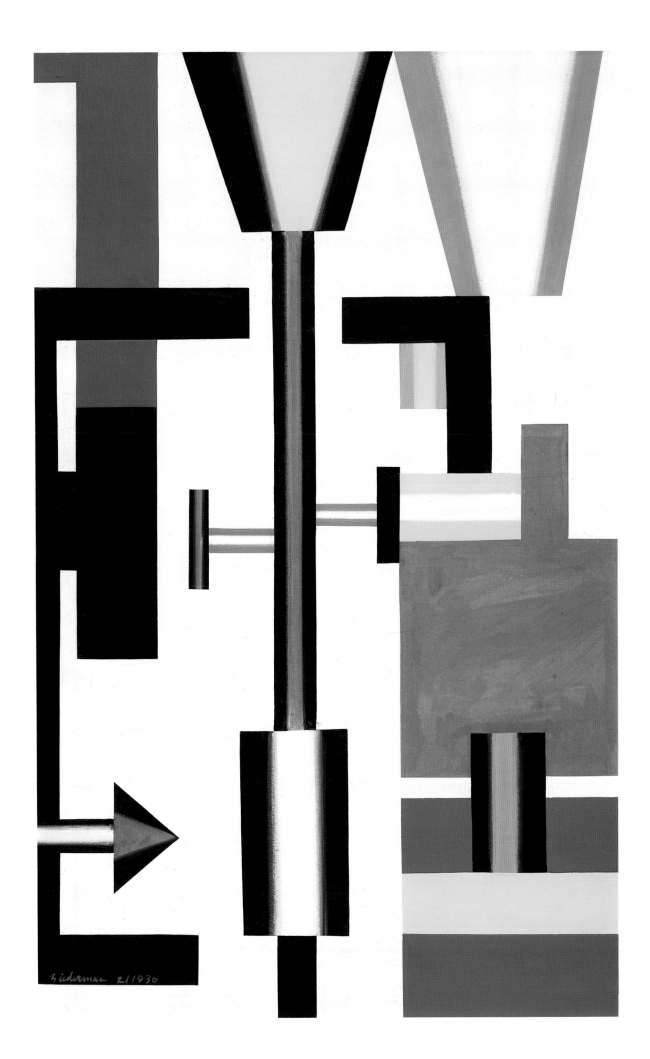

Although some of the abstract murals created for these projects have survived and have been restored recently (for example, Arshile Gorky's *Aviation: Evolution of Forms Under Aerodynamic Limitations*, made for Newark Airport in 1936), others are known only through small studies made as formal proposals submitted to Mural Division committees. Ilya Bolotowsky's Study for mural for *Williamsburg Housing Project, New York* (c. 1936) records the composition of a mural that was lost for many years and has just been relocated and restored. The Whitney Museum has gathered a small but significant group of WPA mural studies on paper; along with those by Bolotowsky and Gorky are works by Rosalind Bengelsdorf, Hananiah Harari, Louis Schanker, and Albert Swinden.

While the more severely geometric structures of Cubism and Neoplasticism were being adapted by many American painters, abstract Surrealism, as practiced by European artists Jean Arp and Joan Miró, was more often admired by younger American sculptors. The fluid, almost weightless planes of Ibram Lassaw's *Sculpture in Steel* (1938) have a mysterious, intangible character, as if their material existence were lived in a Surrealist-inspired, stagelike space. A similar volumetric sculptural form is depicted in Charles Biederman's painting *New York, February 1936* (1936), hovering in the glow of a red vaporous background. The biomorphic shapes of Louise Bourgeois' *Quarantania* of 1941 are real and three-dimensional. They challenge us to touch their bonelike surfaces and to propose the real-life circumstances in which these clustered biological entities might actually exist. In *The Gunas* of 1946, Isamu Noguchi adapted the skeletal forms of nature into an abstract hybrid of curves. The flattened curvilinear planes create a calm, reassuring rhythm that suggests renewal and the eternally transformative processes of the earth.

Artistic activity in America between the two world wars is currently the object of renewed study and reevaluation, prompting our own efforts to present it more fully and with the complexity it deserves. The period is also that of our Museum's founding, a time when the Whitney Museum became a part of the history of American art as well as an observer and conservator of this heritage.

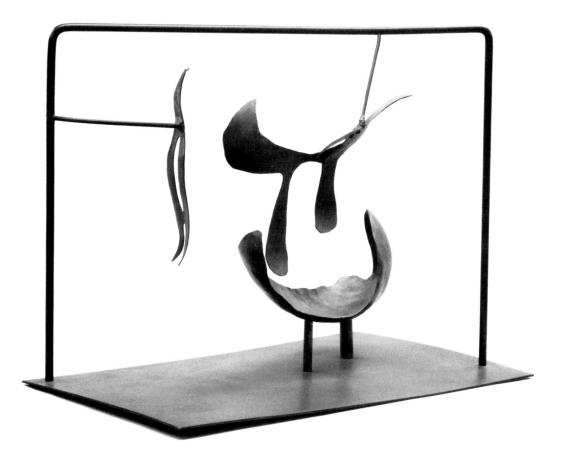

IBRAM LASSAW
Sculpture in Steel, 1938
Steel, 18⅝ x 23⁹⁄₁₆ x 15 inches
including base
Purchase, with funds from the Painting
and Sculpture Committee 86.11

ILYA BOLOTOWSKY
Study for mural for *Williamsburg Housing Project, New York*, c. 1936
Gouache and ink on board,
16 ¼ x 29 ½ inches
50th Anniversary Gift of the Edward R. Downe, Jr. Purchase Fund, Mr. and Mrs. William A. Marsteller, and the National Endowment for the Arts 80.4

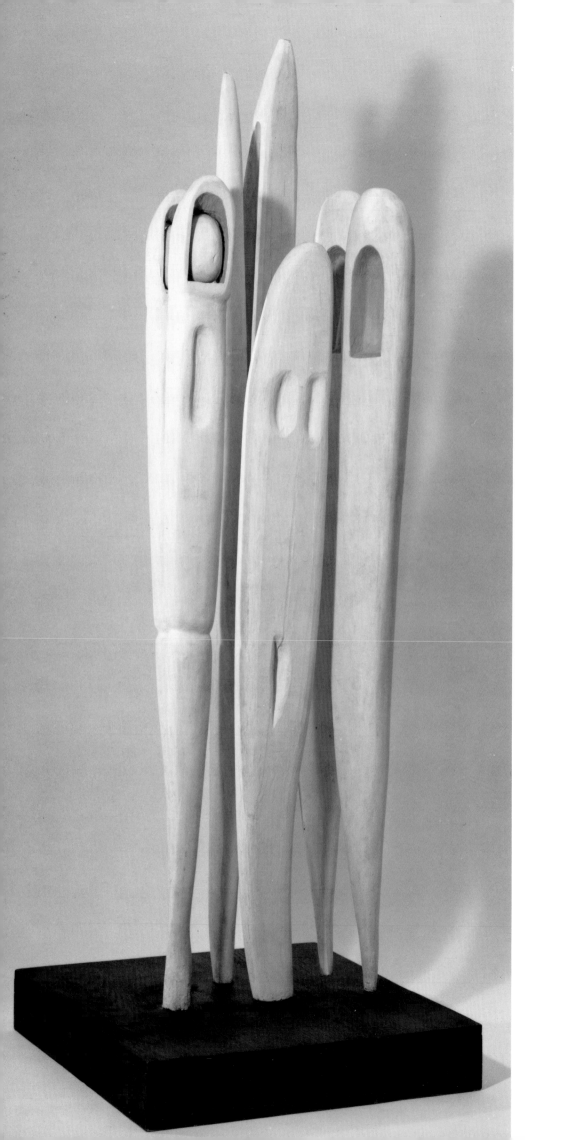

LOUISE BOURGEOIS
Quarantania, 1941
Wood, 84¾ x 31¼ x 29 inches
Gift of an anonymous donor 77.80

ISAMU NOGUCHI
The Gunas, 1946
Marble, 73¼ x 26¼ x 25½ inches
Purchase, with funds from the Howard
and Jean Lipman Foundation, Inc. 75.18

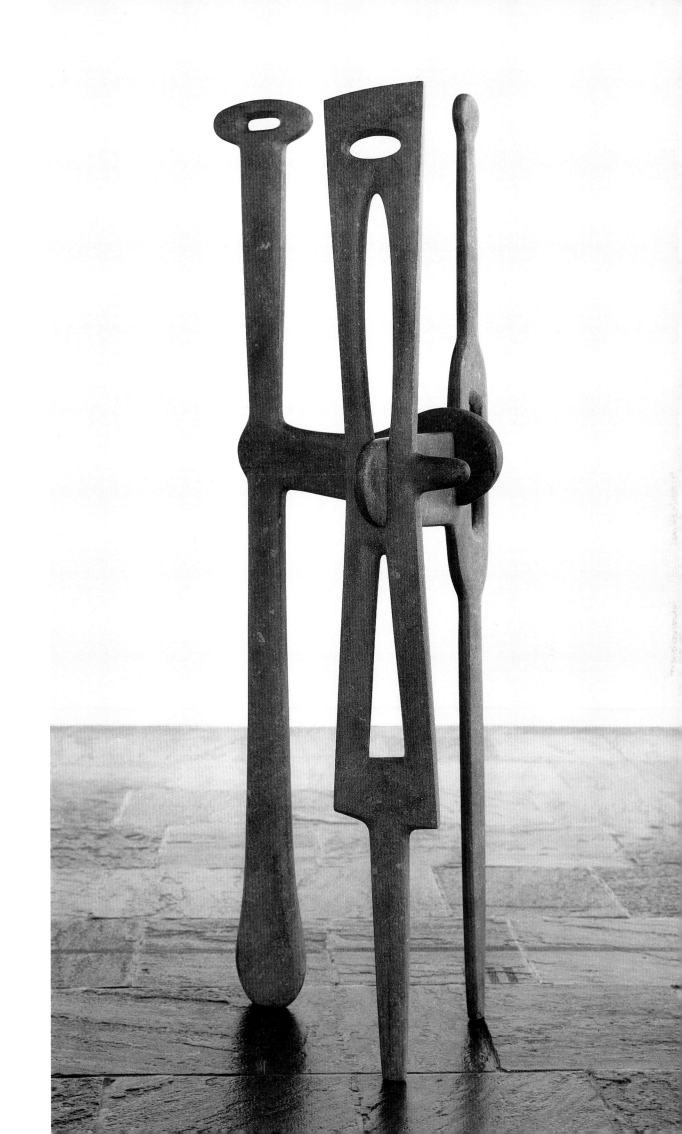

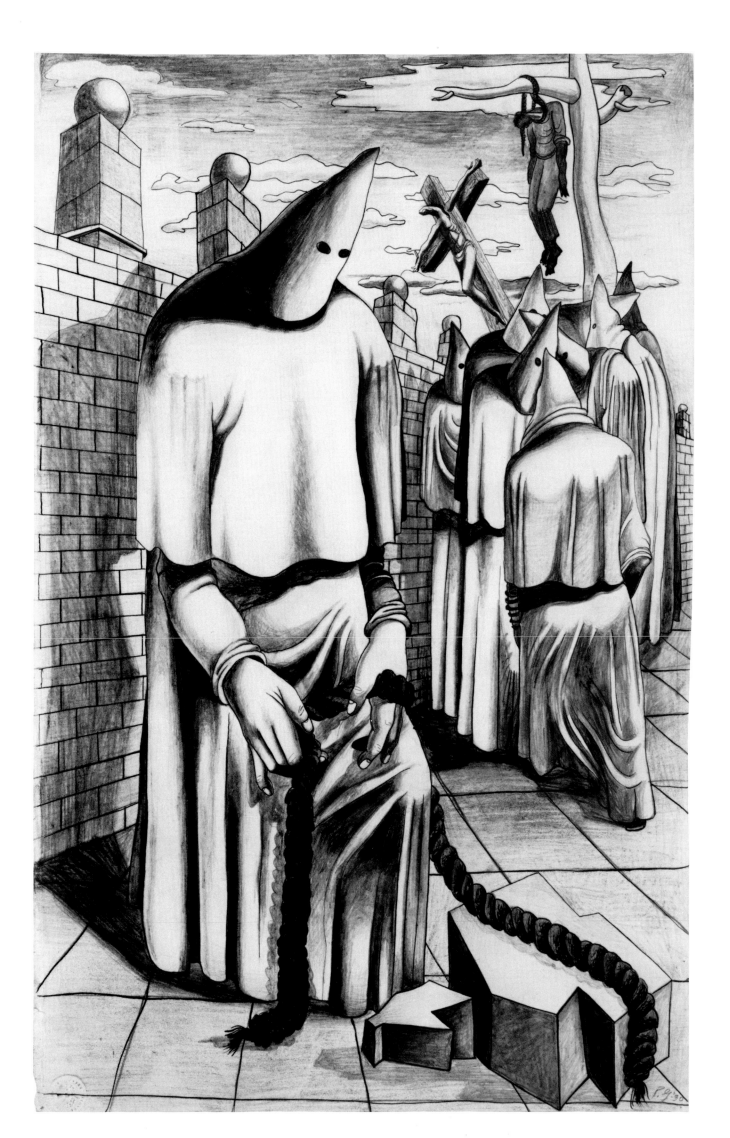

THE AMERICAN SCENE AND FIGURATIVE SURREALISM

PHILIP GUSTON
Study for *Conspirators*, 1930
Graphite, ink, colored pencil, and crayon
on paper, 22 1/2 x 14 1/2 inches irregular
Purchase, with funds from The Hearst
Corporation and The Norman and Rosita
Winston Foundation, Inc. 82.20

When the Whitney Museum of American Art opened in 1931, America was facing a series of deepening economic and social crises. The early history of the Museum also coincided with a resurgence of realism and an emphasis on American subject matter and traditional values in art and life. Gertrude Vanderbilt Whitney, founder of the Museum, was a professional artist as well as a patron, and her preference for realism reflected the figurative character of her own sculpture. Figurative art in the United States took on many guises, from social scene painting, to realist portraiture, to imaginative renderings of fictional places or literary events. By the later 1930s the Museum's collection included expressionist scenes of daily life by George Bellows and Robert Henri, the visionary realism of Charles Burchfield and Edward Hopper, and modernist treatments of American subjects by Georgia O'Keeffe and Charles Sheeler. This collection spoke for the vitality of the American realist tradition despite the formidable challenge being posed by European modernism.

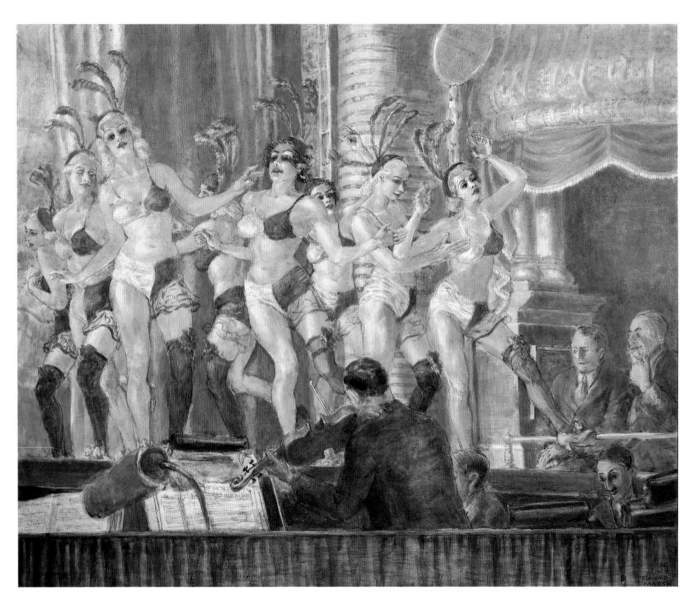

REGINALD MARSH
Minsky's Chorus, 1935
Tempera on composition board,
29³/₄ x 35⁷/₈ inches
Partial and promised gift of Mr. and Mrs.
Albert Hackett in honor of Edith and
Lloyd Goodrich P.5.83

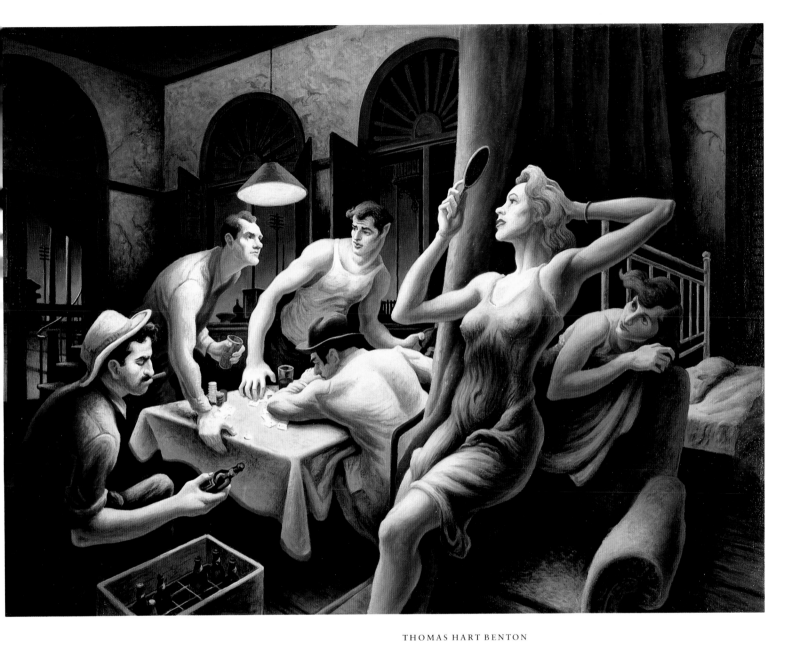

THOMAS HART BENTON
Poker Night (from A Street Car Named Desire), 1948
Tempera and oil on panel, 36 x 48 inches
Mrs. Percy Uris Bequest 85.49.2

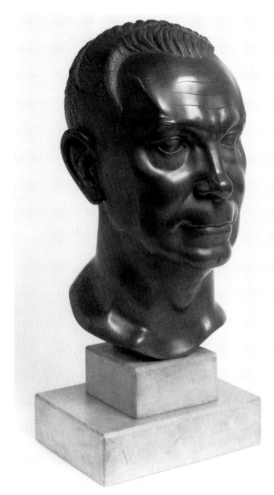

PAUL FIENE
Bust of Grant Wood, c. 1942
Bronze, 13 x 7½ x 8 inches
Gift of Mr. and Mrs. George
D. Stoddard 81.33.1

During the difficult years of the
Depression, some realistic art affirmed democratic values
and recorded the society's yearning for the return of peace
and plenty. Other images of this troubled period served
documentary and polemical purposes, exposing the social
iniquities, hunger, and hopelessness which were eroding
American life and making a painful caricature of demo-
cratic ideals. Within the government-sponsored WPA
Federal Art Project and in many other areas of American
art, the Regionalist movement celebrated and documented
the ethnic traditions of specific areas of the country. The
best-known painters in this movement were Thomas
Hart Benton of Missouri, John Steuart Curry of Kansas,
and Grant Wood of Iowa. Each had a distinctly personal
style, but all were united in their dedication to a forth-
right, if at times imaginative and idealized, rendering of
scenes from American life and history. Thomas Hart
Benton's *Poker Night (from A Street Car Named Desire)*
of 1948 reinterprets a moment from the classic modern
drama by Tennessee Williams as played by Marlon
Brando and Jessica Tandy. The psychological tension
of the play was, of course, expressed in both words and
gestures. Benton pictorializes the drama by exaggerating

GRANT WOOD
Study for *Breaking the Prairie*, 1935–39
Colored pencil, chalk, and graphite on
paper, triptych, 22¼ x 80¼ inches overall
Gift of Mr. and Mrs. George D. Stoddard
81.33.2a-c

physical attributes, expressive gestures, and points of spatial distinction between the characters. This recent acquisition complements the earlier paintings by Benton that the Museum acquired in the 1930s.

The Museum's original collection included works by two of the most prominent American Regionalists, Benton and Curry, but there was no major painting by Grant Wood, though his carefully crafted and often humorous paintings were often shown in Whitney Museum exhibitions, and the Museum has a fine collection of his drawings and graphic work. Therefore, the recent gift of Study for *Breaking the Prairie* (1935–39), a highly finished and entirely typical major drawing, has given Wood a stronger presence in our collection.

Outside the Regionalist movement, many artists dedicated themselves to a detailed and comprehensive portrayal of the American Scene, a theme as open-ended as American society itself. American Scene was a general term for a broadly based movement in literature and the visual arts, including photography and film, which dealt with the physical environment and everyday life of the average citizen in both urban and rural settings. It emphasized indigenous qualities and frequently had a

nationalistic, even at times isolationist, point of view. However, critics of the 1930s often used the term American Scene to cover a wide spectrum of art, from the urban lower- and middle-class pleasures depicted by Reginald Marsh to the solitary visions of Edward Hopper or the equation of Cubist pictorial structure and American jazz in Stuart Davis' work.

The art of Reginald Marsh has always been closely identified with the Whitney Museum. In the 1920s, Marsh took part in the Whitney Studio Club, where he had his first one-man show in 1924, and he continued to participate in the exhibitions and programs of the Museum until his death in 1954. Our Permanent Collection is rich in every aspect of Marsh's spirited imagery of Coney Island bathers, vaudeville dancers, and thoughtful considerations of average Americans at work and play. Marsh found dramatic moments in the midst of everyday life and embraced the nobler aspects of his subjects along with their coarser tastes and preferences for popular forms of amusement. His is a generous and hearty view of the American Scene and one that differs markedly from the more ideological program of the Regionalists.

In 1978, Felicia Meyer Marsh, the artist's widow, acknowledged the long-standing relationship between her husband and the Whitney Museum through a bequest of paintings, prints, and drawings. Her generosity encouraged others to donate important works by Reginald Marsh to the Museum, such as the buoyant and robust *Minsky's Chorus* (1935), full of the earthy sensuality and markedly effective theatrical lighting that Marsh understood and conveyed so dramatically.

A deep and lasting relationship also existed between the Whitney Museum and the great American realist Edward Hopper, who had his first one-man exhibition at the Whitney Studio Club in 1920; he was included in numerous Annuals and Biennials and had two major retrospectives at the Whitney Museum during his lifetime. Josephine Nivison Hopper, following a plan she and her late husband had developed, bequeathed Hopper's entire artistic estate to the Whitney Museum when she died in 1968. This bequest of more than 2,500 paintings, drawings, and prints has made the Museum the international center for the study and exhibition of Edward Hopper's art. The depth and range of the works in the Hopper Bequest is impressive, covering all periods and aspects of his long career. There were, however, few major late oil paintings, since most had been acquired by museums and collectors during Hopper's lifetime. *A Woman in the Sun* (1961) came as a gift to the Permanent Collection in 1984. The spare rectilinear configuration of the bedroom, with its deep shadows and sharply defined shafts of sunlight, sets up a dramatic context for the nude woman who stands in a self-contained state of contemplation. *A Woman in the Sun* is an important work because it so clearly embodies the restrained and abbreviated character of Hopper's late work, qualities which only seem to add to its powerful hold on the imagination.

Charles Burchfield's dreamlike imagery was drawn from rural American life and filtered through the romantic sensibility of one who saw nature as vividly alive and vibrating with transcendental energy. Burchfield's oil paintings, watercolors, and gouaches were featured prominently in the original collection of the Whitney Museum. It is through an artist such as Burchfield that we can understand how the American realist tradition extended itself and prospered in the early twentieth century. Though it is tempting to ally Burchfield's visionary art to that of the European Surrealists, the essential character of his work was already apparent by 1917 and emerges from his spiritual reverence for nature. The radiant, otherworldly light surrounding the trees and landscape of *Golden Dream* (1959) is of Burchfield's own imaginative creation. This late work was acquired for its evident beauty, but it also reveals how the artist's style and special focus deepened and intensified over the decades.

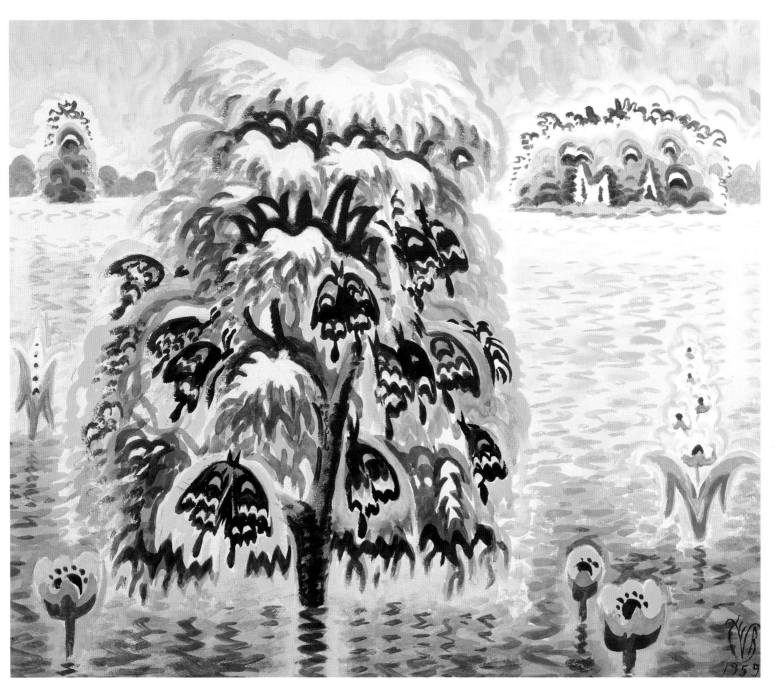

CHARLES BURCHFIELD
Golden Dream, 1959
Watercolor on paper, 31 ¼ x 38 inches sight
Promised 50th Anniversary Gift of Mrs.
Nicholas Millhouse P.11.80

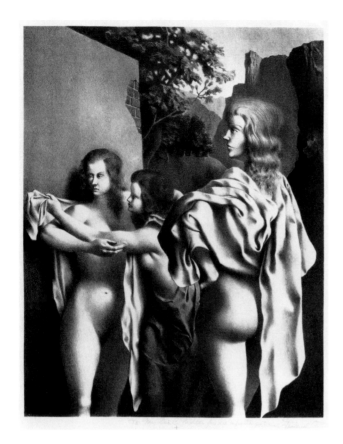

FEDERICO CASTELLON
The New Robe #2, 1939
Lithograph: sheet, 15 15/16 x 11 7/8 inches;
image, 12 7/16 x 9 15/16 inches
Purchase, with funds from the Print
Committee 86.24

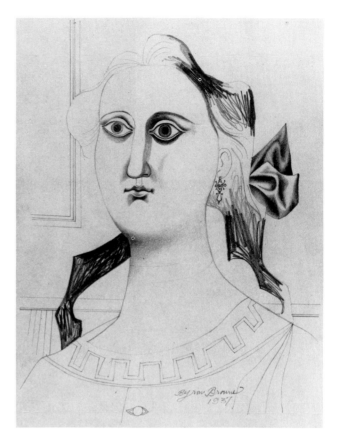

BYRON BROWNE
Woman with Hairbow, 1937
Graphite on paper, 12 x 9 inches
Gift of an anonymous donor 77.4

By the 1930s, many American artists trained in a broadly realist style began to employ purposeful distortions of form, scale, and narrative as they encountered the work of certain European Surrealists, specifically Salvador Dali, René Magritte, and Yves Tanguy. Study for *Conspirators* (1930), a fully realized drawing for a lost oil painting, is Philip Guston's most important and justly famous early work. Here the young artist gives vent to his strong emotional reaction to an all too common event, a lynching by Klansmen acting out despicable racial and political prejudices. Guston makes purposeful use of Surrealist distortion and a high degree of abstraction to create a chilling, somnolent image like that of an evil nightmare. That this work emerges from reality and not from a dream only reinforces its horror and the artist's power to engage us through drama and empathy.

The Surrealists' suggestion that the visible world only screens other levels of reality encouraged many American artists to engage in fantasy and speculation through selective transformations of the realist pictorial language. The expressive eyes and sinuously curled edges of the garment and hair in Byron Browne's *Woman with Hairbow* (1937) uncover the darker side of her highly stylized beauty. In his lithograph *The New Robe #2* of 1939, Federico Castellon engages in metamorphosis as the fragmented world of a dream becomes evident reality. The work of Kay Sage, wife of Yves Tanguy, is also closely tied to European Surrealism, yet her handling of illusionistic passages of watercolor, some of them cut out and pasted onto the sheet in *Constant Variation* (1958), creates a tantalizing confusion, as if these segments had landed here from another world.

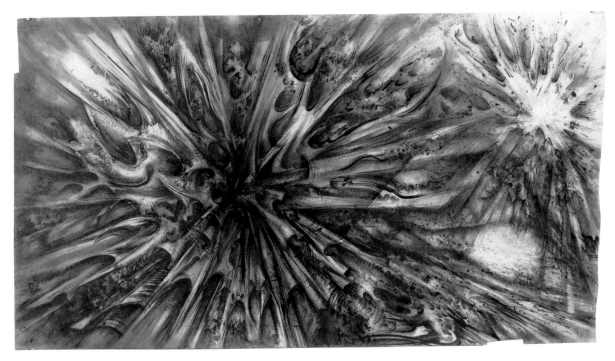

THEODORE ROSZAK
Star Burst, 1954
India ink and colored ink on paper, 43 ½ x 79 inches irregular
Gift of Mrs. Theodore Roszak 83.33.10

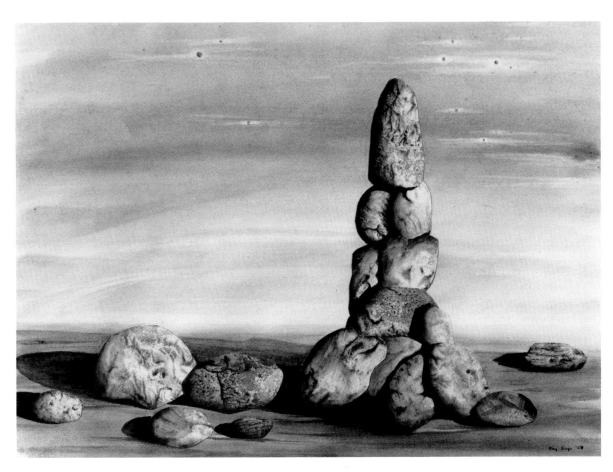

KAY SAGE
Constant Variation, 1958
Watercolor and collage on paper, 19 1/16 x 26⅞ inches
Gift of Flora Whitney Miller 86.70.2

This provocative intersection of a long-standing American realist tradition with the rarefied world of European Surrealism served to stimulate young artists of the 1930s who, as their work matured, would contribute directly to the creation of Abstract Expressionism. Jackson Pollock learned a great deal from Surrealist imagery, both from the abstract work of Joan Miró and the more veristic language of Dali, Tanguy, and others. Fascinating early drawings such as *Untitled* (c. 1933–39) show how rich were his sources and how capable he was of extrapolating the most potent elements from each of them.

As we examine the multiple avenues open to American realists in the 1930s and later, we recognize, as did Gertrude Vanderbilt Whitney and Juliana Force, that artists with insight and ability could maintain our native realist tradition while carefully considering the advances made by European modernists. In the period between the two world wars, realism served not only as an alternative to innovation, but as a familiar starting point for those who dared to reflect on the fundamental changes occurring in twentieth-century American life. Despite sometimes radical transformations, the images these artists created bring us closer to the realities of the era.

ABSTRACT EXPRESSIONISM AND
THE NEW YORK SCHOOL

Abstract Expressionism has maintained its position of central importance in the history of twentieth-century American art even as every aspect of its evolution, iconography, social history, and subsequent influence has been investigated and reevaluated in recent years. We have become more aware of the complexity of the experience of American artists in the late 1930s and early 1940s as they worked toward their brilliant synthesis of Cubist abstraction, the automatic writing of the European Dadaists and Surrealists, and the expansive, poetic space of abstract Surrealism. We now understand more clearly, perhaps as the artists understood then, how much the strong and self-confident character of this movement relied on individual contributions within the larger framework of the New York School.

From this somewhat broadened perspective, the New York School appears as a community of artists working in a variety of styles with a shared commitment to a more internationalist outlook for American art, an avowed interest in European modernism, and a

MARK ROTHKO
Agitation of the Archaic, 1944
Oil on canvas, 35 ⅜ x 54 ¼ inches
Gift of The Mark Rothko Foundation, Inc.
85.43.1

desire to treat broadly philosophical issues and personal experiences rather than regional or topical themes. Although European modernist abstraction played a central role in the genesis of Abstract Expressionism, we can now acknowledge the important presence of the human figure and narrative in the work of Arshile Gorky, Willem de Kooning, Jackson Pollock, David Smith, and others who created the basic formal and iconographic vocabulary of the movement. Abstract Expressionism is no longer considered a single style, but the collective expression of a generation working according to a few shared ideals.

As the center of international artistic activity shifted from prewar Paris to postwar New York City, the newly ascendant New York School gained credibility from the achievements of the Abstract Expressionists. But as a "school," it included other types of American modernism. Thus, the abstract figurative works of de Kooning, the reductive romantic canvases of Mark Rothko, the tumultuous and expansive calligraphic fields of Pollock, and the softly tonal figurative paintings of Milton Avery could live simultaneously under the New York School roof.

Important recent additions to our Permanent Collection have enabled us to see the evolution of individual artists' careers more clearly and in greater detail. Mark Rothko's *Agitation of the Archaic*, a seminal painting of 1944, is full of the primitivist, biomorphic imagery and delicately washed fields of color which distinguish his early work. In Rothko's classic painting *Untitled* (1953), a stunning quietude has replaced the fluid energy of his earlier imagery, and his command of light and color now transmits a powerful elegiac mood.

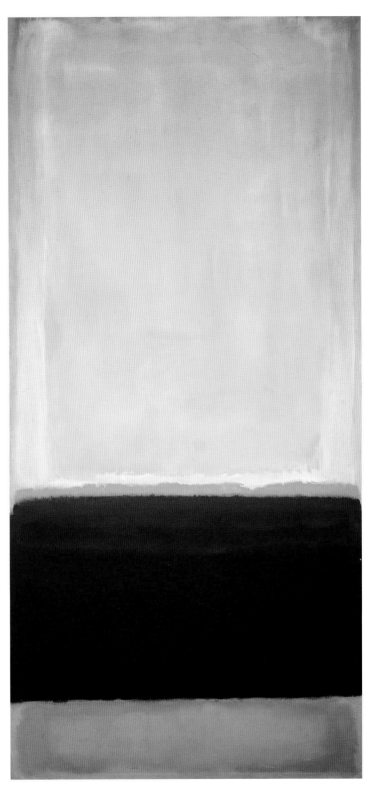

MARK ROTHKO
Untitled, 1953
Mixed media on canvas, 106 x 50⅞
inches irregular
Gift of The Mark Rothko Foundation, Inc.
85.43.2

LEE KRASNER
The Seasons, 1957
Oil on canvas, 92¾ x 203 ¹¹⁄₁₆ inches
Purchase, with funds from Frances and
Sydney Lewis (by exchange), the Mrs.
Percy Uris Purchase Fund, and the Painting
and Sculpture Committee 87.7

LEE KRASNER
White Squares, c. 1948
Oil on canvas, 24 x 30 inches
Gift of Mr. and Mrs. B.H. Friedman 75.1

RICHARD POUSETTE-DART
Within the Room, 1942
Oil on canvas, 36 x 50 inches
Promised 50th Anniversary Gift
of the artist P.4.79

Lee Krasner's long career is one of purposeful continuity from her modestly scaled and carefully modulated early paintings to her expansive but still structured later works. An early canvas, *White Squares* (c. 1948), with its intricately calligraphic surface delimiting a field of uneven squares, precisely charts the conjunction of Cubist-based geometry with the rhapsodic freedoms of Surrealist automatic writing. In her major painting *The Seasons* (1957), the ebullient rhythms created by biomorphic forms traverse the canvas in a spirited dance in space and time.

Within the Room (1942), an early work by Richard Pousette-Dart, is filled with painterly and narrative incidents: ritual masks; biomorphic and geometric symbols; glowing embers of color; and fragments of human figures and animals. Some of Robert Motherwell's most important early work was done on paper and in the medium of collage. *Three Figures Shot* (1944), a drawing in colored inks, sets up a dramatic confrontation as abstracted human figures stand and then fall amidst a dense thicket of black lines and red washes.

The entire oeuvre of David Smith was characterized by the unity of drawing, painting, and sculpture. The fluid energetic line of his sculpture *Running Daughter* (1956) is a visual memoir of his own daughter at play. Line carries the spirit and the substance of Smith's formal sensibility in much of his sculpture and is also of paramount importance in his beautiful drawings and paintings on paper. Smith's sculpture is full of the rich counterpoint of moving lines describing shapes and filling space with rhythm and incident. Drawings such as *Eng No. 6* (1952) establish not only the sensuous colored surface of the page, but also suggest the three-dimensional movements of his abstracted forms. Our collection of David Smith's drawings has grown substantially in recent years in recognition of the important role the medium played in his sculpture and of the works' unique and beautiful qualities.

Milton Avery's artistic contemporaries often expressed their warm regard for his art, which spoke in soft tones of familiar landscapes, domesticity, and quiet reverie in nature. A profoundly original colorist

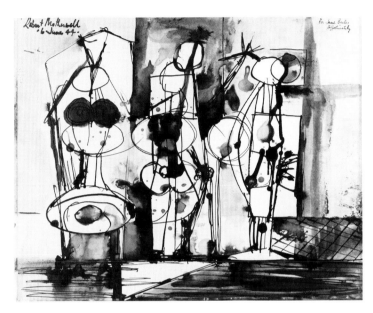

ROBERT MOTHERWELL
Three Figures Shot, 1944
Colored ink on paper, 11 3/8 x 14 1/2 inches
Purchase, with funds from the Burroughs
Wellcome Purchase Fund and the National
Endowment for the Arts 81.31

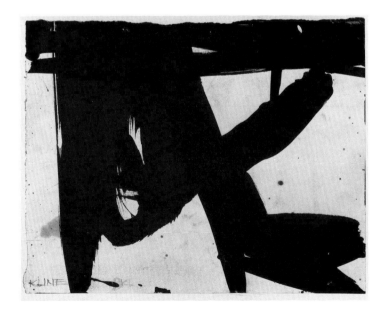

FRANZ KLINE
Untitled, 1960
Ink on paper, 8 1/2 x 10 1/2 inches
Purchase, with funds from Mr. and Mrs.
Benjamin Weiss 78.53

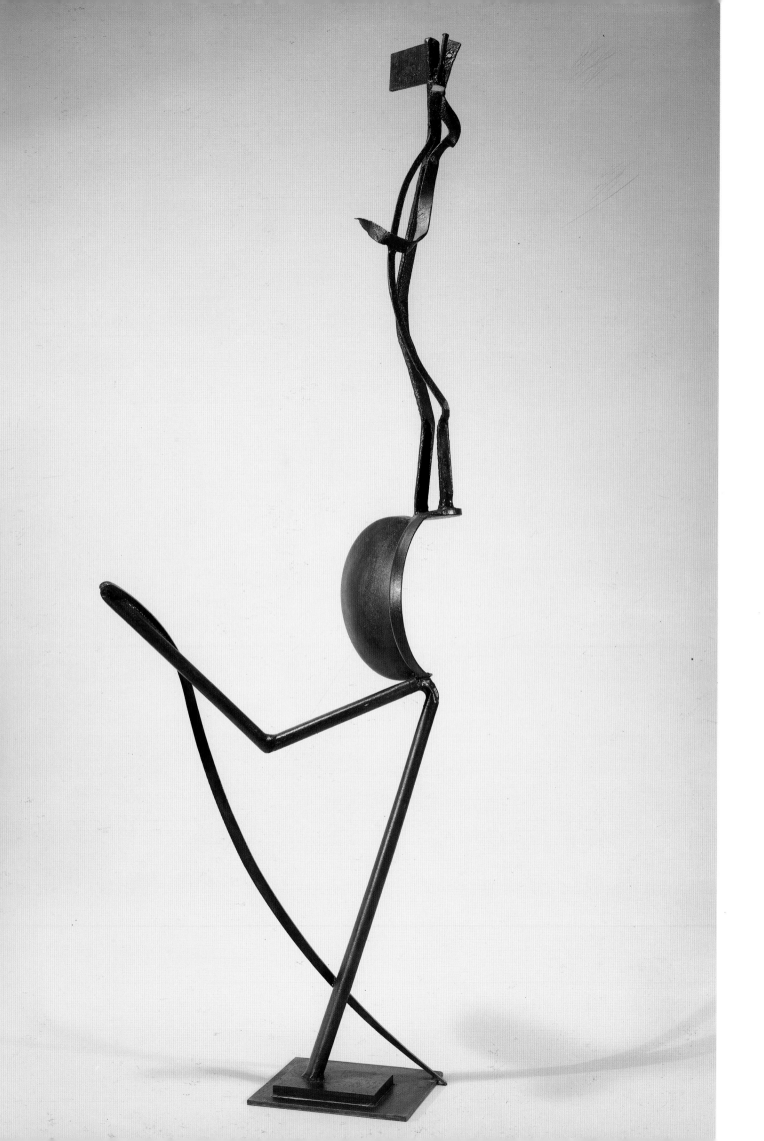

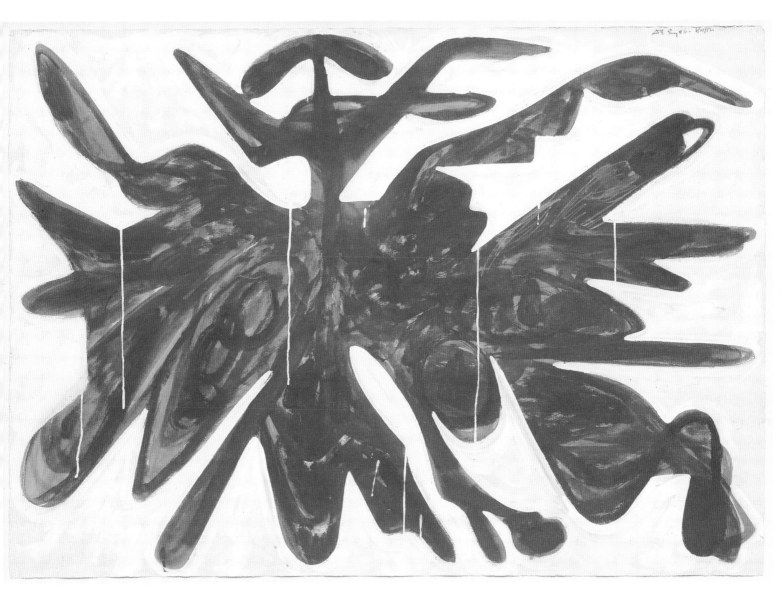

DAVID SMITH
Eng No. 6, 1952
Tempera and oil on paper,
29¾ x 42¼ inches
Purchase, with funds from Agnes Gund
and an anonymous donor 79.43

DAVID SMITH
Running Daughter, 1956
Painted steel, 100½ x 36 x 17 inches
50th Anniversary Gift of Mr. and Mrs.
Oscar Kolin 81.42

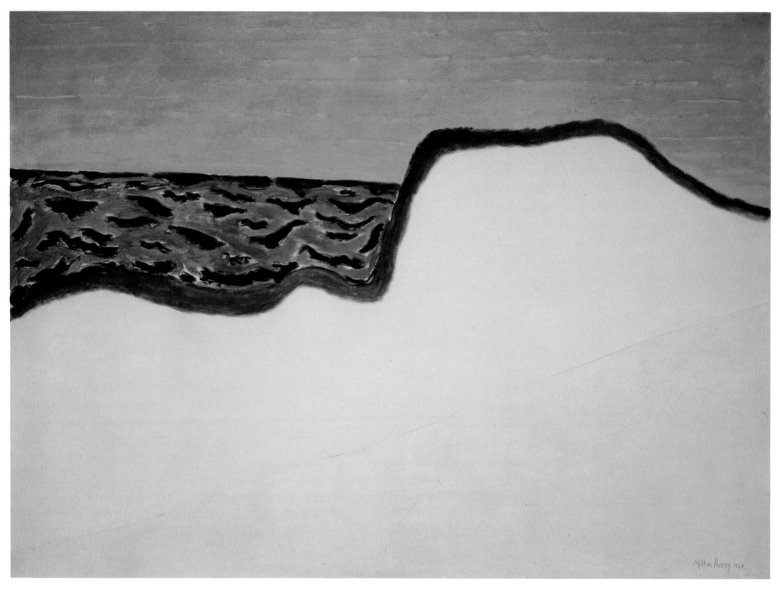

MILTON AVERY
Dunes and Sea II, 1960
Oil on canvas, 52 x 72 inches
Promised 50th Anniversary Gift
of Sally Avery P.14.80

WILLIAM BAZIOTES
Sand, 1957
Oil on canvas, 48 x 36 inches
Lawrence H. Bloedel Bequest 77.1.6

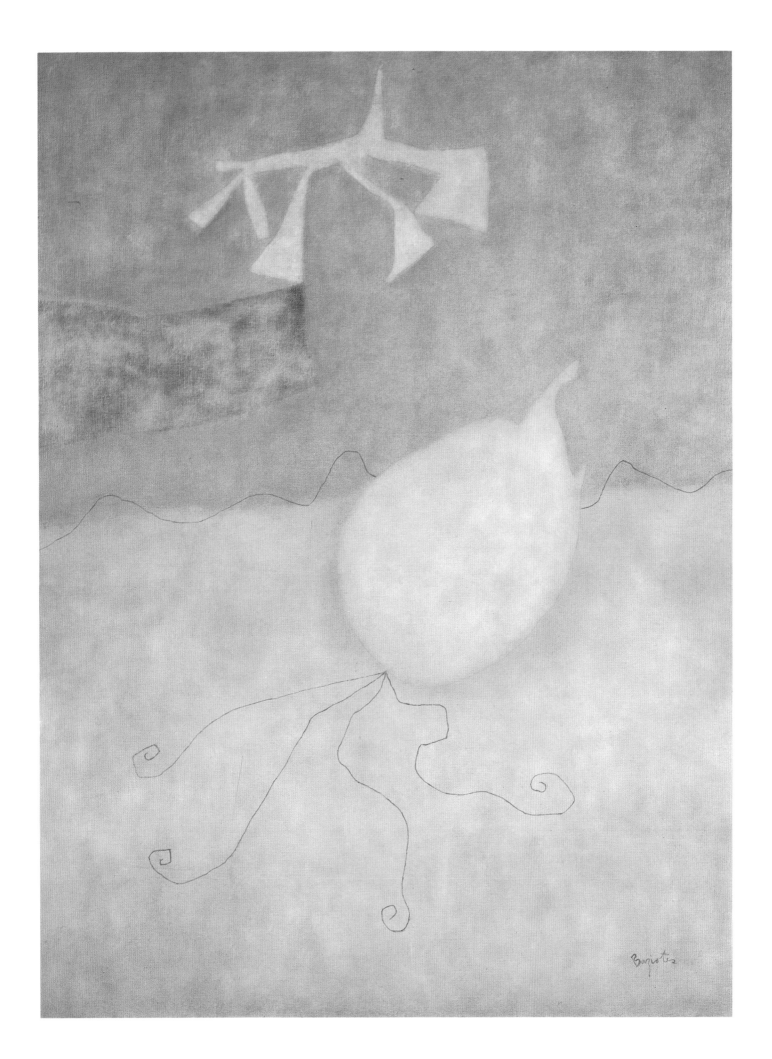

and the architect of some startlingly reductive canvases, Avery maintained his affectionate bond with natural forms and with his own domestic realm throughout his long career. The stark, dramatic achievements of Action Painting and the epic scale of many Abstract Expressionist works did not persuade him to stray from his carefully conceived world of form and feeling. *Dunes and Sea II* (1960) recently entered our Permanent Collection; it is a splendidly clear and memorable image supported by the artist's intelligent understanding of the limits of abstract form to describe personal experiences in nature.

Recent studies have emphasized the interaction of picture making and tribal cultures in the genesis of Abstract Expressionism, and artists noted a connection between pictographic art and the appearance of written language. Searching for a similar connection in their own work, many turned to abstract forms of calligraphy, to the Dada and Surrealist concepts of automatic writing, in order to invent pictographic structures.

In Bradley Walker Tomlin's swiftly paced *Number 2–1950* (1950), a dense field of calligraphy screens the carefully mapped surface of his canvas. Mark Tobey understood the multicultural history of calligraphy as it was practiced in many highly developed religious and artistic traditions. The dense field of calligraphy in *Battle of the Lights* (1956) serves as a vibrating atmospheric presence rather than as a legible narrative. It communicates through graphic energy alone, transcending the grammatical structures of written language. Tobey's belief in the communicative power of the graphic gesture was shared by his contemporary Franz Kline, who transformed the intimate and familiar realm of handwriting into a new experience of gesture in epic proportions, more physical and architectonic than ruminative and private. Our Permanent Collection includes works such as Kline's great painting *Mahoning* (1956), which came to the Museum less than a year after its creation. Kline's *Untitled* (1960), a small but powerful drawing in ink, enables us to study the fascinating and significant issue of scale in his work, as he made the difficult transition from intimate gesture to potent graphic assertion.

The long and distinguished career of Willem de Kooning has spanned six of the liveliest and most innovative decades in American art. We are fortunate to have had masterworks such as *Woman and Bicycle* (1952–53) and *Door to the River* (1960) in our Permanent Collection for many years; both of these paintings were acquired shortly after completion by the Friends of the Whitney Museum of American Art. More recently, we have acquired de Kooning's bronze sculpture *Clamdigger* (1972), which continues the long-standing figurative emphasis in his work while employing expressive distortions of form in three dimensions. The weighty, earthbound figure of the clamdigger, whose vivid outline describes an exhausted worker, was a new subject in de Kooning's art, possibly inspired by life on the shores of Long Island, where the artist had a home and studio. The attitude of the toiler at the sea, however, is sharply distinct from that of the many provocative sensuous female bathers and beachcombers in de Kooning's paintings. A major charcoal drawing on translucent vellum, *Untitled (Woman)* (c. 1974), demonstrates the vitality and longevity of the artist's fascination with the form and psychology of woman as a subject of his art and as an object of complex fascination and desire.

As de Kooning's art has developed, there have been some periods of involvement with figuration and others in which abstract form has been the dominant force. Never entirely one or the other, his work is the richer for its merger of form and image and its play of line or shape with a psychological probing of human feelings, desires, capabilities, and weaknesses. A very graceful late painting, *Untitled VII* (1983), entered our Permanent Collection soon after its creation; it is a work full of de Kooning's unique blend of sensuous reverie and deep speculations on living forms and the way we see them. Its fluid arcs and calligraphic passages describe the densely inhabited broken planes, their paths uninhibited and their interaction carefully orchestrated. It is a work that arises from the pleasures of motion in a living body, an awareness of physicality which has occupied de Kooning's attention and informed his paintings for many decades.

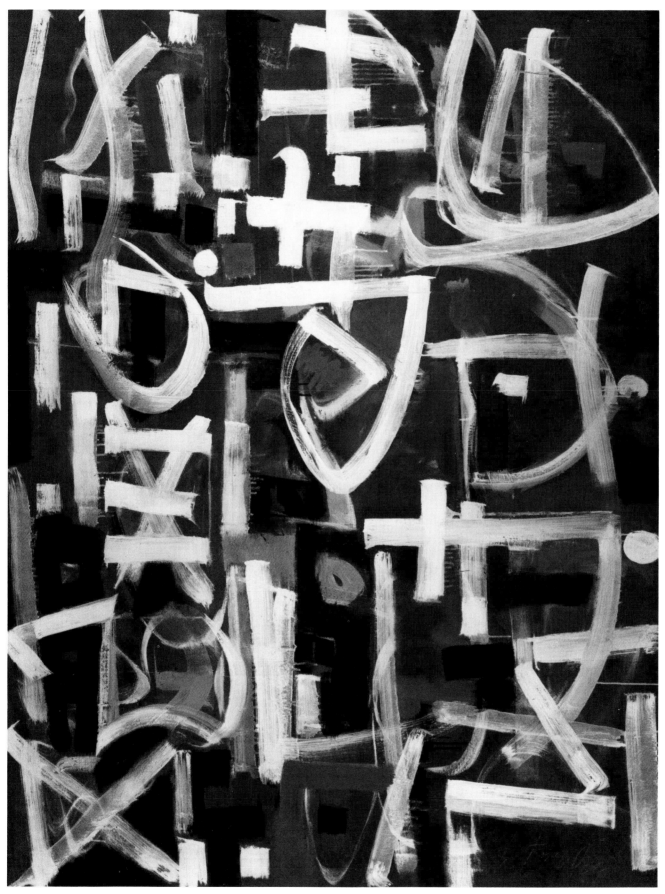

BRADLEY WALKER TOMLIN
Number 2 — 1950, 1950
Oil on canvas, 54 x 42 inches
Gift of Mr. and Mrs. David Rockefeller
in honor of John I.H. Baur 81.8

Overleaf
Installation view of Willem de Kooning
paintings and sculpture, left to right:
Untitled (Woman), *Clamdigger*,
Untitled VII.

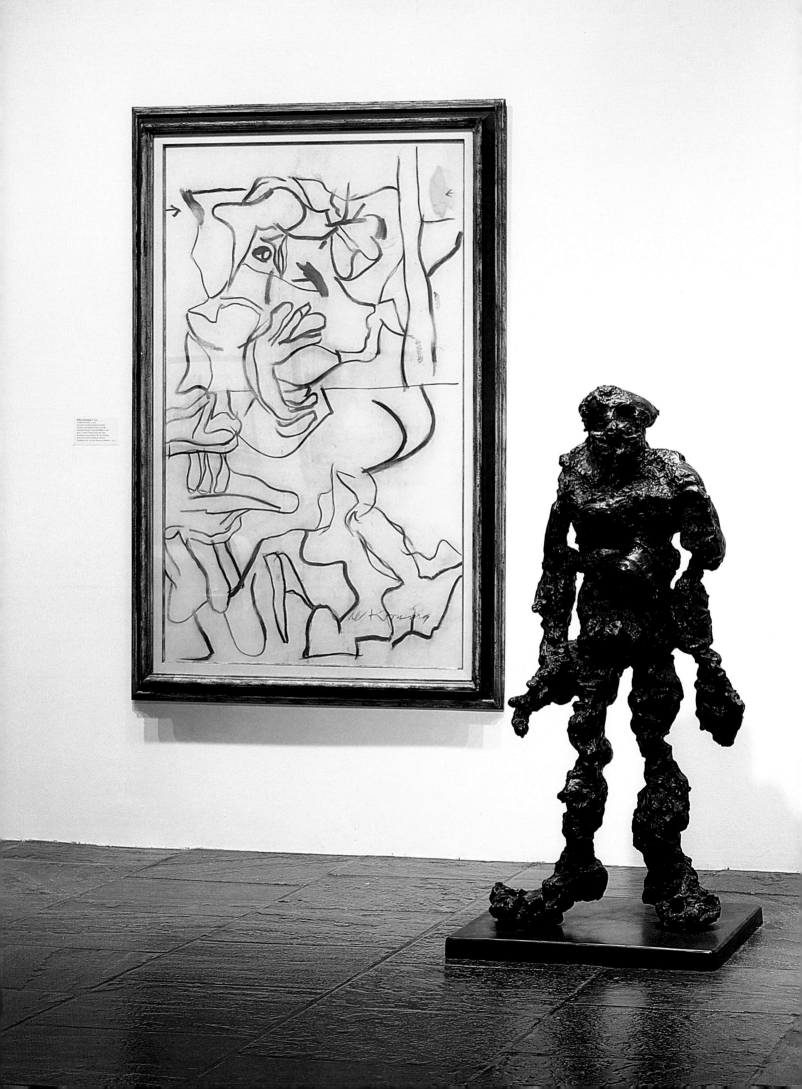

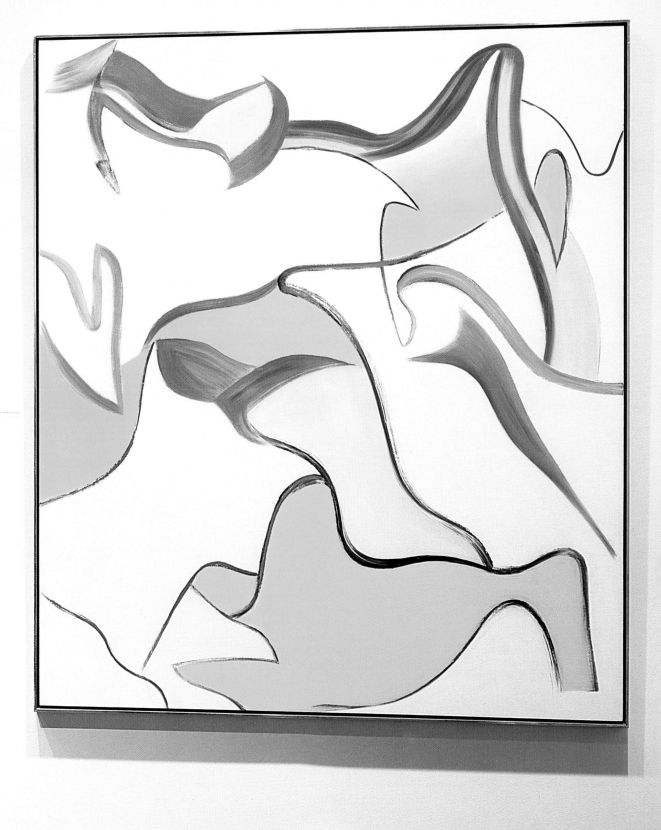

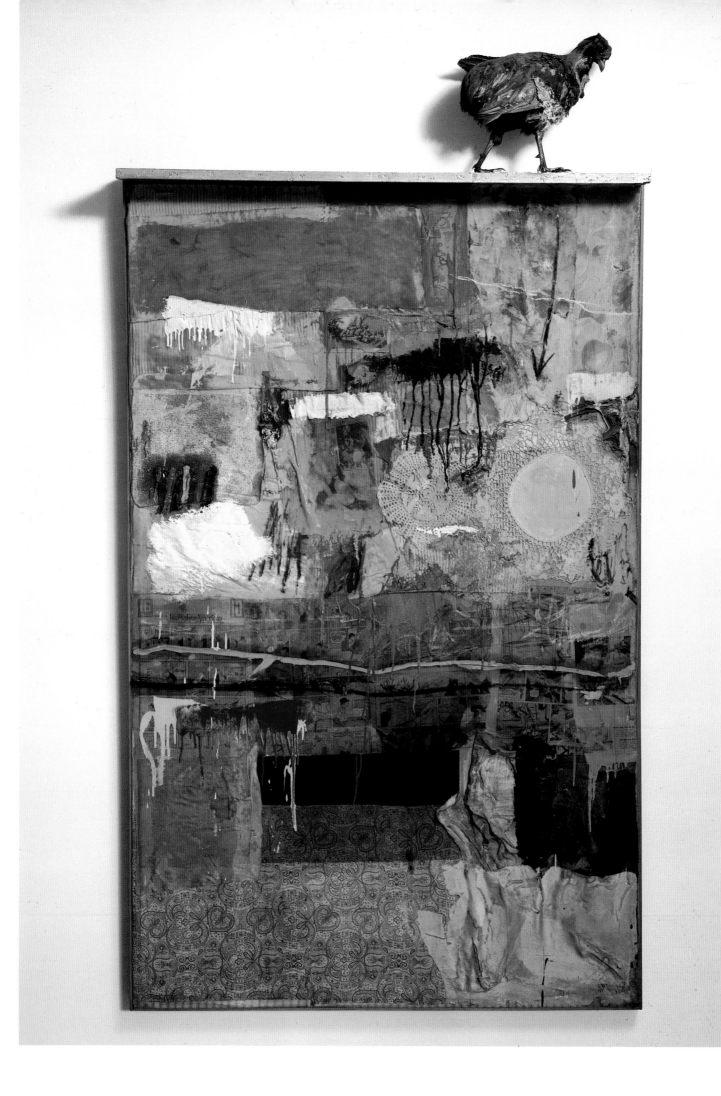

NEO-DADA, POP ART, AND FIGURATIVE REALISM

ROBERT RAUSCHENBERG
Satellite, 1955
Oil, fabric, paper, and wood on canvas,
with stuffed pheasant, 80 x 42 ½ inches
Partial and promised gift of Claire B.
Zeisler and purchase, with funds from the
Mrs. Percy Uris Purchase Fund P.2.86

Overleaf
Installation view: Claes Oldenburg, *Soft
Toilet* (front); left to right: Jim Dine,
Double Isometric Self Portrait (Serape);
Robert Rauschenberg, *Bellini #1, #2,
#3, #4*; Jasper Johns, *Studio II,
Racing Thoughts.*

America's postwar period of economic and social recovery saw the growth of a national mass market for consumer goods and the potent influence of television and other forms of mass communication in American life. Artists, poets, musicians, playwrights, and others began to question and even to parody the style and content of mass communication and marketing, to celebrate their seductive exteriors and query their growing influence on American life. In the 1950s, acting in what Robert Rauschenberg described as the "gap between art and life," artists such as Jim Dine, Alan Kaprow, and Claes Oldenburg staged events called Happenings, which incorporated live theater, objects, and the audience in freely improvisational situations. Musician John Cage and choreographer and performer Merce Cunningham worked with Rauschenberg and others in performances that opened up the formal structure of music and dance to the dynamic patterns and chance operations of nature, random playfulness, and the ordinary practical activities of daily living.

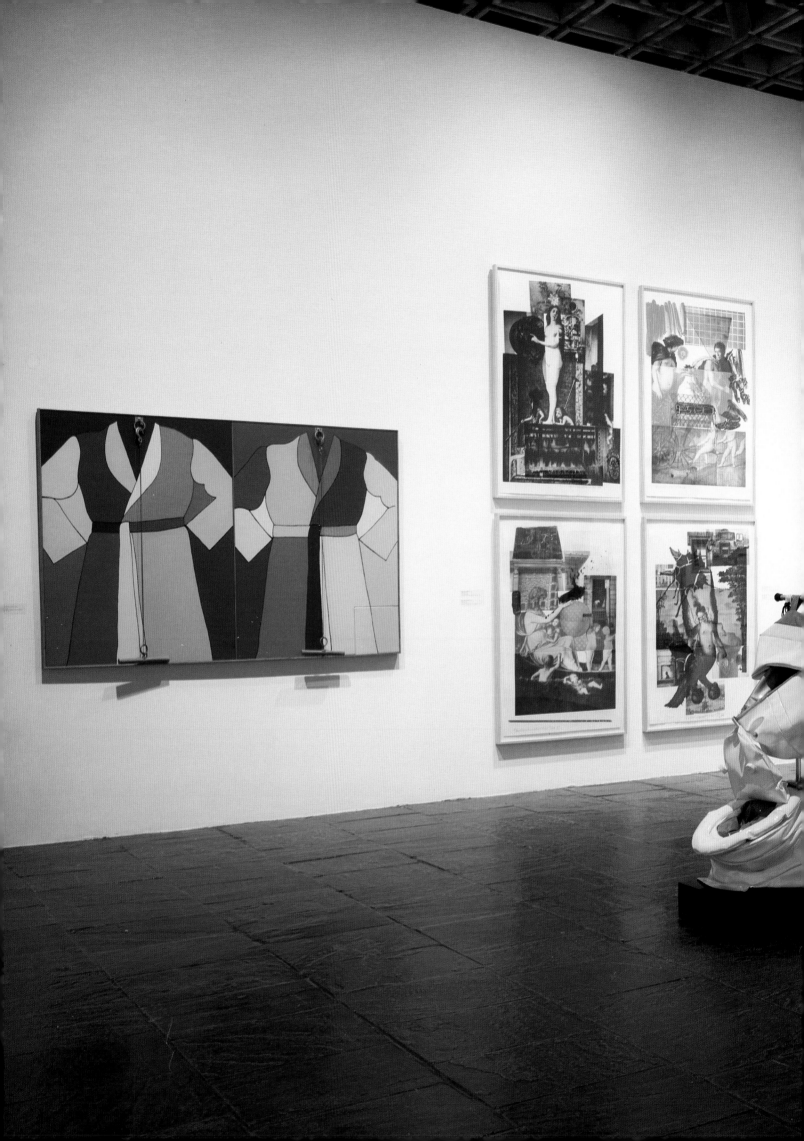

The visual art of this transitional
and innovative time is also characterized by a spirit of
improvisation and an unusual responsiveness to the
changing life-styles of many Americans. This art sports a
studied indifference to the heavily romantic individualism
of Abstract Expressionism, which was much admired in
the United States and abroad by the mid-1950s. One of the
pivotal works of this period was Rauschenberg's *Satellite*
(1955), now a promised gift that brings an important dimen-
sion of mid-century American art to our collection. In such
early Combine paintings as this, Rauschenberg crossed
the boundary between art and life by inserting objects of
everyday use, especially those with intriguing histories,
directly into the planar environment of his canvases. The
pieces of weathered cloth, crocheted doilies, newspaper
cartoons, and photographs accommodated themselves to
the flat space of the canvas. However, the stuffed pheasant
without a tail who strides across a ledge atop the work is
like a satellite tenuously connected to the canvas and
following its own trajectory through space. Numerous
images pasted to the surface refer to flight, personal mem-
ories, and fantasies, creating a rich mixture of past and
present and of real and pictured places and objects.

When Rauschenberg's Combine
paintings were first exhibited some critics, noting their
physical resemblance to the work of European Dadaists
such as Marcel Duchamp and Kurt Schwitters, referred
to them as Neo-Dada. This rubric, also applied to the art
of Jasper Johns, acknowledges the obvious differences
between the Americans and their European predecessors,
who were less involved in popular culture and its sublimi-
nal influence in contemporary life. Also obvious was the
homage paid by Rauschenberg and others to the Abstract
Expressionists through the gestural marks that figured
prominently in their paintings, even if these new marks
were often drained of overt emotional impact.

JASPER JOHNS
Untitled, 1983
Monotype: sheet, 32 x 92 ¼ inches sight;
image, 30 ¼ x 90 ¼ inches
Purchase, with funds from the Grace Belt
Endowed Purchase Fund, the Wilfred P.
and Rose J. Cohen Purchase Fund, the
Equitable Life Assurance Society of the
United States Purchase Fund, Sidney S.
Kahn, The List Purchase Fund, Mr. and
Mrs. William A. Marsteller, the Print
Purchase Fund, and the Print Committee
84.28

JASPER JOHNS
Untitled, 1984
Charcoal on paper, 44 x 33 3/16 inches
Purchase, with funds from the Burroughs
Wellcome Purchase Fund, the Equitable
Life Assurance Society of the United States
Purchase Fund, the Mr. and Mrs. Thomas
M. Evans Purchase Fund, and the Mrs.
Percy Uris Purchase Fund 86.4

ROY LICHTENSTEIN
Study for *Figures in Landscape*, 1977
Graphite and colored pencil with collage
on paper, 22 1/2 x 27 1/4 inches
Purchase, with funds from the Drawing
Committee 84.4

JAMES ROSENQUIST
Fahrenheit 1982 Degrees, 1982
Colored ink on frosted mylar,
33 ⅛ x 71 ½ inches
Purchase, with funds from the John I.H.
Baur Purchase Fund, the Mr. and Mrs.
M. Anthony Fisher Purchase Fund, and
The Lauder Foundation—Drawing Fund
82.35

Jasper Johns' beautifully crafted and carefully conceived images of the American flag, targets, and maps of the United States are, despite their subjects, without utilitarian purposes. As Johns lavished his painterly attentions on borrowed and entirely familiar graphic images, he marked the distance between their existence as visual readymades known to the mind and the eye and their appearance as useful objects.

Three Flags (1958), in encaustic on canvas, involves the purposeful positioning of one painted canvas on top of another. Here we observe the mutable nature of an indelible cultural image, able to change scale, texture, and position in space while staunchly maintaining its identity. When this work entered our collection, some celebrated the acquisition, while others, questioning its price and its significance in twentieth-century art, assumed it had been created in a spirit of ironic parody. Johns clearly understood that the American flag carried within its graphic identity a host of cultural and political meanings. His multiple transpositions of the image point toward its role as a carrier of content rather than to that content itself. Johns is not indifferent to the cultural role of the flag, but his own use of it is intellectual and speculative rather than ironic or celebratory.

The gift of Johns' *Studio II* (1966), a painting full of intriguing ruminations on the creative process, has complemented the Museum's much earlier acquisition of *Studio* (1964). A magnificent later painting, *Racing Thoughts* (1983), contains many allusions to the artist's influences, friendships, heroes, and private fears. Our Permanent Collection is also enriched by important drawings, etchings, lithographs, and monotypes by Johns. These further extend his intricately cross-referenced iconography by building on the subjects of his paintings and sculpture.

During the early 1960s, sculptors such as Claes Oldenburg and George Segal further collapsed the boundaries between life and art. In 1961, Oldenburg opened up his famous *Store* on East 2nd Street, where he made and sold works of art in the form of every-day objects, such as hats, underwear, hamburgers, and cups of coffee. *Soft Toilet* (1966) is typical of Oldenburg's extraordinary transformations of ordinary things. Also in 1961 George Segal began to make castings in plaster of live models dressed in commonplace clothing performing unremarkable but very familiar tasks. Segal carefully restaged and reworked situations from life to achieve a strong degree of empathy between subject and viewer. *Walk, Don't Walk*, a major work of 1976, implies activity and a direct link with the gallery space inhabited by the viewer. Other works by Segal have a quietude and pathos at times reminiscent of the silently inhabited spaces of Edward Hopper.

In 1962, a brash assertive style the critics called Pop Art burst upon the New York art world with frank quotations of media imagery and a focus on quotidian events and people treated with uncommon drama and intensity. The movement had, in fact, been established in Britain in 1956 with the "This Is Tomorrow" exhibition at London's Whitechapel Gallery. Here artists such as Richard Hamilton, Eduardo Paolozzi, R.B. Kitaj, and David Hockney showed works based, in large part, on the imagery of American advertising. Several of the New York artists who came to dominate the Pop movement in America during the early 1960s had spent years of apprenticeship within the very world of Madison Avenue advertising that their British counterparts had appropriated.

Andy Warhol adopted techniques he had learned in advertising graphics as he subjected the imagery of consumerism and the news media to telling alterations that commented on the role of the print media, television, and film in our lives. Brilliant and enigmatic, Warhol focused his sights on the interaction of self and self-image in his well-known *Ethel Scull 36 Times* (1963), an icon of the period and a collaboration between sitter and artist. Warhol assembled and edited the photographs Ethel Scull took herself in a photo-booth camera in a Times Square arcade. It is at once a portrait and a self-portrait created through the emotionally neutral medium of a machine.

EDWARD RUSCHA
Motor, 1970
Gunpowder and pastel on paper,
23 x 29 inches
Purchase, with funds from The Lauder
Foundation—Drawing Fund 77.78

James Rosenquist, who had helped support his artistic career by painting billboards, exposed the tactile and erotic nature of the abbreviated realist style employed in commercial advertising. His knowing and highly controlled exploitation of that style is apparent in a later work, *Fahrenheit 1982 Degrees* (1982), a drawing whose scale and assertive, implicitly erotic imagery is central to his artistic program. Roy Lichtenstein's sharpened vision was also filtered through the graphic conventions of advertising to achieve an unusually artificial and quite expressive degree of objectivity. When Lichtenstein employs this cool style to describe natural organic forms, as in the drawing Study for *Figures in Landscape* (1977), it imparts a curious, abstracted stillness to his subject, making us aware of the drawing as an artificial mirror of nature.

Hard and soft edges alternate in the paintings of Alex Katz, whose choice of subjects differed markedly from that of his contemporaries in the 1960s. Katz focused on beloved faces and familiar places; his wife, Ada, posed for the woman in *The Red Smile* of 1963. Her self-confident expression and the work's grand scale provide not only the record of a face the artist knew well, but also an image of American life.

The familiar and the bizarre come together in the work of Ed Ruscha, who uncovered a bittersweet poetry in the unique graphic style and often eccentric sensibility of Los Angeles and its environs. His *Large Trademark with Eight Spotlights* (1962) has a curious reality—bold, easily read, and very revealing of the inflated scale and theatricality of late twentieth-century commercial architecture. Ruscha's drawings evince a tender regard for odd and seductive materials, as in the handling of gunpowder on paper in the drawing *Motor* of 1970.

The dramatic character of Pop Art, with its multiple references to media and consumer society, seems to obscure the fact that Pop brought new attention to the depiction of the human figure, landscape, and architecture, among other subjects. Realism in its various forms remained an active element in American art throughout the postwar era, as it has been from the beginning of our national culture. Alice Neel's *Andy Warhol* (1970) involved the intense scrutiny and thoughtful regard of one artist by another. Unsparing of Warhol's vanity as she reveals the corset he wore following a much-publicized violent attempt on his life, Neel exhibits something of the penetrating analysis Warhol worked upon his own subjects while engaging our emotions more than our curiosity. Philip Pearlstein's *Female Model on Oriental Rug with Mirror* (1968) is a most unusual realist work. Pearlstein's nudes are more than formal devices, yet also more than sentimental or erotic presences. Their cool, contemporary self-possession creates an emotional barrier as the artist scrutinizes them from many points of view.

EDWARD RUSCHA
Large Trademark with Eight Spotlights,
1962
Oil on canvas, 66¾ x 133¼ inches
Purchase, with funds from the Mrs. Percy
Uris Purchase Fund 85.41

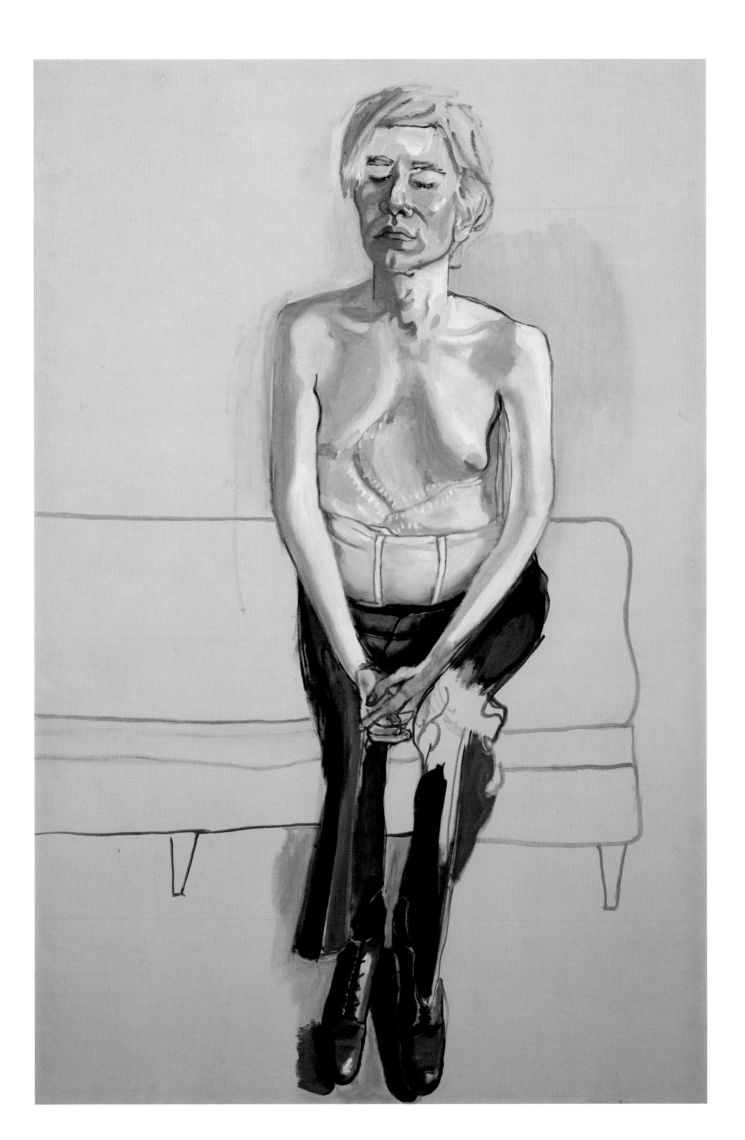

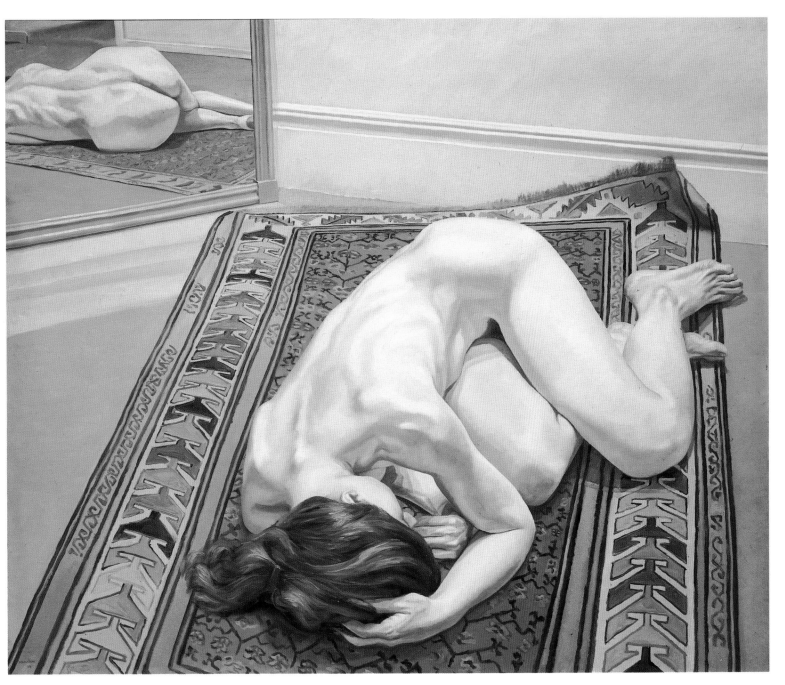

ALICE NEEL
Andy Warhol, 1970
Oil on canvas, 60 x 40 inches
Gift of Timothy Collins 80.52

PHILIP PEARLSTEIN
Female Model on Oriental Rug with Mirror, 1968
Oil on canvas, 60 x 72 inches
50th Anniversary Gift of Mr. and Mrs. Leonard A. Lauder 84.69

In studying and parodying the abbreviated graphic language of advertising, the Pop artists often dealt with the translation of photographic imagery into printed approximations. The Photo-Realists who emerged in the 1960s took another approach to photography, exploring the differences between human vision, the visual record of the photograph, and the possible rendering of photographic vision in a painting. Each of these forms of vision, they knew, was ultimately a separate experience. The more fascinating works of Photo-Realism, for example, Richard Estes' painting *Ansonia* (1977), are able to tell us how optical vision, photographic vision, and the painter's approximations are different but related. Estes uses the camera to bring order and stillness to a rapidly moving world where light constantly changes the relationships between one object and another. His paintings are, however, carefully staged approximations of optical experience. Estes has softened edges, brought perspectives into a new alignment through subtle alterations, and changed the placement of the sidewalk's edge to expand our view.

Duane Hanson's startling sculpture elicits strong personal reactions when viewers come upon a work such as *Woman with Dog* (1977) and assume that they are confronting a real person sitting in a chair. The hyperrealism of this work is a calculated device and not necessarily the entire subject of the piece. Hanson uses it to engage the viewer's attention, so that he may comment on the human condition, old age, infirmity, or the lost bloom of youth in precise detail while seeming to share our life as well as our physical space.

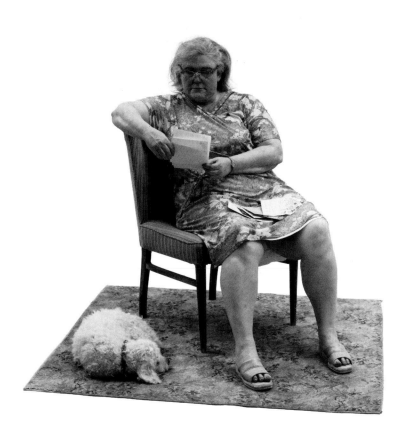

DUANE HANSON
Woman with Dog, 1977
Cast polyvinyl, polychromed in acrylic,
with mixed media, life size
Purchase, with funds from Frances
and Sydney Lewis 78.6

RICHARD ESTES
Ansonia, 1977
Oil on canvas, 48 x 60 inches
Purchase, with funds from Frances
and Sydney Lewis 77.33

POSTWAR SCULPTURE:
ASSEMBLAGE AND EXPRESSIONISM

Within the New York School, painting was the dominant medium of expression despite the formidable contributions of David Smith and other American sculptors. However, the vast scale of many Abstract Expressionist paintings and the acute awareness of the physical dialogue between viewer and object soon led to a wider exploration of the gallery and studio as environments and of the work of art as a work in process. As David Smith had demonstrated so eloquently, modern sculpture could be painted, burnished, and given a sensuous surface without sacrificing its three-dimensionality. He also showed that the third dimension could be beautifully articulated by a line traveling through space as well as by mass occupying space.

Mark di Suvero's broadly gestural *Hankchampion* (1960) is an early work that declares the young artist's admiration for the brusque, self-assertive spirit of the New York School and his own generation's ambition to spread this energy freely beyond the boundaries of the canvas. The materials for *Hankchampion* came

Installation view, left to right: George Sugarman, *Inscape*; Louise Nevelson, *Black Cord*.

from the streets of Manhattan. Their almost romantically weathered surfaces speak of the terrible beauty of great American cities, a favorite subject of American art and letters. But the abstract concreteness of di Suvero's style dispells sentimental associations as it urges us to consider the materials, the risky points of balance, the wonder of man-made structures as they break down and become once again elements of nature.

George Sugarman's *Inscape* (1964) spills out across the gallery floor, a sprawling cornucopia of form and color that overtakes the viewer's ability to assimilate each part and consider the work as a whole. Orange, green, black, cream, and red compete for attention, further fragmenting the work. Soon it reveals itself as ribbons of energy tracked by separate colors flowing across the planar field of the floor. Here a sculptor's sensibility is expressed in almost painterly form, the letting loose of the gesture in space.

A great deal of the sculpture of the 1960s was created from unusual materials, assembled and painted in ways that alternately embellished and obliterated its basic three-dimensional structure. Among the materials were those that reflected America's consumer-oriented culture. John Chamberlain's sculptures, made from the metal parts of well-worn automobiles, knowingly exploit our intimacy with cars, our pride in them, and our willingness to cast them off for newer models. *Jackpot* (1962) is an elegantly formal structure, as gestural and full of implied action as the paintings of the New York School or di Suvero's *Hankchampion*. Treating these burned, dented, scraped pieces of painted metal as mere materials, Chamberlain achieves a physical balance of uneven parts, the whole crowned by a gaudy and seductive folded sheet of gold paper backed by cardboard, perhaps the golden prize in the "jackpot." It is nearly impossible, however, to ignore the wounded metal parts, their scars and scrapes, and to avoid thinking of the shining autos they once were.

JOHN CHAMBERLAIN
Jackpot, 1962
Metal and paper, 60 x 52 x 46 inches
Gift of Andy Warhol 75.52

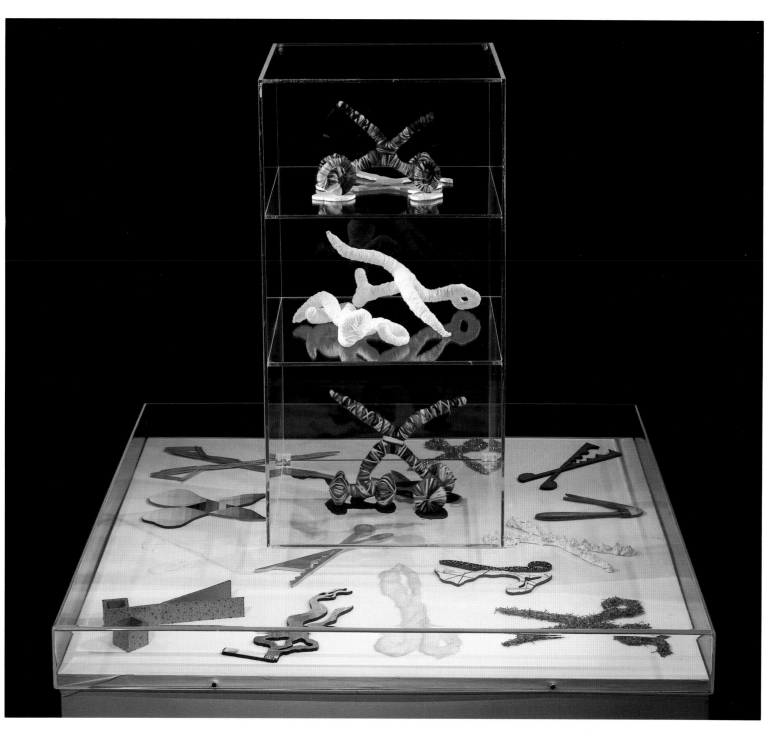

FRANK STELLA
Silverstone, 1981
Mixed media on aluminum and fiberglass,
105 ½ x 122 x 22 inches
Purchase, with funds from the Louis and
Bessie Adler Foundation, Inc., Seymour M.
Klein, President, the Sondra and Charles
Gilman, Jr. Foundation, Inc., Mr. and Mrs.
Robert M. Meltzer, and the Painting and
Sculpture Committee 81.26

LUCAS SAMARAS
Transformation: Scissors, 1968
Mixed media, 51 ½ x 36 ½ x 36 ½ inches
50th Anniversary Gift of Frances and
Sydney Lewis 80.18

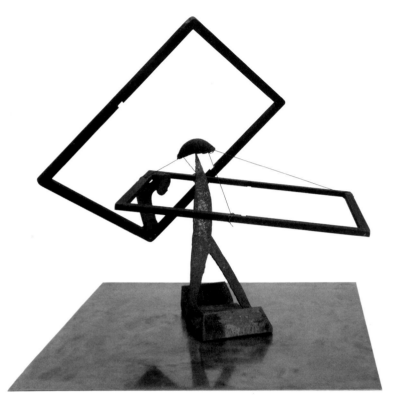

MARK DI SUVERO
Achilles' Heel, 1969
Welded steel and wire,
35 x 40¼ x 40¼ inches
Promised 50th Anniversary Gift of Mrs.
Robert M. Benjamin P.4.80

As a young artist, Louise Nevelson searched the buildings, streets, subways, and shops of New York for materials to use in her assembled structures. In her early work of the 1950s, she unified found objects by applying a uniform coat of paint and by arranging them with an almost theatrical sense of form. *Black Cord* of 1964 is a particularly welcome addition to our important and comprehensive collection of Nevelson's sculpture. This mature work reveals her ability to take hold of disparate physical elements and forge a clear visual and conceptual structure for them. The discipline she imposed on her materials through a strong rectilinear framework allowed her to give free reign to her inventive and expressive choices of wood elements.

The materials and working methods employed by artists for assembled sculpture have long been associated with those of earlier European Surrealists and with the artistic and poetic tradition of the *objet trouvé*, or found object. European Dadaists and Surrealists knew that objects, especially those with a past, lent themselves to the telling of stories, real and imagined. The Surrealist concept of metamorphosis, involving imaginative transformation or transposition as in a dream, stimulated the imaginative play of artists in several media. It is as old as human storytelling, common to folklore and myth, and provides the basis for many modern films.

The sculpture of Lucas Samaras often involves an elaborate and extended experiment in metamorphosis, as a single form or set of objects is subjected to successive transformations. *Transformation: Scissors* of 1968 offers a rich, and in concept virtually unlimited, set of possible physical forms in which scissors can appear. Soft and hard, useful and useless, macabre and upsetting, or poignantly ineffectual, they play on our familiarity with the look and functions of scissors. Samaras' intellectual curiosity is paired with his superb sense of theater: he takes us through his mental and physical permutations until an innocent pair of scissors on a dresser begins to stir up feelings in quite unexpected ways.

Installation view of Mark di Suvero,
Hankchampion, "20th-Century American
Art: Highlights of the Permanent
Collection I," 1985.

Perhaps the most provocative and versatile object in the typical American home is the television, purveyor of ever changing images, ideas, and goods. Nam June Paik is aware, more than most of us, of the ways television has expanded and intruded on our daily lives. His *V-yramid* (1982) is indeed an assembled sculpture, a stack of televisions large and small. Its real focus, however, is obviously not the rectilinear form of the television cabinets but the incredible level of energy they contain, for Paik's programmed images ebb and flow and burst upon the screen, alternately stirring up the environment with noise and providing sweet music and sunsets. As a work of sculpture, *V-yramid* makes us see the infinity of shapes, sounds, and information the television contains.

Assemblage is a tradition that also has room for small objects capable of conveying big ideas. Joseph Cornell, alone among his contemporaries at mid-century, did not try to impress by physical size or artistic theory. His is a contemplative art given to vague and arcane subject matter, but one which speaks with a quiet authority. In *Grand Hôtel Bon Port* (1952), the delicate contours of a young woman's face, a fragment from a painting by Vermeer, are fondly traced, her shadowy existence confirmed as she stares at us from the interior of a white box framed with a geometric lattice of verticals. Even as Vermeer achieved his delicate poetry through the activity of light in space, Cornell employs real cast shadows in his box environment. He also blocks off the first letters of "Grand," so that we initially read the word as "and" and only later apprehend its complete form. With his evocation of Vermeer and his network of horizontals and verticals, could he have been thinking of the modern Dutch master Mondrian?

H.C. WESTERMANN
The Evil New War God, 1958
Brass, partly chrome-plated,
16¼ x 9¾ x 10¼ inches
Promised gift of Howard and
Jean Lipman P.62.80

Boxes also fascinated H.C. Westermann, who engineered elegantly crafted wooden boxes and filled them with provocative and enigmatic objects of his own creation. Working in Chicago, with its fine collections of Surrealist art and especially the works of Dubuffet and Art Brut, Westermann was heir to a rich tradition that encouraged and supported his eccentric sensibility. Although known for his wood objects, he often worked brilliantly in other materials. *The Evil New War God* (1958) is appropriately incarnated in metal—chrome over bronze—as if wearing a suit of armor. That the figure partially resembles a toy may tell us more about the nature of our toys than about the meaning of Westermann's own sculpture, which quietly keeps its own counsel. Westermann's bittersweet romanticism is also expressed quite openly in a late watercolor, *The Sweetest Flower* of 1978.

NOTHING CONFORMS TO X SPECK STATIONS · FANCY REAM ARCHS AND A LIL FILTER PEACE WHILE WAITING FOR THE MODEL ·
SHADOWS LICK AS EALS SLITHER THROUGH

Within the image:
"Death lies on her, like an
untimely frost —
Upon the sweetest flower of
the field."
Shakespeare

WILLIAM T. WILEY
Nothing Conforms, 1978
Watercolor on paper, 29½ x 22½ inches
Purchase, with funds from the Neysa
McMein Purchase Award 79.25

H.C. WESTERMANN
The Sweetest Flower, 1978
Watercolor on paper, 22⅛ x 31 inches
Purchase, with funds from The Lauder
Foundation—Drawing Fund 78.102

JESS
Young People in Particular Will Find It,
1983
Collage on paper mounted on wood,
21 x 48¼ inches
Purchase, with funds from the Drawing
Committee 86.17

Ed Paschke interpreted the style and
emotional tone of contemporary urban social gatherings
in broadly Surrealist terms in his painting *Violencia*
(1980). A key figure in the growth of a Chicago school of
contemporary painting since the late 1950s, Paschke had
an early interest in popular culture and explored the
graphic imagery of pulp magazines, narrative cartoon
strips, and the raw, violent world of action comics. The
mood of *Violencia* is established by the lighting and eerie
silhouettes of the figures rather than by any overt action,
yet Paschke is very adept at conveying the restless energy
behind polite appearances.

Outside New York many kinds of
Assemblage art flourished. In the work of Jess, who has
lived and worked in San Francisco most of his life, it

acquired a distinct and special emphasis. The title of his massive and intricate collage *Young People in Particular Will Find It* (1983) comes from a phrase imbedded in the thicket he has created of fragmented words, printed images, and passages of drawing and color. It is an appropriate title, evocative of the counter-culture of San Francisco's young poets and artists. The future tense assures us that the young people will indeed be successful, though we are left wondering what is the "it" they will find.

Many recent exhibitions of Assemblage sculpture have stressed regional differences in various parts of the United States, among them Chicago, Los Angeles, and San Francisco. However, Assemblage is by now an international language with a long history in this country. New Yorker Saul Steinberg's *Giant Table III*

(1974) could be thought of as an assembled sculpture, but it is also a humorous and elegant dissertation on his beloved art of drawing. Steinberg has recreated an artist's table with the implements of his craft carefully rendered in new materials. In this work, his pencils and brushes are made entirely of wood, so that they are not functional; yet they are so fondly carved that one senses the artist's pleasure in their making and use in real life. Books and blocks of paper are also rendered in wood and with a touching awkwardness that enables us to appreciate Steinberg's wonder at them. Drawings placed throughout the work tell of the processes of the artist's craft and imagination. By refashioning his creative world in the stillness of wood, Steinberg has been able to slow it down, to share his ruminations with us.

MINIMALISM AND REDUCTIVE ABSTRACTION

The international recognition of postwar American painting and sculpture focused on the achievements of the New York School and Abstract Expressionism. The art of Willem de Kooning, Franz Kline, and Jackson Pollock was the expressive result of a willed act of creation. The vulnerability of this act to the exigencies of improvisational processes, the artist's psychology, and the conjunction of material and idea gave the paintings of many major New York School artists the dramatic character of an unrepeatable event.

Within the New York School, however, there were other voices and approaches to the creation and interpretation of art. In the more reductive work of Barnett Newman, for example, the willed act of the artist had to be definite and permanent, not based on circumstance and contingency. In their mature work, Mark Rothko and Clyfford Still placed less emphasis on gesture and more on the architectonic structures of their large compositions. The late work of these artists has fewer compositional elements and a surer command of scale.

Ad Reinhardt based his early work on the structured geometric styles of European modernism, borrowing liberally from Synthetic Cubism, Neoplasticism, and Constructivism. If his debt to European art was obvious, so too was his original handling of color for expressive rather than decorative purposes. Close tones of red compete with one another in Reinhardt's early paintings, as do multiple blues and greens placed in unsettling proximity to challenge or comfort one another. By the 1950s, his compositions were often symmetrically divided, conceived in the mind according to abstract principles of uncompromising calm and order. The beautiful mid-century work *Abstract Painting, Blue 1953* (1953) was produced at the moment when Abstract Expressionism was the dominant style at home and abroad. Reinhardt's conviction that a painting is not a record of individual emotion but a separate entity created according to timeless aesthetic and philosophical principles ran directly counter to the ethos of Action Painting, but his work and his role as an intellectual provocateur within the New York School were prophetic of things to come.

The art of Californian John McLaughlin was informed by his expertise in Japanese prints, his admiration for the work of Mondrian, and his patient study of Malevich's Suprematist paintings and the work of the Russian Constructivists. These and other influences prompted him to devote his energies to a form of reductive, non-objective painting which by the early 1950s had evolved into a very personal style. McLaughlin's *Untitled (Geometric Abstraction)* of 1953 is a typical work, with its unusual division into two areas, one brightly colored, the other quite subdued in tone. His geometry is intentionally provocative and unsettling. McLaughlin's paintings are like visual propositions containing unresolvable elements that must be reconciled by intuition rather than reason. His art has inspired many younger West Coast painters to pursue forms of non-objective painting

BARNETT NEWMAN
Untitled, 1961
Lithograph: sheet, 30 x 22¼ inches; image, 22⅝ x 16¼ inches
Purchase, with funds from the Print Committee 84.57

that challenge the mind by through purposeful simplicity and oddly asymmetrical pictorial structure.

The work of Tony Smith also played a pivotal role in the development of American art in the late 1950s and 1960s. In works such as *Die* (1962), a recent acquisition, Smith proposed a role for sculpture akin to that of architecture—one of parity with the massive structures of nature, but one that also expressed the conceptual and physical order generated by man. The surface of *Die* has acquired the subtly graded patination expected of Corten steel. This too anticipates the Minimalist sculptors who came to prominence in the early 1960s, insisting on a unity of material, form, and surface. Smith was a contemporary of the Abstract Expressionists and the dramatic presence of his sculpture parallels certain expressive qualities of the New York School; but, like Reinhardt, he traveled another path and opened it up for others, who would take it further in the 1960s.

It was Frank Stella's massive paintings in black enamel, created in late 1958 and 1959, which marked the definitive change from one generation to the next. With the examples of Newman, Reinhardt, and Rothko as a background and the recent paintings of Johns as a challenging precedent, Stella instilled a chilling rigor into his early work. The image was preconceived; a seamless unity was forged between the shape of the canvas and the structure placed within and upon it. *Die Fahne Hoch* (1959), one of the most ambitious and celebrated works from this early cycle, refers to a military song sung by Nazi youth raising a banner to the supposed dawn of a new era. Stella's adoption of the title reflects his eager sureness that in his own life and work, and in a vastly different time and spirit, he had indeed turned a corner. The uncompromised clarity of these Black paintings might have limited another artist; instead, Stella was propelled into a highly active period of innovation, and his early paintings influenced many artists of his generation.

MYRON STOUT
Untitled (Wind Borne Egg), 1959–80
Oil on canvas, 26 x 20 inches
Purchase, with funds from the Mrs. Percy
Uris Purchase Fund 85.42

AL HELD
South Southwest, 1973
Synthetic polymer paint on canvas,
96 x 144 inches
Purchase 73.65

AD REINHARDT
Abstract Painting, Blue 1953, 1953
Oil on canvas, 50 x 28 inches
Gift of Susan Morse Hilles 74.22

Paintings and sculpture of the early 1960s suddenly seemed to have one issue in common, that of presentation—the direct presentation of a work of art as a new, self-sufficient entity and not as a re-presentation of nature or of some parallel formal abstraction of nature. Donald Judd, a former painter and a perceptive art critic, had a keen understanding of these crucial differences between the art of the New York School and that of his contemporaries, whom some critics of the time called "minimalists." As is often the case, artists did not like this term and stressed the evident physicality of their work and the richness of what was indeed presented to the viewer.

Judd's *Untitled* (1965) is a fine example of the coincidence of form, material, and concept, a hallmark of the best American sculpture of this period. Occupying the planar field of the floor, it activates the room or gallery in which it is placed, creating a heightened awareness of corners, angles, and planes by its diagonality, pierced surfaces, and assertive scale.

Critics remarked on the dramatic theatricality of some Minimalist sculpture. Much of it seemed to them impossibly outscaled, made for a museum, outdoor spaces, or large public buildings. The scale of Robert Morris' *Untitled (L-Beams)* (1965) has been a challenge to our own institution, although a stimulating and ultimately satisfying one. Originally conceived as two L-shaped units, Morris added a third, thereby increasing the possible configurations in which they can be placed. With each new installation of the work we explore it anew.

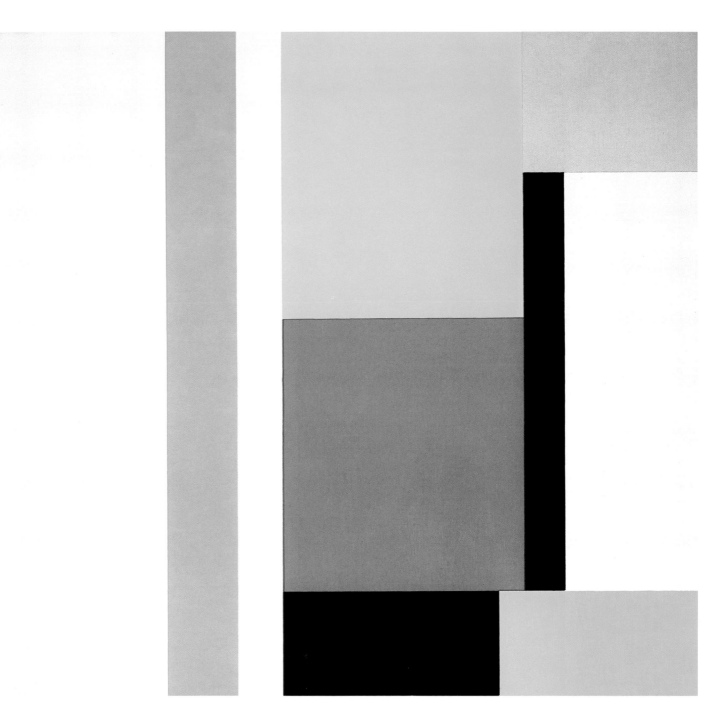

JOHN McLAUGHLIN
Untitled (Geometric Abstraction), 1953
Oil on panel, 32 x 38 inches
Promised gift of Beth and James DeWoody
P.1.86

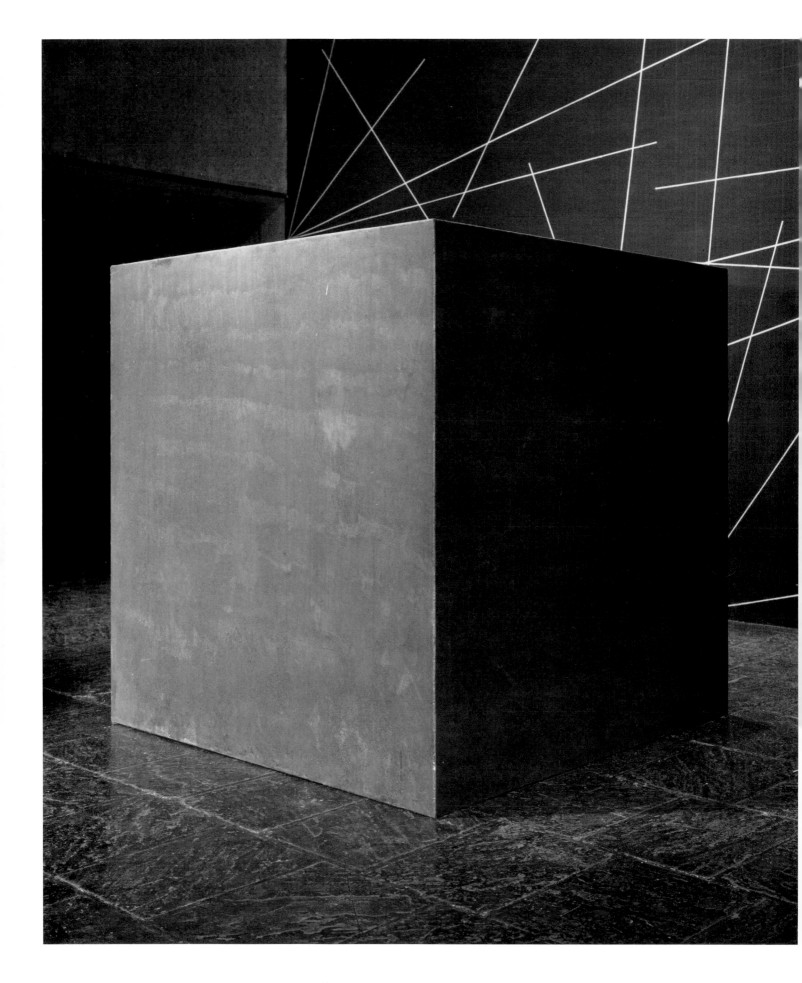

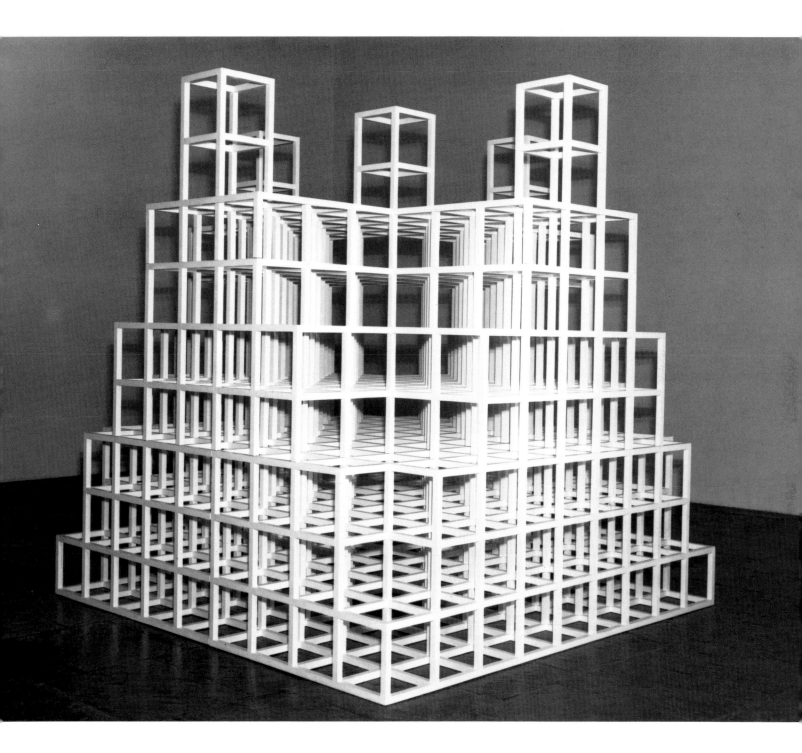

SOL LeWITT
Five Towers, 1986
Painted wood, eight units, 86⁹/₁₆ x 86⁹/₁₆ x
86⁹/₁₆ inches overall
Purchase, with funds from the Louis and
Bessie Adler Foundation, Inc., Seymour
M. Klein, President, the John I.H. Baur
Purchase Fund, the Grace Belt Endowed
Purchase Fund, the Sondra and Charles
Gilman, Jr. Foundation, Inc., The List
Purchase Fund, and the Painting and
Sculpture Committee 88.7a-h

TONY SMITH
Die, 1962
Steel, 72⅜ x 72⅜ x 72⅜ inches
Purchase, with funds from the Louis and
Bessie Adler Foundation, Inc., James Block,
the Sondra and Charles Gilman, Jr. Foundation,
Inc., Penny and Mike Winton, and the
Painting and Sculpture Committee 89.6

Color, overwhelmingly sensuous and immediately self-evident, seems to dominate Dan Flavin's *Untitled (for Robert, with fond regards)* (1977) to such a degree that it may not seem to have much in common with Minimalist ideals. It does, however, exhibit precisely the coincidence of material, form, and surface (in this case electronic equipment, glass tubes, and colored light) that characterizes the work of other Minimalists. Flavin here establishes a wall of brilliant yellow and pink light, each color working with and modulating the other. Running vertically at the back and almost unseen from the front is a grid of deep crimson neon tubes, radiating a steady glow that supports and enhances the frontal plane.

Ellsworth Kelly was an innovator in the productive dialogue between painting and sculpture in postwar American art. His shaped canvases of the 1950s and 1960s propose a non-illusionistic existence for a painting while setting it free to interact with the three-dimensional environment of a room. Likewise, his painted sculptures have the planar character of paintings folded and shaped to perform new roles. *Blue Panel I* of 1977 has the taut edges and carefully considered colorism that have characterized Kelly's best work from the outset.

It was not until 1959 that Agnes Martin arrived at the essential pictorial structure that she still explores with such poetic beauty. She became identified with younger artists, among them Ellsworth Kelly and Jack Youngerman, who were neighbors for a time in New York. Works such as *Untitled #11* (1977) have a satisfying and dramatic quietude underscored by the careful intervals she has established in the canvas and the subtle natural variations of line—each one drawn by hand.

Robert Ryman is a painter who also operates within a self-imposed set of variables—white pigment, an exploitation of the edges where pigments end and the canvas begins, the role of various supportive surfaces and devices. It is not Ryman's desire to erase a gesture but to discipline it according to his own sensibility, to admit a certain degree of emotion yet to contain it, sometimes with a fascinating degree of obsessiveness.

DAN FLAVIN
Untitled (for Robert, with fond regards),
1977
Pink, yellow, and red fluorescent light,
96 x 96 inches
Purchase, with funds from the Louis and Bessie Adler Foundation, Inc., Seymour M. Klein, President, the Howard and Jean Lipman Foundation, Inc., by exchange, and gift of Peter M. Brant, by exchange
78.57

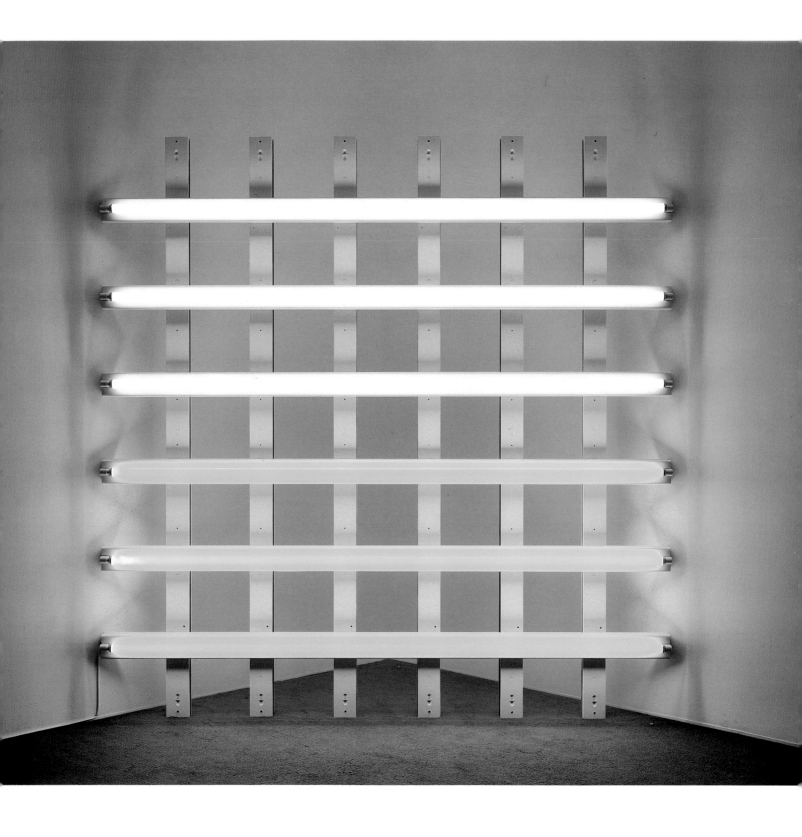

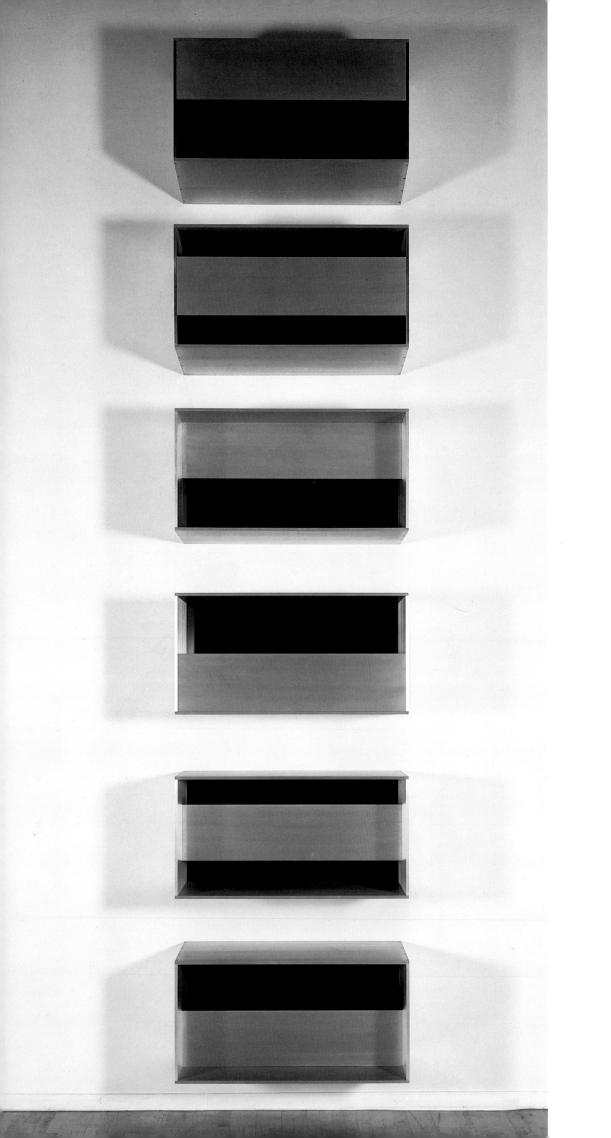

DONALD JUDD
Untitled, 1984
Aluminum with blue plexiglass over b[...]
plexiglass, six pieces, 19^{11}/$_{16}$ x 39^{3}/$_{8}$ x 1[...]
inches each
Purchase with funds from the Brown
Foundation, Inc. in memory of Marga[...]
Root Brown 85.14a-f

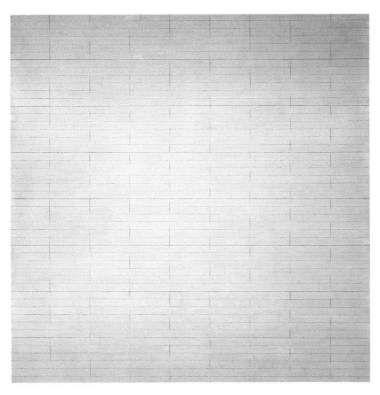

AGNES MARTIN
Untitled #11, 1977
Graphite and gesso on canvas,
72 x 72 inches
Gift of The American Art Foundation 77.44

ROBERT RYMAN
Carrier, 1979
Oil on cotton with metal brackets,
81 ½ x 78 inches
Purchase, with funds from the National
Endowment for the Arts and the Painting
and Sculpture Committee 80.40

Brice Marden's seductively painted canvases appear to have a great deal in common with Minimalist aesthetics, but his is a slightly different turn of mind, one admitting references to places, objects, and experiences outside the immediate physical realm of the work of art. In his encaustic paintings of the 1960s and 1970s, he lingered over the translucent softness of his materials, turning the quietly minimal colors of his individual panels into opportunities for sensual reverie. In *Number One* (1981–84), he returns to oil on canvas to create a massively architectonic structure reminiscent of ancient post-and-lintel architecture in all its simplicity.

By the early 1970s, the vocabulary of Minimalist art was established in American art and criticism. Significant departures from it were charted by artists such as Richard Serra, whose *Left Corner Rectangles* of 1979, with its abutting planes of deep black pigment, pushes the corner of the room back so far that it seems to dissolve. In his often quoted essay "Sentences on Conceptual Art, 1968," Sol LeWitt declared that "the idea is the machine that makes the art." LeWitt focuses on the idea and the work of art, observing just how they are related and different. In our recently acquired *Five Towers* (1986), an evident relationship exists between LeWitt's concept for the work and our experience of it. The concept behind it is quite clear and simple: the same unit is repeated in ever increasing intervals in clearly stated increments. It can be described in simple instructions or in an elementary mathematical formula. However, our physical experience of the work is far from formulaic. It has intriguing interior perspectives, and many shadows and right angles appear to bend when viewed from the side. LeWitt's interest is not optical but theoretical; he wishes to dispel something of the certainty of form and content inspired by the successes of Minimalism and to allow a degree of wonder to enter the arena of serious contemporary art. His is an ambition shared by many artists today whose work would be called Post-Minimalist.

Installation view, clockwise from front: Donald Judd, *Untitled*; Richard Serra, *Left Corner Rectangles*; Brice Marden, *Number One*.

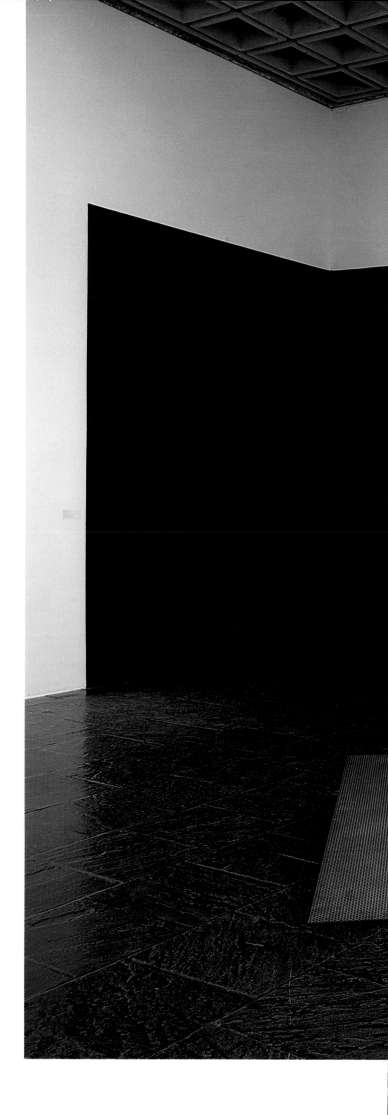

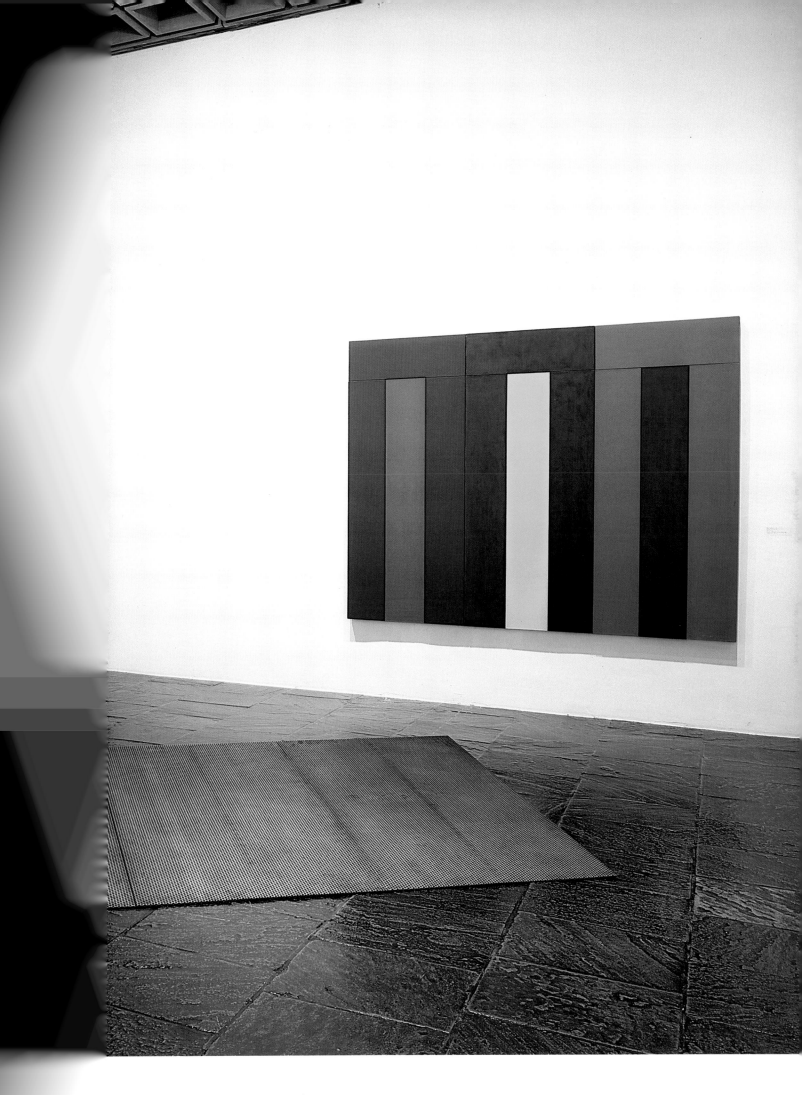

red, *n.* [ME. *red, redde*; AS. *read*; akin to G. *rot*, ON. *rauthr*: from same root come also L. *rutilus, rufus, ruber*, Gr. *erythros*, W. *rhwdd*, Ir. and Gael. *ruadh*, also Sans. *rudhira*, blood.]

1. a primary color, or any of a spread of colors at the lower end of the visible spectrum, varying in hue from that of blood to pale rose or pink.

2. a pigment producing this color.

3. [*often* R–] [senses *a* and *b* from the red flag symbolizing revolutionary socialism.] (a) a political radical or revolutionary; especially, a communist; (b) a citizen of the Soviet Union; (c) [*pl.*] North American Indians.

POST-MINIMALISM

If imitation is a sincere form of admiration, the American artists who began to exhibit in the mid-1960s had a grudging respect for their immediate predecessors. Critics called some of this work "Post-Minimalism," noting its resemblance to Minimalism but also its significant deviations. In the minds of many younger artists, such as Eva Hesse, Sol LeWitt, Bruce Nauman, Robert Smithson, and Richard Tuttle, contemporary art had begun to embody rather than critique the materialistic values of American society. The work of the Pop and Minimalist artists had acquired a matter-of-fact sophistication they fully understood but did not wish to emulate.

Minimalists had endeavored to remove their art from imaginative associations or narratives, to focus the viewer's attention on physical experiences in the immediate present. Post-Minimalists brought back a host of possible readings for a single work without making that work merely illustrative. In *Drift III* (1965), *Fountain* (1965), and other early works, Richard Tuttle

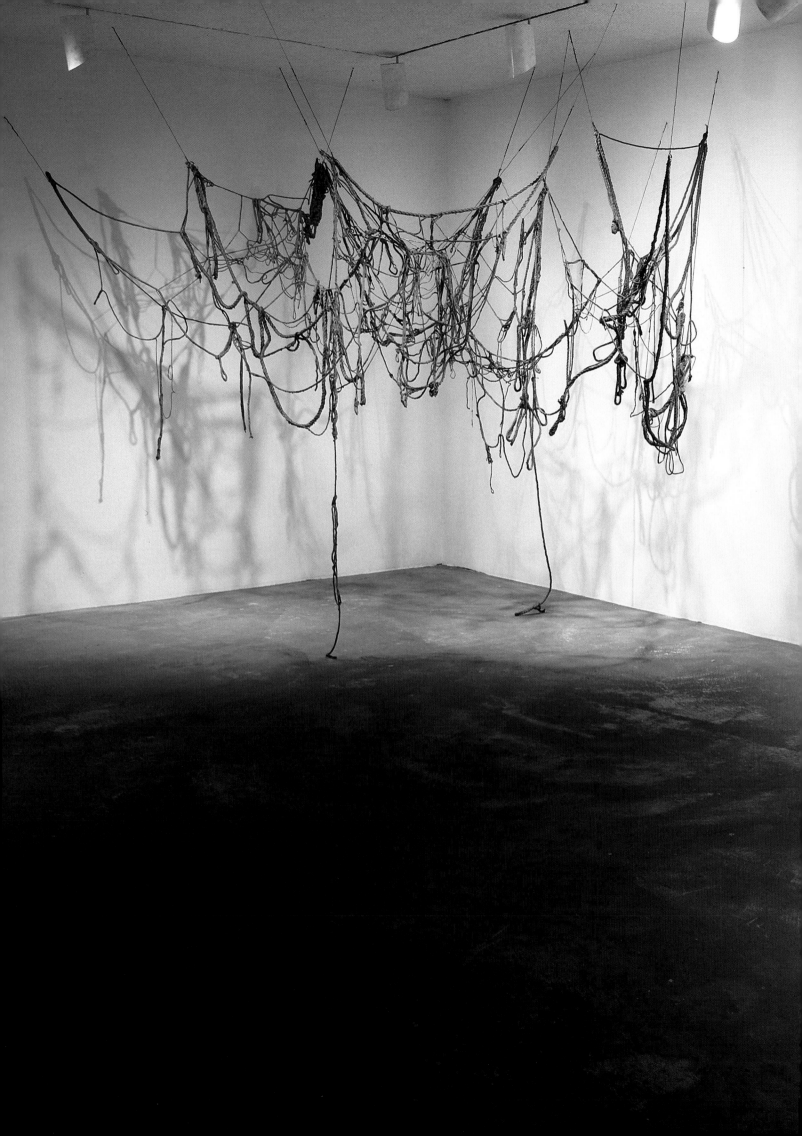

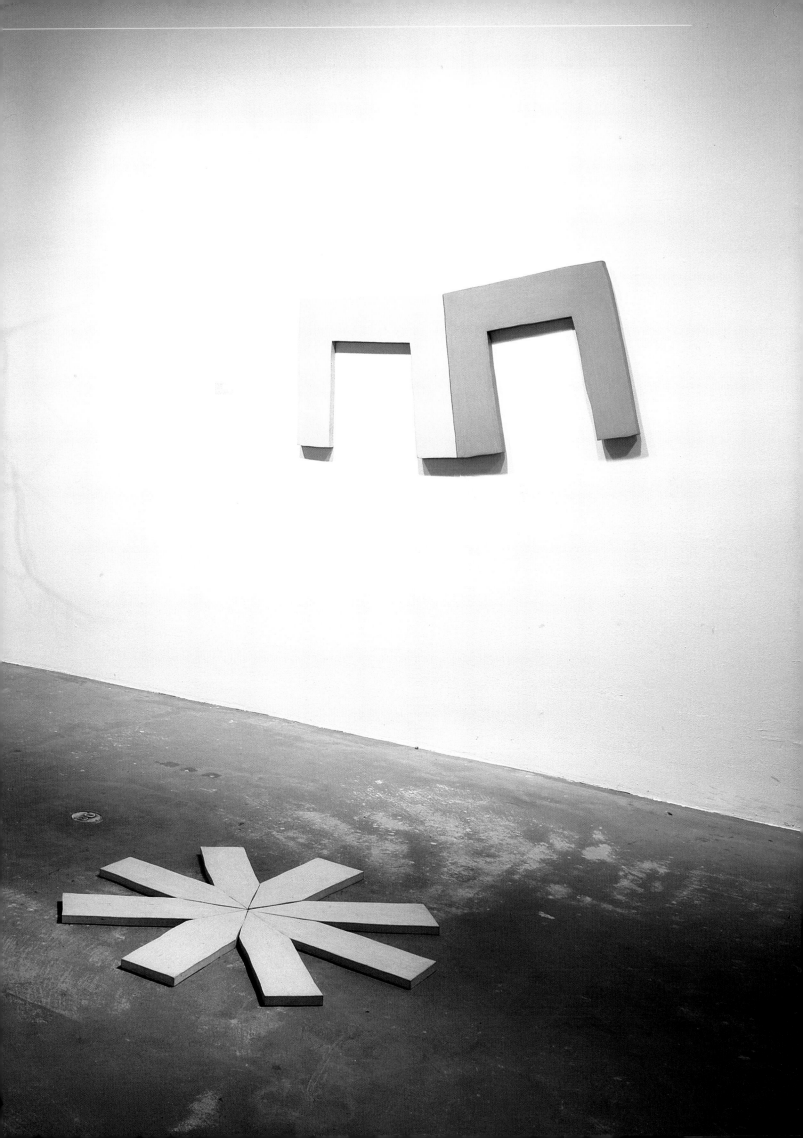

turned the formal language of Minimalism inside out. *Drift III* is a handmade work in wood, whose soft edges and irregular contours indicate a purposeful departure from the hard-edged industrial forms created by the Minimalists. Painted mauve and a soft shade of green, it hangs on the wall like a painting but also has the dimensionality and weight of sculpture. Minimalist art was often massive and imposing, dominating and defining the spaces of a room. Tuttle's *Fountain*, with arrowlike, irregular wooden forms, seems utterly fragile and vulnerable in its position on the floor. These wood pieces, whose softened contours are placed dramatically within a gallery environment, command attention like an audible whisper in a concert hall.

Eva Hesse's early drawings are enriched by her subtle sense of humor as well as her implicit commentaries on Pop and Minimalist art. In *Untitled* (1966), she set up a small grid and filled it with six concentric circles, reminiscent of Jasper Johns' painted targets but also resembling mounds of earth, breasts, and other circular forms frequently found in nature. Carefully and deliberately, Hesse created an evenly rhythmic surface so that no part of the drawing assumes dominance over another. It is this equality of viewing that establishes and preserves multiple layers of allusion in the work.

Vulnerability and variability are built into the composition and materials of Hesse's *Untitled (Rope Piece)* (1969–70). Recalling the sweeping fields of Pollock's calligraphy and commanding the three-dimensional space of a room, the work should seem self-confident. Instead, the familiar natural materials of the rope and the translucent and bumpy latex with its fleshy connotations remind us of the transient character of living things.

Joel Shapiro's sculpture evinces very close ties to Minimalist form. But he also felt a need to reengage imagery in simple yet sophisticated forms — houses, people, the flat planes of a landscape. A work such as *Untitled (House on Field)* (1975–76) establishes a small and abstracted world so removed from reality that it functions as a sign recalling the elemental and universal role that these forms have played in human history. We read the moving figure of Shapiro's *Untitled* (1980–81) as the

underlying dynamic structure of a figure conceived as geometry, an abstracted everyman, but not an automaton. On a larger scale, in vivid flat colors, Elizabeth Murray creates another kind of intimacy in her painting *Children Meeting* of 1978. The entire work seems to be in a state of gentle animation as large rounded forms collide playfully with one another.

The large scale and strangely illusionistic materials employed in Richard Artschwager's *Organ of Cause and Effect III* (1986) invite the viewer to play a mental game. A more highly developed and complex version of his unplayable pianos of the 1960s, this organ is made of plastic materials claiming to be wood, reed, and ivory but fooling the eye very little indeed. Like a grand piece of furniture in a Surrealist's dream, it focuses on the mind's transformative capabilities and powers of fantasy. Minimalist artists had used industrial materials, but never with this purpose or with such provocative results.

JOEL SHAPIRO
Untitled (House on Field), 1975–76
Bronze, 3 ½ x 28 ¾ x 21 ½ inches
Purchase, with funds from Mrs.
Oscar Kolin 76.22

EVA HESSE
Untitled, 1966
Ink wash on ragboard, 9 ¹¹/₁₆ x 7 inches
Purchase, with funds from David J. Supino
in honor of his parents, Muriel and Renato
Supino 87.51

Overleaf
JENNIFER BARTLETT
Falcon Avenue, Seaside Walk, Dwight Street, Jarvis Street, Green Street, 1976
Enamel on steel, baked enamel, and silkscreen grid, 51 x 259 inches
Purchase, with funds from the Louis and Bessie Adler Foundation,
Inc., Seymour M. Klein, President, and the National Endowment for
the Arts 77.22

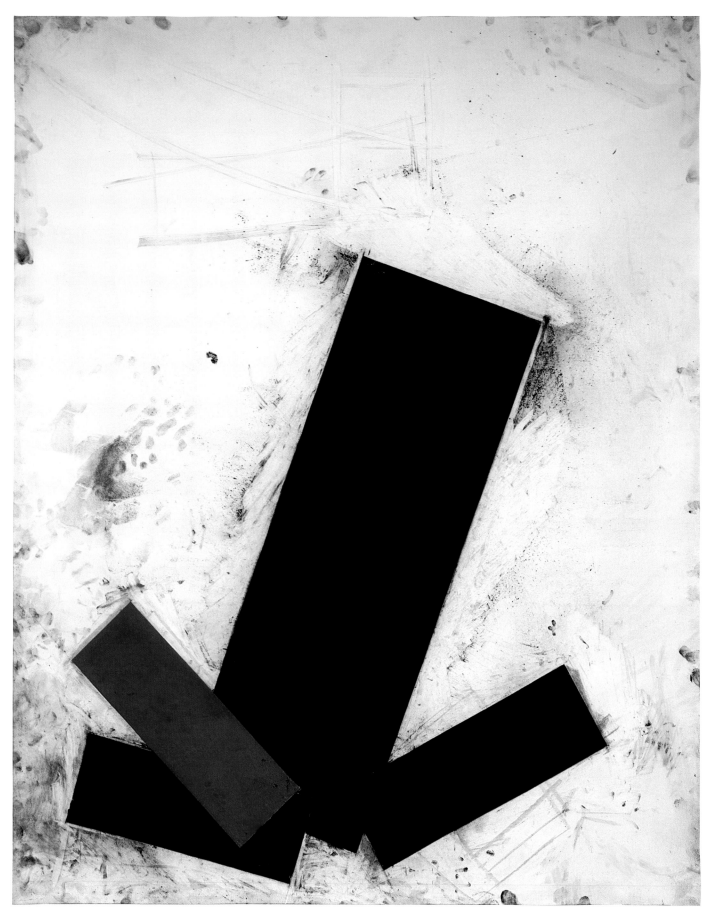

JOEL SHAPIRO
Untitled, 1987
Charcoal and chalk on paper, 53 ⅛ x 42⁹⁄₁₆ inches
Purchase, with funds from Mrs. Nicholas
Millhouse and the Drawing Committee 88.21

Imaginative reverie is also encouraged by the lyrical, painterly passages in Jennifer Bartlett's *Falcon Avenue, Seaside Walk, Dwight Street, Jarvis Street, Green Street* of 1976, a large work made up of individual steel squares painted with enamel. The use of modular units to compose a larger whole was a common feature of Minimalist art. Here Bartlett uses the sequence of individual squares to develop the larger composition as a semi-abstract narrative. As the title suggests, we walk down several avenues, some full of calmly simplified houses, yards, and trees, others intensely calligraphic, each grouping a reminiscence of California and New York neighborhoods she lived in at various times in her life.

The late 1960s was a period of historic social and political change in America, when many began to question the limits of industrial technology, human sexuality, and the American role in global political conflict. Some of the artists who addressed political and social issues did so with great eloquence, particularly those who concerned themselves with the growing concern over the deterioration of the environment. Robert Smithson's earth projects grew out of his involvement with Minimalist forms—his desire to use them in outdoor landscapes to explore the dynamic ecological systems of nature. His work depended, in part, on the physical and chemical processes of nature, but it served as an important symbolic reminder of nature's longevity and power in the face of man's temporary and fragile creations.

Since the direct realization of large-scale outdoor projects was often impossible, drawings played a major role in the early evolution of Smithson's art. The drawing *Mud Flow* is a proposal of 1969 for

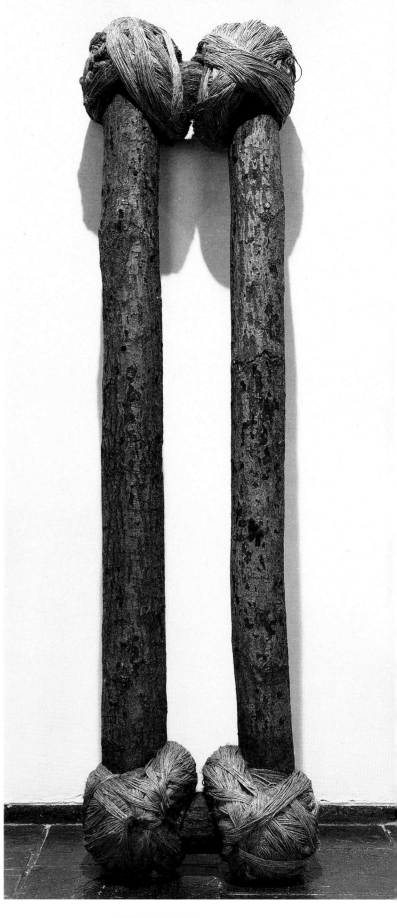

JACKIE WINSOR
Bound Logs, 1972–73
Wood and hemp, 114 x 29 x 18 inches
Purchase, with funds from the Howard and Jean Lipman Foundation, Inc. 74.53

179

MICHAEL HEIZER
Untitled, 1969
Photograph, graphite, and watercolor on
paper, 39 x 30 inches
Gift of Norman Dubrow 80.26.1

ROBERT SMITHSON
Mud Flow, 1969
Crayon and felt-tip pen on paper,
17 ½ x 23 ¾ inches sight
Gift of Norman Dubrow 77.99

a sculpture that would take its forms from the motion of earth flowing down an inclined plane, an emulation of processes occurring on a much larger scale in landscapes everywhere in the world. How very different such a concept is from the hard-edged industrial forms of Minimalism and yet how impossible it would be to imagine this kind of work without the prelude of Minimalist sculpture, with its aspirations to the scale and stature of architecture.

Michael Heizer's *Untitled*, a drawing of 1969, employs photographic imagery as well as hand-drawn and painted areas to suggest the scale and drama of a work designed to be excavated in a vast stretch of the Western desert. Heizer was able to build some of his projects in the natural landscape, in lightly inhabited areas where land was available and where monumental works of sculpture would be undisturbed by human activity. The earth projects that Smithson, Heizer, and others created in the late 1960s and 1970s often emulated or even rivaled ancient sites dedicated to religious rituals. These contemporary works were often attempts to recover the ritualistic and commemorative functions of art in a secular age when practicality, economics, and technology dictated architectural forms.

Here and abroad, the image of the contemporary artist changed during the 1960s. Once perceived as a romantic individual moved by private feelings, the artist came to be seen as a philosopher or technician whose art was directed by concepts and who explored modes of communication. Many artists began to ask just how works of art communicated with their audiences and to investigate the interactions of art and language. In time, the term Conceptual Art was used to describe a way of working that stressed the idea or concept for the piece as well as its physical existence as a work of art. Conceptual Art included works realized entirely within the medium of language, performances that took place in real time, leaving behind nothing more than a memory or a photographic documentation, and works that existed in a temporal framework, such as Robert Smithson's famous *Spiral Jetty* of 1970, slowly eroding until they vanished from view.

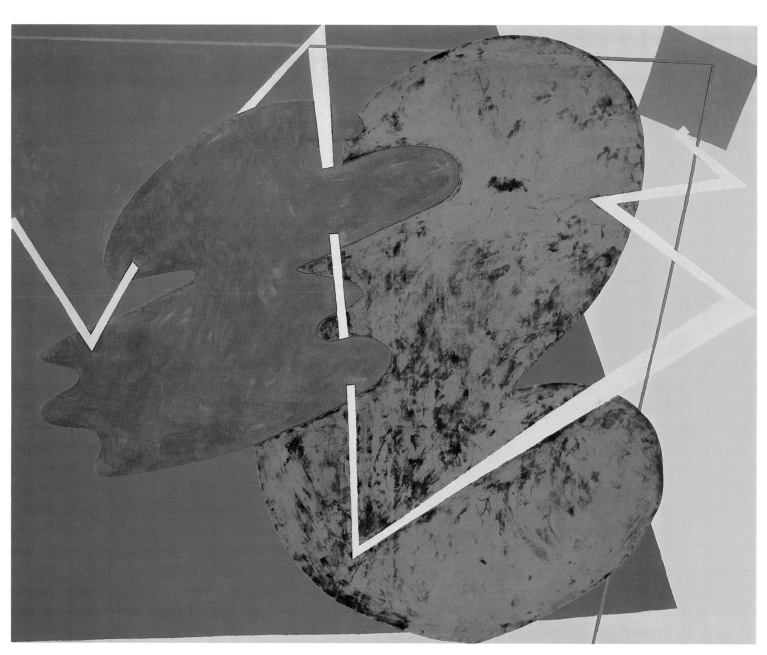

ELIZABETH MURRAY
Children Meeting, 1978
Oil on canvas, 101 x 127 inches
Purchase, with funds from the Louis and
Bessie Adler Foundation, Inc., Seymour
M. Klein, President 78.34

Sol LeWitt, an early explorer of the intricate and sometimes mysterious interaction of concept and form, said in an often quoted essay of 1968, "the idea is the machine that makes the art." Written instructions are the generative force behind LeWitt's wall drawing *A six-inch (15 cm) grid covering each of the four black walls. White lines to points on the grids* (1976). His instructions contain a few simple graphic elements with clearly defined limits of variation. Never exactly the same, the executed drawings may be said to be the authentic creation of the artist, whose concept dictated their form and character. It is an amusing and thought-provoking paradox that brief instructions can often produce complex, almost indecipherable drawings, while a verbal description of a simple line situated in space is often quite long and difficult to envision. LeWitt demonstrates time and time again that concepts and objects are related but not identical, that the physical and mental realms exist in a mysterious counterpoint in life as well as in art.

Joseph Kosuth's "*Titled (Art as Idea as Idea)*" (1967) is a speculative, visual-verbal encounter suggesting alternative readings. On the black surface of this photographic enlargement, the word RED appears in white type with a dictionary definition to amplify its meaning. Had Kosuth chosen a red field for the background, the work might be seen as a tautology. In this balance, however, our experience is almost entirely an intellectual one based on prior associations. Red is a color, a historical term for radical Socialists or Communists, an indelicate racial description of Native Americans, and much more. Kosuth consciously frustrates the viewer's assumption that a painting is concerned with color on a painted plane. He and other Conceptual artists were urging a more thoughtful consideration of language and images in all aspects of life. The dry, severe character of this early work served as something of a purgative, dismissing romantic assumptions about the correspondences of private emotions and graphic expressions in painting.

The social and political turmoil of the late 1960s prompted many changes in American life, especially in the private lives of individuals. The mood of self-examination it generated was not confined to the young but touched many generations, as can be seen in the later life and work of the painter Philip Guston. By the late 1960s, he had a secure historical position within the New York School and was renowned for his lyrical, often elegiac and tonal paintings. Like so many of the early innovators of the New York School, he had begun in the 1930s as a figurative painter involved with social themes of the Depression and the American Scene. After World War II, he adopted the more open-ended and speculative language of gestural abstraction, finding his own poetic voice within a range of controlled marks on darkened, gray fields that function like the vibrato of a cello against the warm, insistent rhythms of his calligraphy.

In 1969, with an old man's urgency and uncommon courage, Guston risked his fixed position as an elder statesman in the world of art and embarked on a series of figurative drawings and paintings. They were not well received at their debut. Guston had brought back into his art a host of characters from his earliest paintings —hooded Klansmen committing horrible deeds, baldheaded men who bore some resemblance to the artist himself, people of all races and types drawn in an awkward but expressive style bordering on caricature. Guston's musing on the human condition and contemporary politics had the biting edge of satire, deftly intermixed with his compassion for human fallibility, not least his own. *Cabal* (1977), a work from this phase of his career, represents a group of plotting characters engaged in a secret plan. They express the semi-comic spirit of a group of children playing at warfare yet have an undercurrent of serious intent common to all plots, real and fictional. By the later 1970s, at the very end of his life, these paintings found their most appreciative audience among the young artists of America and Europe. They saw in Guston's sensitive use of crude and expressive images an encouraging signal for their own explorations of fictional and narrative imagery.

Installation view, clockwise from front:
Joel Shapiro, *Untitled*; Robert Therrien, *No Title*;
Philip Guston, *Cabal*; Bryan Hunt, *Step Falls*.

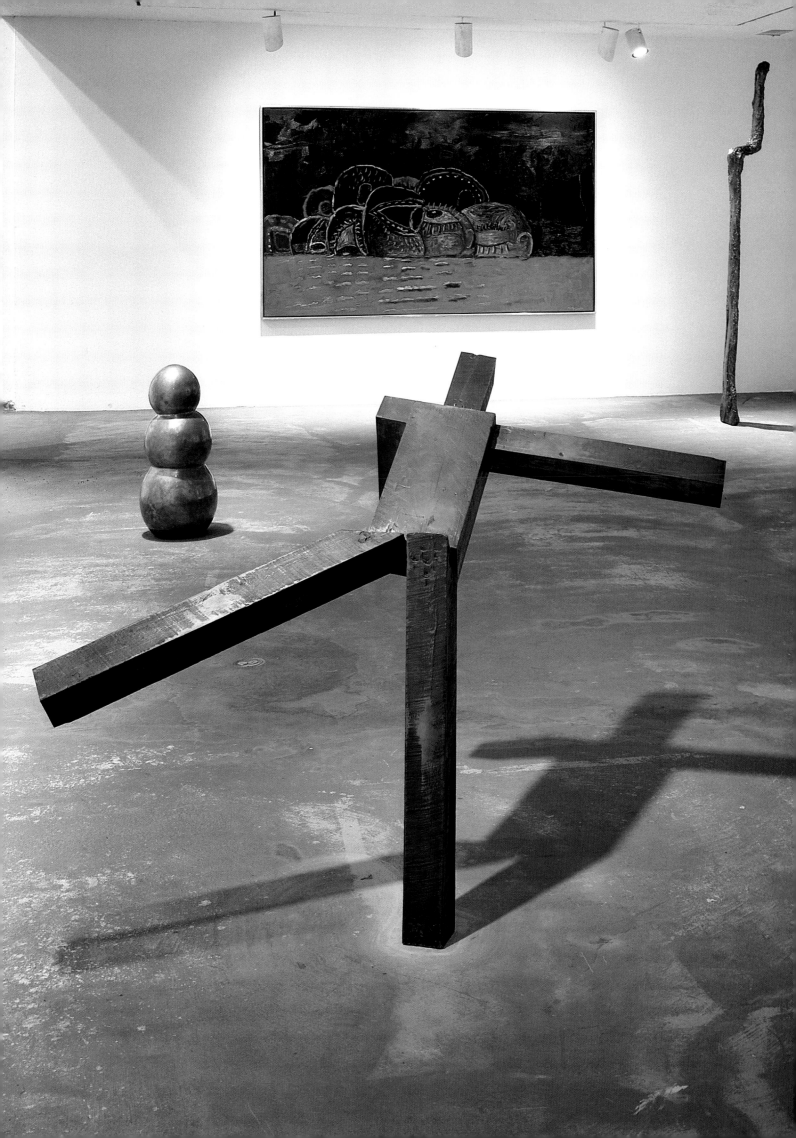

C E R T I F I C A T E

This is to certify that the Sol LeWitt wall drawing
number ___289___ evidenced by this certificate is authentic.

```
A six-inch (15 cm) grid covering each of the four
black walls.  White lines to points on the grids.
1st wall:  24 lines from the center;
2nd wall:  12 lines from the midpoint of each of
           the sides;
3rd wall:  12 lines from each corner;
4th wall:  24 lines from the center, 12 lines from
           the midpoint of each of the sides, 12
           lines from each corner.
(The length of the lines and their placement are
determined by the draftsman.)

White crayon lines, black pencil grid, black walls
First Drawn by:  Jo Watanabe
First Installation:  Detroit Institute of Arts,
                 Detroit, MI.  July, 1976
First Installation 4th wall:  Museum of Modern Art,
                 New York, NY.
                 January, 1976
First Drawn by:  Jo Watanabe, Ryo Watanabe
```

This certification is the signature for the wall drawing and must

accompany the wall drawing if it is sold or otherwise transferred.

Certified by _____*Sol LeWitt*_____

Sol LeWitt

© Copyright Sol LeWitt_____
 Date

Sol LeWitt, certificate of authenticity and
diagrams for *A six-inch (15 cm) grid . . .*,
1976.

D I A G R A M

This is a diagram for the Sol LeWitt wall drawing number *289 1/4* . It should accompany the certificate if the wall drawing is sold or otherwise transferred but is not a certificate or a drawing.

D I A G R A M

This is a diagram for the Sol LeWitt wall drawing number *289 2/4*. It should accompany the certificate if the wall drawing is sold or otherwise transferred but is not a certificate or a drawing.

D I A G R A M

This is a diagram for the Sol LeWitt wall drawing number *289 3/4*. It should accompany the certificate if the wall drawing is sold or otherwise transferred but is not a certificate or a drawing.

D I A G R A M

This is a diagram for the Sol LeWitt wall drawing number *289 4/4*. It should accompany the certificate if the wall drawing is sold or otherwise transferred but is not a certificate or a drawing.

NEO-EXPRESSIONISM AND CONCEPTUAL NARRATIVE

JONATHAN BOROFSKY
*Man in Space II at 2,783,196 and
2,783,197, 1982*
Acrylic on canvas and wall with
newspaper, photograph, plastic ring,
string, and motor, 129⅛ x 120 x 19
inches overall
Purchase, with funds from the Louis and
Bessie Adler Foundation, Inc., Seymour
M. Klein, President 82.26a-e

During the 1980s American artists were challenged by the prominence of European Neo-Expressionists whose massive, pigment-encrusted canvases initiated an important period of historical revisionism and self-scrutiny. In Germany, Italy, and Spain, artists eagerly seized upon the postwar period, with its physical and emotional reconstruction, to understand and to make peace with their own national identities.

This search for national cultural identity prompted a revival of national styles of the early twentieth century: Expressionism in Germany, Futurism and Metaphysical painting in Italy, Expressionist Abstraction in Spain. When these styles were borrowed or quoted, it was often in the spirit of questioning or parody. Clearly it was not desirable or possible to return to the early days of modernism or to national schools of art. Younger artists, in America as well as Europe, also expressed widespread skepticism about the utopian idealism and mysticism of early twentieth-century art. Even the modernist myth of the self had little credence among them. And when they

ERIC FISCHL
A Visit To/A Visit From/The Island, 1983
Oil on canvas, two panels,
84 x 168 inches overall
Purchase, with funds from the Louis and
Bessie Adler Foundation, Inc., Seymour
M. Klein, President 83.17a-b

used imagery, they did so fully conscious of its fictive character. It became their task to manipulate and analyze these fictions, to scrutinize and expose the hidden meanings behind national symbols and cultural myths; in this process, they created an art often brutally critical and highly sophisticated.

In America, Expressionism was most often associated with the gestural style of Abstract Expressionism and its self-revealing exploration of unmediated private emotion. Abstract Expressionism depended for its authority and legitimacy on an assumption of authenticity—that the work was an urgent communication between artist and viewer. But in the early 1980s, the Neo-Expressionists introduced painting that involved the broken brushwork and heroic scale of Abstract Expressionism yet offered no claim to authenticity or self-revelation. Instead, this art presented troubling, paradoxical situations and open-ended, interrupted narratives with no fixed meanings. A work such as Eric Fischl's *A Visit To/ A Visit From/The Island* (1983) depicts two perspectives, in two completely different ranges of color, of an island paradise—one that of privileged vacationers enjoying the water and the sun, the other the desperate plight of natives caught in a natural or man-made disaster. Fischl's title, with its double layer of meaning, suggests that one perspective is insufficient, that both sides of this split-focus painting are true, or perhaps neither one.

In David Salle's *Sextant in Dogtown* (1987), an even more fragmented narrative is established through divisions of the canvas, abrupt changes in color and style, and the positioning of fragments of historical works of art adjacent to erotic scenes. The undressed and undressing women in the lower register of the painting are rendered in an unnatural grisaille. We see only their bodies, not their faces, and experience their corporeality as voyeurs. The carved wooden man holding sextant, a well-known piece of American folk art, takes up his eager stance atop the upper panel, his presence strangely artificial even though the actual sculpture

has great naive charm. A contorted piece of drapery like that of a loincloth in a *Crucifixion* painting hovers within the composition, creating a disquieting parallel to the loosely draped garments of the women below. A work such as this reflects the printed, broadcast, and painted images that have invaded daily life, as an unedited stream of thoughts and dreams spills from the artist's memory onto his canvases.

John Baldessari and Nam June Paik were early explorers of the syntax and the heady pace of media imagery. Baldessari's *Ashputtle* (1982) effects a forceful estrangement between the viewer and the familiar scenes of American entertainment reproduced in the cool light of his black-and-white gridded work. Like a television viewer, removed in place and time from the events depicted, Baldessari stands as mute witness to the strange styles of dress, habits, and opinions portrayed in the media as the normal pleasures of everyday life. Nam June Paik celebrates our undeniable fascination with television, that magical, brightly colored box filled with moving images. Endlessly delightful and powerfully persuasive, we tend to look past the box itself toward its inner world. Paik's work is able to convey his rapturous enchantment with television even as he unmasks its strategies of presentation and causes us to rethink our automatic belief in the veracity of the images we see within the glowing box.

More recently, Jenny Holzer has evolved strategies for communicating private messages in public places by employing the devices used by professional advertising technology. Her pithy, sometimes disturbing Truisms are directed toward the individual human conscience. Moving electronic signs such as our *Unex Sign #1* (1983) pose tough problems: "What urge will save us now that sex won't?" Holzer's work, part literature, part social activism, always involved with the visual aspects of contemporary life, appears in various formats. With dramatic clarity, she expresses the often angry skepticism of her generation yet has the courage to assert her own values in a public forum.

TERRY WINTERS
Good Government, 1984
Oil on linen, 101¼ x 136¼ inches
Purchase, with funds from The Mnuchin
Foundation and the Painting and Sculpture
Committee 85.15

JOHN BALDESSARI
Ashputtle, 1982
Eleven black-and-white photographs,
one color photograph, and text panel,
84 x 72 inches overall
Purchase, with funds from the Painting and
Sculpture Committee 83.8a-m

JENNY HOLZER
Unex Sign #1, 1983
Spectrocolor machine with moving
graphics, 30 1/2 x 116 1/2 x 11 5/8 inches
Purchase, with funds from the Louis and
Bessie Adler Foundation, Inc., Seymour
M. Klein, President 84.8

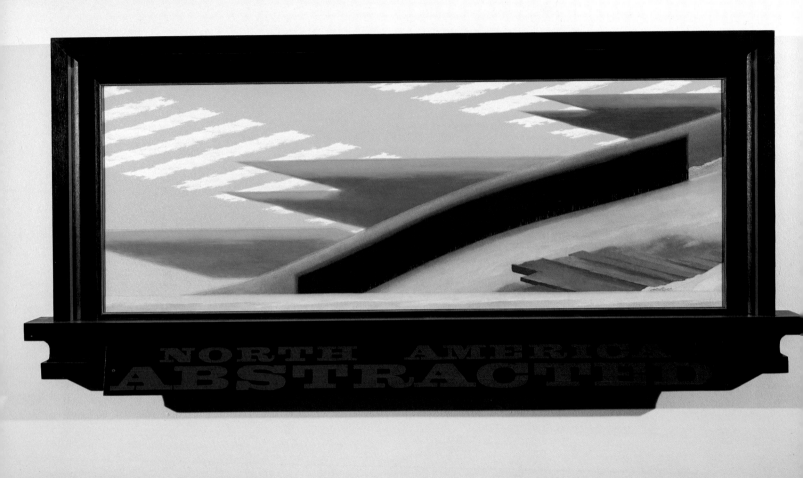

NEIL JENNEY
North America Abstracted, 1978–80
Oil on wood, 38 x 85 ¼ x 5 ¼ inches
Purchase, with funds from the Burroughs
Wellcome Purchase Fund, the Wilfred P.
and Rose J. Cohen Purchase Fund, and the
Painting and Sculpture Committee 83.19

SUSAN ROTHENBERG
For the Light, 1978–79
Acrylic and Flashe on canvas,
105 x 87 inches
Purchase, with funds from Peggy
and Richard Danziger 79.23

BILL JENSEN
The Meadow, 1980–81
Oil on linen, 22 x 22 inches
Purchase, with funds from the Wilfred P.
and Rose J. Cohen Purchase Fund 81.36

Installation view, left to right: Carroll
Dunham, *Pine Gap*; Nancy Graves,
Cantileve; "Vital Signs," 1988.

These artists and many others active
in the 1980s have used figurative images to further philo-
sophical speculations on contemporary life rather than to
merely record or reflect its outward face. Since the late
1960s, Neil Jenney's paintings have been directed toward
a purposeful examination of our relationship with the
natural environment. Jenney's belief that "art is a social
science" has guided his choice of subject matter and his
unique means of communicating with the viewer. He
adopted a crudely primitivist style in his early paintings
and combined almost childish narratives with wordplay.
The boldly painted titles in his work are part of his images,
amplifying their meanings and causing us to ponder them
from many perspectives. *North America Abstracted*
(1978–80) presents a chilling vision of our natural habi-
tat, one that offers little human and animal warmth and
no life-giving vegetation. Its sharply delineated perspec-
tives are tilted toward a gray and vacant terrain, like some
grim parody of the idea of manifest destiny which led our
forebears to conquer the wilderness.

Much of the art of the 1980s is charac-
terized by a sober awareness of the perilous condition of the
national environment. Biomorphic abstraction, a stylistic
mainstay of early modernism central to the work of Jean
Arp, Joan Miró, and others, has reappeared in a new con-
text. Bill Jensen's *The Meadow* (1980–81) is a modestly
scaled canvas filled with the implied energy of soaring
biomorphic forms. Jensen has studied the growth patterns
of plants and animals, finding in them geometric structures
more dynamic and inspiring than the sterile geometries
often proposed by human architects. An anti-geometric
sense of structure pervades the twisting, multicolored
forms of Nancy Graves' sculpture *Cantileve* (1983).

Bryan Hunt's work is often inspired
by the most elusive formal structures of nature. *Step Falls*
(1978), for example, is a waterfall created in the obdurate
material of bronze. Carroll Dunham's *Pine Gap* (1985–86)
employs the random but seductive patterns of wood
veneer as the ground for a spirited exploration of abstract
calligraphy and provocative graphic devices borrowed
from comic strips and pulp magazines. The tones and

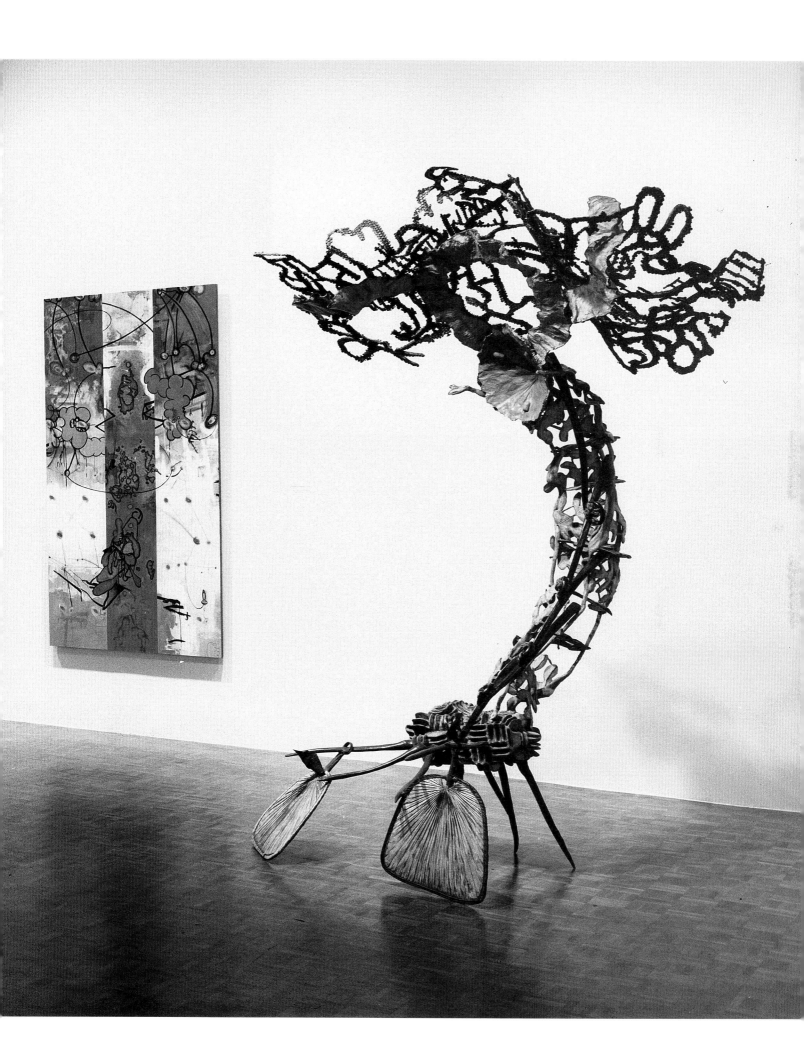

DAVID SALLE
Sextant in Dogtown, 1987
Oil and acrylic on canvas,
96³⁄₁₆ x 126¼ inches
Purchase, with funds from the Painting and
Sculpture Committee 88.8

CINDY SHERMAN
Untitled #146, 1985
Color photograph, 71⁹⁄₁₆ x 48⅛ inches
Purchase, with funds from Eli and
Edyth L. Broad 87.49

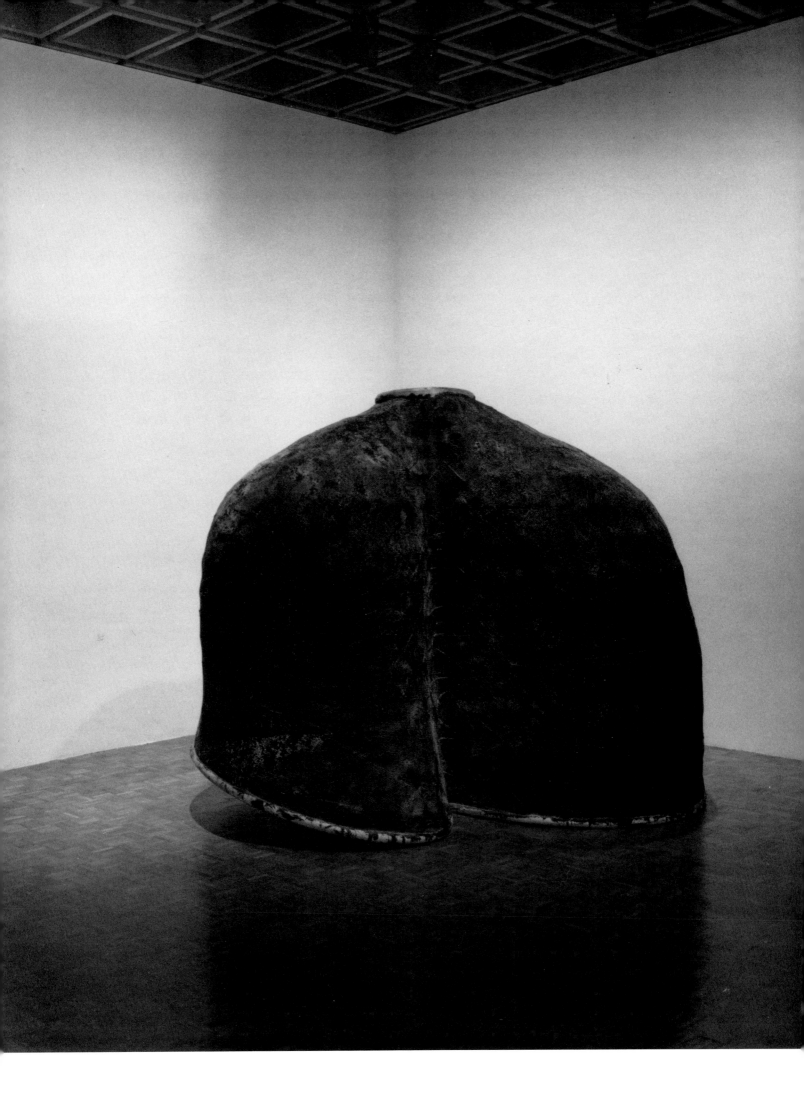

textures of the natural wood dominate *Pine Gap* and force Dunham's graphic additions into sharp relief, creating a poignant interface of nature and culture.

Terry Winters chooses hovering, spinning cellular forms as the major forces of his painting *Good Government* of 1984. Its title refers to the famous fourteenth-century narrative fresco by the Italian master Ambrogio Lorenzetti. Winter's painting charts a turbulent world where biological forms appear in ever changing combinations as they grow, interact, and die. Through his citation of the Lorenzetti painting, which depicted an ideal and orderly structure fostering the prosperity of the human community, Winters suggests both a parallel need for order in nature and man's tendency to upset the complex structures that underlie natural systems.

Martin Puryear's sculpture *Sanctum* (1985) is at once suggestive of a primitive dwelling and of shelters made by living creatures during critical parts of their life and nesting cycles. Strong and yet strangely delicate with its interlace of wire and tar, *Sanctum* embodies the resilient energy of nature's forms while referring to a primitive level of technology still used to solve simple building needs in all parts of the world.

Self-scrutiny has also become an aspect of the art of the 1980s, as in Jonathan Borofsky's self-imposed exercise of counting and writing down each number as the process continues through time. Over many years, Borofsky has included the current tally of his counting project as part of the title of each work of art. The multipanel *Man in Space II at 2,783,196 and 2,783,197* of 1982 contains other self-referential elements, such as a photograph of the work attached to a lower part of one panel. Time itself is part of the subject of Borofsky's art. He has contrasted the real time of a clock ticking and recording the passage of one moment after another with remembered time, which tends to form irregular units in the human memory. Borofsky knows that the creation of a work of art occurs in time and that the work is viewed long after it is made. His awareness of the complexity of this situation has become part of the subject matter of his art.

The photographic work of Cindy Sherman represents a notable instance of self-scrutiny. One of the major themes in modern art has been the search for an authentic self and the expression of individual feeling. Sherman's generation of artists has often engaged in this search while also proving it a hopelessly romantic concept. Her self-portraits are transformations of the self into many different roles and identities, each of them a blatant fiction. She investigates the elastic nature of human identity, not her own personality. The exotic woman of Sherman's *Untitled #146* (1985) is the artist herself wearing stage makeup, fake teeth, and exaggerated plastic breasts. Self-portraits are traditionally excercises in artistic self-analysis, but very little of Sherman's private life or personality can be ascertained through her work.

The artists of the 1980s brought to their agenda an awareness of the burdens of cultural and social history and an attitude of skepticism regarding received ideas and icons, whether derived from long-standing national traditions or from the global network of the mass media. They have endeavored to find secure ground upon which to build a future for American art. Throughout the 1980s, this skeptical spirit of critical analysis, especially self-analysis, has pervaded the arts. The work that has emerged is remarkably diverse in style but consistent in its effort to understand how works of art communicate with an audience and how they express both the typical experiences of a culture and its basic beliefs and aspirations.

MARTIN PURYEAR
Sanctum, 1985
Wood, wire mesh, and tar,
76 x 109 x 87 inches
Purchase, with funds from the Painting and
Sculpture Committee 85.72

Overleaf
Installation view, clockwise from front:
John Newman, *Uprooted Symmetry (The Anchor)*; Richard Artschwager, *Organ of Cause and Effect III*; Sherrie Levine, *Untitled (Golden Knots: 1)*; George Condo, *Untitled*.

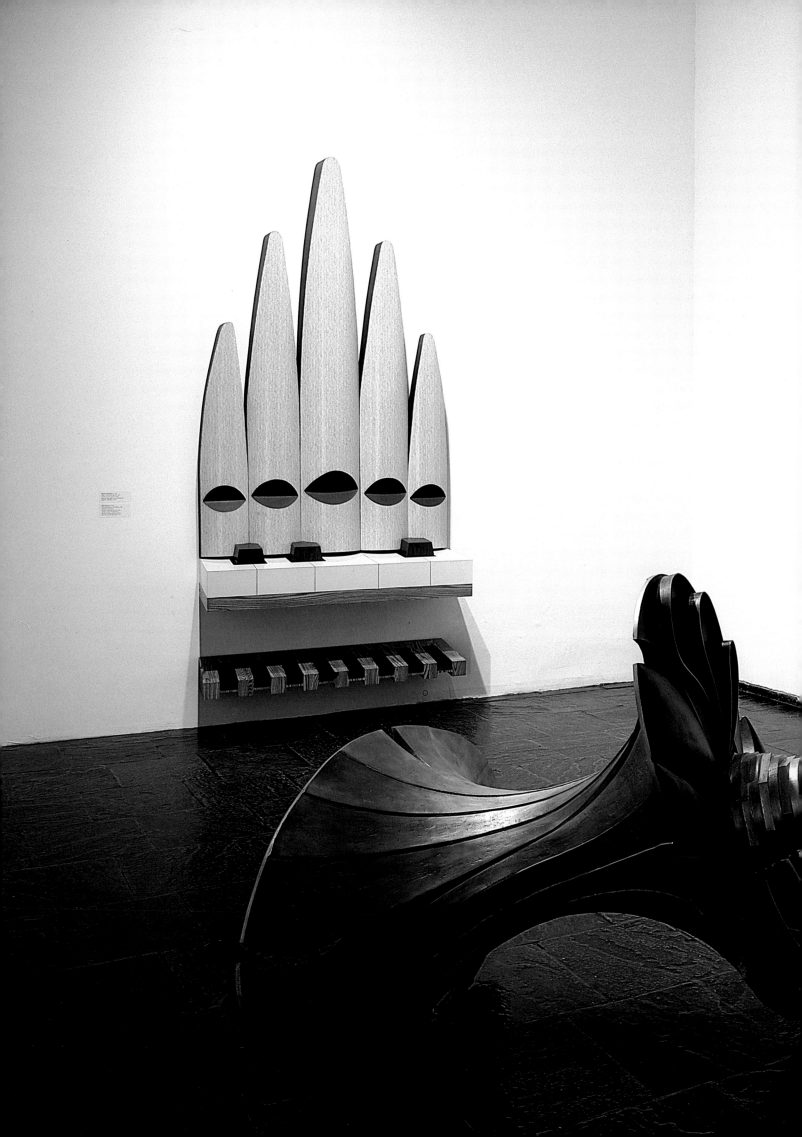

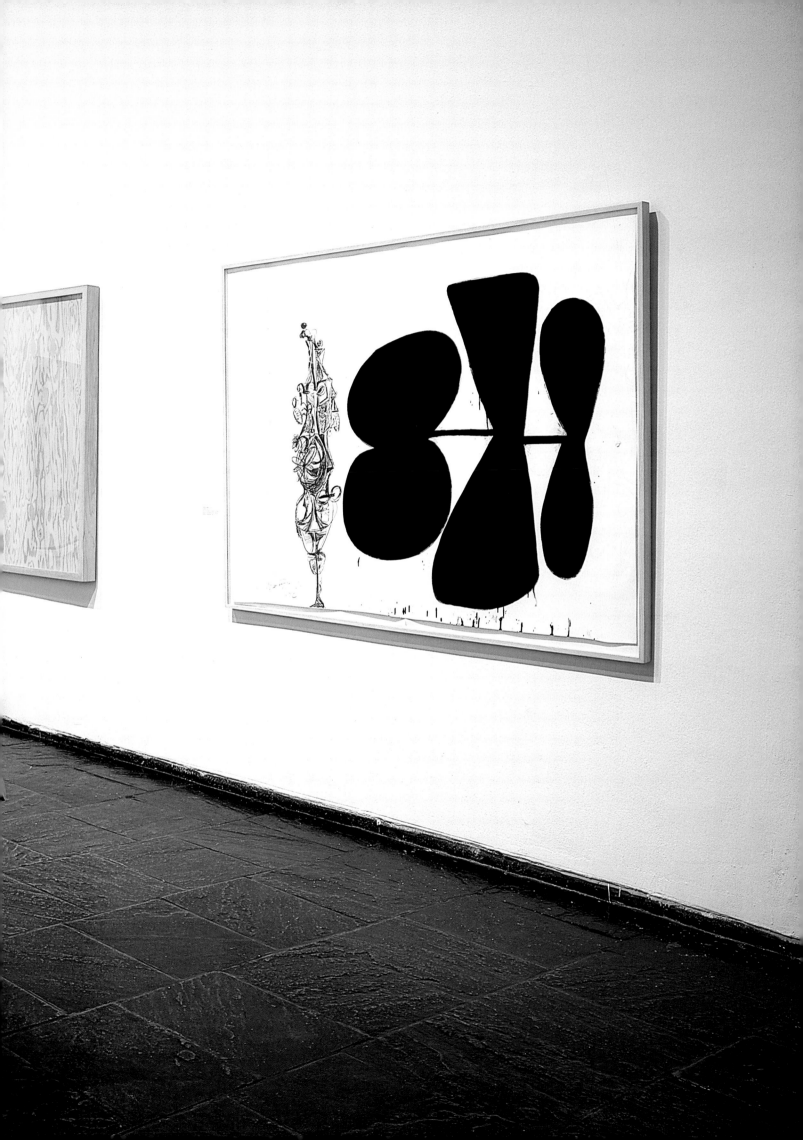

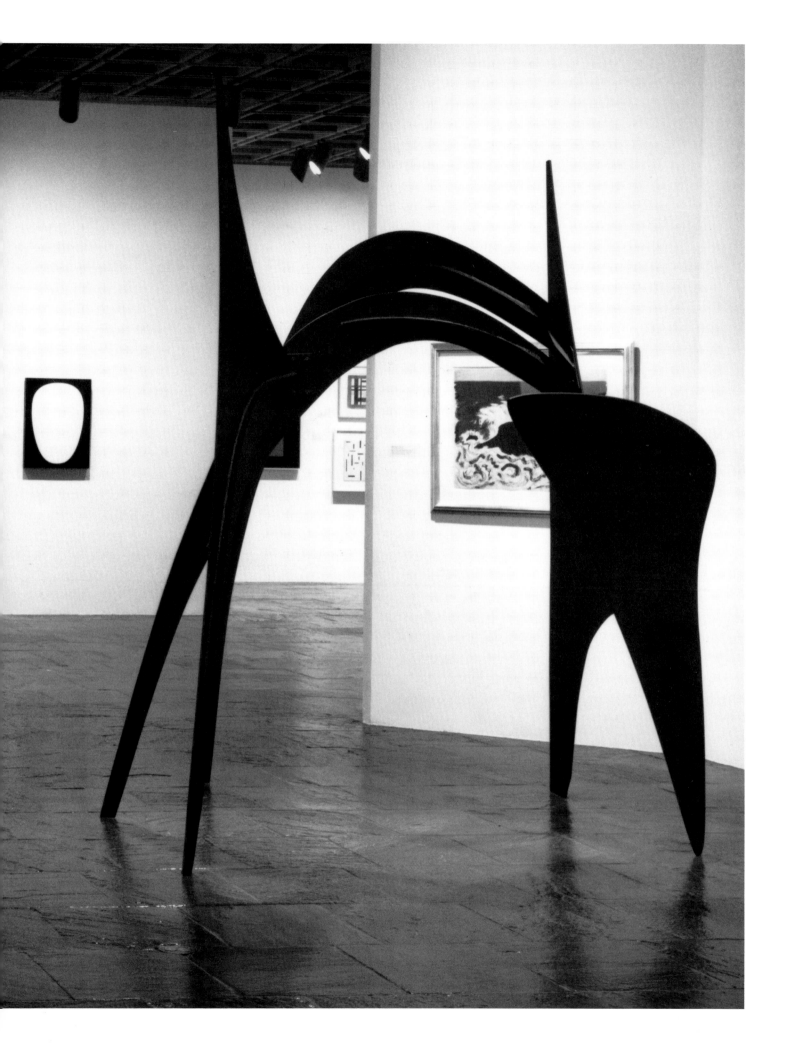

WORKS IN THE EXHIBITION

Dimensions are given first in inches, then in centimeters, height preceding width preceding depth. Dimensions of drawings are overall, unless noted as sight (measured within the frame or mat opening). Dimensions of sculpture do not include base unless it is an integral part of the work.

The accession number of a work refers to the year of acquisition and, after a decimal point, to the sequence of its addition to the Permanent Collection during that year. For example, 88.3 indicates that the work was the third work acquired in 1988. Promised gifts are noted with the letter P and the order of the two figures is reversed. For works accessioned in a group, the year is followed by the group accession number and the individual item number within the group. For example, 87.15.5 and 87.15.6 refer to the fifth and sixth works in a group.

Installation view, clockwise from rear:
Myron Stout, *Untitled (Wind Borne Egg)*;
Milton Avery, *Lone Rock and Surf*;
Alexander Calder, *The Arches*.

JOSEF ALBERS (1888–1976)
Homage to the Square: "White Enclave," 1962
Oil on composition board, 48 x 48 (121.9 x 121.9)
Gift of The Woodward Foundation in memory of Sarah R.
Woodward, wife of Stanley Woodward 85.31

RICHARD ARTSCHWAGER (b. 1923)
Organ of Cause and Effect III, 1986
Formica and latex paint on wood, six units, 129 x 61¼ x 18
(327.7 x 156.9 x 45.7) overall
Purchase, with funds from the Painting and Sculpture Committee
87.6a-f

MILTON AVERY (1885–1965)
Lone Rock and Surf, 1945
Watercolor on paper mounted on cardboard, 22½ x 30¼
(57.2 x 76.8)
Purchase, with funds from S. Sidney Kahn and the Drawing
Committee 84.68

Dunes and Sea II, 1960
Oil on canvas, 52 x 72 (132.1 x 182.9)
Promised 50th Anniversary Gift of Sally Avery P.14.80

JOHN BALDESSARI (b. 1931)
Ashputtle, 1982
Eleven black-and-white photographs, one color photograph, and
text panel, 84 x 72 (213.4 x 182.9) overall
Purchase, with funds from the Painting and Sculpture Committee
83.8a-m

JENNIFER BARTLETT (b. 1941)
*Falcon Avenue, Seaside Walk, Dwight Street, Jarvis Street,
Green Street,* 1976
Enamel on steel, baked enamel, and silkscreen grid, 51 x 259
(129.5 x 657.9)
Purchase, with funds from the Louis and Bessie Adler Foundation,
Inc., Seymour M. Klein, President, and the National Endowment for
the Arts 77.22

WILLIAM BAZIOTES (1912–1963)
Sand, 1957
Oil on canvas, 48 x 36 (121.9 x 91.4)
Lawrence H. Bloedel Bequest 77.1.6

GEORGE BELLOWS (1882–1925)
In the Park (State II), 1916
Lithograph: sheet, 21¼ x 27¹/₁₆ (54 x 68.7); image,
16 x 21⅛ (40.6 x 53.7)
Purchase, with funds from the Vain and Harry Fish Foundation, Inc.
85.32

Dempsey and Firpo, 1923–24
Lithograph: sheet, 21⁷/₁₆ x 25⅛ (54.5 x 63.8); image, 18⅛ x 22⁷/₁₆
(46 x 57)
Purchase, in honor of Charles Simon, with funds given by his friends
from Salomon Brothers on the occasion of his 75th birthday 88.16

THOMAS HART BENTON (1889–1975)
House in Cubist Landscape, c. 1915–20
Watercolor on paper mounted on board, 11¾ x 7¾ (29.9 x 19.7)
irregular
Purchase, with funds from The Hearst Corporation 82.34

Poker Night (from A Street Car Named Desire), 1948
Tempera and oil on panel, 36 x 48 (91.5 x 121.9)
Mrs. Percy Uris Bequest 85.49.2

CHARLES BIEDERMAN (b. 1906)
New York, February 1936, 1936
Gouache on composition board, 29¹⁵/₁₆ x 21³/₁₆ (76 x 53.8)
Purchase, with funds from the Drawing Committee 85.57

Painting, New York, January 1936, 1936
Oil on canvas, 51¼ x 38¼ (130.2 x 97.2)
50th Anniversary Gift of the John I.H. Baur Purchase Fund and the
Wilfred P. and Rose J. Cohen Purchase Fund 80.17

Study for *Sculpture, New York,* 1937
Lithograph: sheet, 24⅞ x 19 (63.2 x 48.3); image, 14⅝ x 11
(37.2 x 28)
Purchase, with funds from the Equitable Life Assurance Society
of the United States Purchase Fund 84.14

Study for *Sculpture, New York,* 1937
Lithograph: sheet, 22⅞ x 15⅞ (58.1 x 40.3); image, 14¾ x 10⅞
(37.5 x 27.6)
Purchase, with funds from the Equitable Life Assurance Society
of the United States Purchase Fund 84.15

OSCAR BLUEMNER (1867–1938)
Study for *Expression of a Silktown (Paterson Centre),* 1914
Charcoal on paper, 29⅛ x 39⅝ (74 x 100.7) sight
Purchase, with funds from the Wilfred P. and Rose J. Cohen
Purchase Fund, the Katherine Schmidt Shubert Purchase Fund, the
Mrs. Percy Uris Purchase Fund, The Norman and Rosita Winston
Foundation, Inc., and the Drawing Committee 89.1

Space Motive, a New Jersey Valley, c. 1917–18
Oil on canvas, 30½ x 40½ (77.5 x 102.9)
Purchase, with funds from Mrs. Muriel D. Palitz 78.2

ILYA BOLOTOWSKY (1907–1981)
Study for mural for *Williamsburg Housing Project, New York,*
c. 1936
Gouache and ink on board, 16¼ x 29½ (41.3 x 74.9)
50th Anniversary Gift of the Edward R. Downe, Jr. Purchase Fund,
Mr. and Mrs. William A. Marsteller, and the National Endowment
for the Arts 80.4

JONATHAN BOROFSKY (b. 1942)
Man in Space II at 2,783,196 and 2,783,197, 1982
Acrylic on canvas and wall with newspaper, photograph, plastic
ring, string, and motor, 129⅛ x 120 x 19 (328 x 304.8 x 48.3)
overall
Purchase, with funds from the Louis and Bessie Adler Foundation,
Inc., Seymour M. Klein, President 82.26a-e

LOUISE BOURGEOIS (b. 1911)
Quarantania, 1941
Wood, 84¾ x 31¼ x 29 (215.3 x 79.4 x 74.3)
Gift of an anonymous donor 77.80

Nature Study, 1984
Bronze, 30 x 14½ x 19 (76.2 x 36.8 x 48.3)
Purchase, with funds from the Painting and Sculpture Committee
84.42

ROGER BROWN (b. 1941)
The Entry of Christ into Chicago in 1976, 1976
Oil on canvas, 72 x 120 (182.9 x 304.8)
Purchase, with funds from Mr. and Mrs. Edwin A. Bergman and the
National Endowment for the Arts, and Joel and Anne Ehrenkranz,
by exchange 77.56

BYRON BROWNE (1907–1961)
Woman with Hairbow, 1937
Graphite on paper, 12 x 9 (30.5 x 22.9)
Gift of an anonymous donor 77.4

CHARLES BURCHFIELD (1883–1967)
Golden Dream, 1959
Watercolor on paper, 31¾ x 38 (80.7 x 96.5) sight
Promised 50th Anniversary Gift of Mrs. Nicholas Millhouse P.11.80

ALEXANDER CALDER (1898–1976)
Calder's Circus, 1926–31
Mixed media, 54 x 94¼ x 94¼ (137.2 x 239.4 x 239.4) overall
Purchase, with funds from a public fund-raising campaign in May
1982. One half the funds were contributed by the Robert Wood
Johnson Jr. Charitable Trust. Additional major donations were given
by The Lauder Foundation, the Robert Lehman Foundation, Inc.,
the Howard and Jean Lipman Foundation, Inc., an anonymous
donor, The T.M. Evans Foundation, Inc., MacAndrews & Forbes
Group, Incorporated, the DeWitt Wallace Fund, Inc., Martin and
Agneta Gruss, Anne Phillips, Mr. and Mrs. Laurance S. Rockefeller,
the Simon Foundation, Inc., Marylou Whitney, Bankers Trust
Company, Mr. and Mrs. Kenneth N. Dayton, Joel and Anne
Ehrenkranz, Irvin and Kenneth Feld, Flora Whitney Miller. More
than 500 individuals from 26 states and abroad also contributed to
the campaign. 83.36.1–56

The Handstand, 1931
Ink on paper, 22¾ x 30¾ (57.8 x 78.1)
Gift of Howard and Jean Lipman 81.23.1

Handstand on the Table, 1931
Ink on paper, 22¾ x 30⅞ (57.8 x 78.4)
Gift of Philip and Lynn Straus 85.50

Juggler with Dog, 1931
Ink on paper, 22¾ x 30¾ (57.8 x 78.1)
Gift of Howard and Jean Lipman 81.23.2

Tumbler on Swing, 1931
Ink on paper, 30¾ x 22¾ (78.1 x 57.8)
Gift of Howard and Jean Lipman 81.23.4

Varèse, 1931
Wire, 13½ x 13¾ x 12¼ (34.3 x 34.9 x 31.1)
50th Anniversary Gift of Mrs. Louise Varèse in honor of Gertrude
Vanderbilt Whitney 80.25

Little Ball with Counterweight, c. 1931
Sheet metal, wire, and wood, 63¾ x 12½ x 12½ (161.9 x 31.8 x 31.8)
Promised 50th Anniversary Gift of Mr. and Mrs. Leonard J.
Horwich P.9.79

Calderberry Bush, 1932
Painted steel rod, wire, wood, and sheet aluminum, dimensions
variable, approximately 88½ x 33 x 47½ (224.8 x 83.8 x 120.7)
Purchase, with funds from the Mrs. Percy Uris Purchase Fund 86.49

Cage within a Cage, c. 1939
Metal, wood, and string, 37½ x 58¾ x 21 (95.3 x 149.2)
Gift of the Howard and Jean Lipman Foundation, Inc. 75.23

Hanging Spider, c. 1940
Painted sheet metal and wire, 49½ x 35½ (125.7 x 90.2)
Mrs. John B. Putnam Bequest 84.41

Constellation with Quadrilateral, 1943
Wood and wire, 15 x 18 x 7¾ (38.1 x 45.7 x 19.7)
50th Anniversary Gift of the Howard and Jean Lipman Foundation,
Inc. 80.28.1

Wooden Bottle with Hairs, 1943
Wood and wire, 22 x 14½ x 10½ (55.9 x 36.8 x 26.7)
50th Anniversary Gift of the Howard and Jean Lipman Foundation,
Inc. 80.28.2

Roxbury Flurry, c. 1948
Painted sheet metal and wire, 100 x 96 x ⅛ (254 x 243.8 x .3)
Gift of Louisa Calder 77.85

The Arches, 1959
Painted steel, 106 x 107½ x 87 (269.2 x 273.1 x 221)
Gift of Howard and Jean Lipman 82.44

Contour Plowing, 1974
Gouache on paper, 29¼ x 43⅛ (74.3 x 109.5)
Gift of the artist 74.91

Four Black Dots, 1974
Gouache on paper, 29½ x 43 (74.9 x 109.2)
Purchase, with funds from the Howard and Jean Lipman
Foundation, Inc. 74.94

FEDERICO CASTELLON (1914–1971)
The Bed, 1937
Graphite on paper, 10¼ x 13 (26 x 33)
Gift of Mr. and Mrs. Benjamin Weiss 78.38

The New Robe #2, 1939
Lithograph: sheet, 15¹⁵⁄₁₆ x 11⅞ (40.5 x 30.2); image, 12⁷⁄₁₆ x 9¹⁵⁄₁₆
(31.6 x 25.2)
Purchase, with funds from the Print Committee 86.24

JOHN CHAMBERLAIN (b. 1927)
Jackpot, 1962
Metal and paper, 60 x 52 x 46 (152.4 x 132.1 x 116.8)
Gift of Andy Warhol 75.52

CHUCK CLOSE (b. 1940)
Phil/Fingerprint II, 1978
Stamp pad ink and graphite on paper, 29¼ x 22¼ (75.6 x 56.5)
Purchase, with funds from Peggy and Richard Danziger 78.55

GEORGE CONDO (b. 1957)
Untitled, 1987
Acrylic, oil, paper, and graphite on paper, 61⁷⁄₁₆ x 80³⁄₁₆
(156.1 x 203.7) irregular
Purchase, with funds from Mr. and Mrs. William A. Marsteller 88.18

HOWARD COOK (1901–1980)
Times Square Sector, 1930
Etching: sheet, 13⅞ x 11½ (35.2 x 29.2) irregular; plate, 11¹³⁄₁₆ X 9⅞ (30 x 25.1)
Gift of Associated American Artists 77.17

JOSEPH CORNELL (1903–1972)
Grand Hôtel Bon Port, 1952
Box construction with painted wood and paper reproductions, 19 x 13 x 3¾ (48.3 x 33 x 9.5)
Promised 50th Anniversary Gift of Mr. and Mrs. Edwin A. Bergman P.15.80

RALSTON CRAWFORD (1906–1978)
Lobster Pots #3, 1960-63
Oil on canvas, 45⅛ x 60¼ (114.6 x 153)
Gift of the artist's son, Neelon Crawford, and purchase, with funds from the Mr. and Mrs. Arthur G. Altschul Purchase Fund, the Mrs. Percy Uris Purchase Fund, and the Painting and Sculpture Committee 87.46

FRANCIS CRISS (1901–1973)
Sixth Avenue El, c. 1937
Oil on canvas, 36 x 41½ (91.4 x 105.4)
Purchase, with funds from the Felicia Meyer Marsh Purchase Fund 82.1

ROBERT CUMMING (b. 1943)
Black Shoe, 1987
Monotype: sheet and image, 29½ x 38 (74.9 x 96.5)
Purchase, with funds from the Print Committee 88.23

JAMES H. DAUGHERTY (1890–1974)
Three Base Hit, 1914
Gouache and ink on paper, 12¼ x 17⅛ (31.1 x 43.5)
Purchase 77.40

STUART DAVIS (1892–1964)
Study for *Egg Beater No. 3*, 1928
Graphite and colored pencil on paper, 17 x 21⅜ (43.2 x 54.3)
Purchase, with funds from the Charles Simon Purchase Fund 80.46

Barber Shop Chord, 1931
Lithograph: sheet, 20³⁄₁₆ x 26 (51.3 x 66); image, 14 x 19 (35.6 x 48.3)
Purchase, with funds from Philip Morris Incorporated 77.84

Sixth Avenue El, 1931
Lithograph: sheet, 15⅞ x 21⅛ (40.3 x 53.7); image, 11¹⁵⁄₁₆ x 18 (30.3 x 45.7)
Purchase, with funds from Mr. and Mrs. Samuel M. Kootz 77.74

Theater on the Beach, 1931
Lithograph: sheet, 15¹³⁄₁₆ x 22⅝ (40.2 x 57.5); image, 11 x 15 (27.9 x 38.1)
Purchase, with funds from Mr. and Mrs. Samuel M. Kootz 77.75

Two Figures and El, 1931
Lithograph: sheet, 20⅛ x 26 (51.1 x 66); image, 11 x 15 (27.9 x 38.1)
Purchase, and gift of Mr. and Mrs. Michael H. Irving, by exchange 77.13

Study for *Bass Rocks*, 1939
Gouache on board, 11⁹⁄₁₆ X 14 (29.4 x 35.6)
Gift of Jerome Zipkin 81.41

Landscape, Bass Rocks, 1941
Serigraph: sheet and image, 13¼ x 17 (33.7 x 43.2)
Purchase, with funds from the Print Committee 88.24

WILLEM DE KOONING (b. 1904)
Untitled, c. 1937
Gouache and graphite on paper, 6¾ x 13¾ (17.2 x 34.9)
Purchase, with funds from Frances and Sydney Lewis 77.34

Manikins, c. 1942
Graphite on paper, 13½ x 16¼ (34.3 x 41.3) sight
Purchase, with funds from the Grace Belt Endowed Purchase Fund, the Burroughs Wellcome Purchase Fund, The Norman and Rosita Winston Foundation, Inc., the Drawing Committee, and an anonymous donor 84.5

Black and White, 1959
Enamel on paper, double sided, 27¼ x 39 (69.2 x 99) sight
Gift in memory of Audrey Stern Hess 75.21

Figures with Bicycle, c. 1969
Graphite on paper, 11½ x 13³⁄₁₆ (29.2 x 33.5)
Gift of the artist 84.16

Clamdigger, 1972
Bronze, 57½ x 24½ x 21 (146 x 62.2 x 53.3)
Gift of Mrs. H. Gates Lloyd 85.51

Untitled (Woman), c. 1974
Charcoal on vellum paper mounted on board, 66½ x 42 (168.9 x 106.7)
Purchase, with funds from the Grace Belt Endowed Purchase Fund, the Wilfred P. and Rose J. Cohen Purchase Fund, the Dana Foundation Incorporated, The List Purchase Fund, The Norman and Rosita Winston Foundation, Inc., and the Drawing Committee 85.23

Untitled, c. 1975–80
Graphite on paper, 11 x 13⅞ (27.9 x 35.2)
Gift of Xavier Fourcade 84.17

Untitled VII, 1983
Oil on canvas, 80 x 70 (203.2 x 177.8)
Partial and promised gift of Robert W. Wilson P.4.84

CHARLES DEMUTH (1883–1935)
Red Gladioli, 1928
Watercolor on paper, 22 x 28 (55.9 x 71.1)
Promised gift of Mr. and Mrs. Laurance S. Rockefeller P.1.87

RICHARD DIEBENKORN (b. 1922)
Ocean Park #125, 1980
Oil on canvas, 100 x 81 (254 x 205.7)
Purchase, with funds from the Charles Simon Purchase Fund, the Painting and Sculpture Committee, and anonymous donors, by exchange 80.36

BURGOYNE DILLER (1906–1965)
First Theme, 1933–34
Oil on canvas, 30¹/₁₆ x 30¹/₁₆ (76.4 x 76.4)
Purchase, with funds from Emily Fisher Landau 85.44

Second Theme, 1938
Graphite and crayon on paper, 12½ x 12¾ (31.8 x 32.4)
Purchase, with funds from The List Purchase Fund 79.5

Untitled, 1944
Collage on board, 15 x 15 (38.1 x 38.1)
Purchase, with funds from the Mr. and Mrs. M. Anthony Fisher
Purchase Fund, Martin and Agneta Gruss, and the Felicia Meyer
Marsh Purchase Fund 82.21

JIM DINE (b. 1935)
Double Isometric Self Portrait (Serape), 1964
Oil with objects on canvas, 56⅞ x 84½ (144.5 x 214.6)
Gift of Helen W. Benjamin in memory of her husband, Robert M.
Benjamin 76.35

MARK DI SUVERO (b. 1933)
Hankchampion, 1960
Wood and chains, 77½ x 149 x 105 (196.9 x 378.5 x 266.7)
Gift of Mr. and Mrs. Robert C. Scull 73.85

Achilles' Heel, 1969
Welded steel and wire, 35 x 40¼ x 40¼ (88.9 x 102.2 x 102.2)
Promised 50th Anniversary Gift of Mrs. Robert M. Benjamin P.4.80

ARTHUR G. DOVE (1880–1946)
The Critic, 1925
Collage, 19¾ x 13½ x 3⅝ (50.2 x 34.3 x 9.2)
Purchase, with funds from the Historic Art Associates of the
Whitney Museum of American Art, Mr. and Mrs. Morton L.
Janklow, the Howard and Jean Lipman Foundation, Inc., and
Hannelore Schulhof 76.9

CARROLL DUNHAM (b. 1949)
Pine Gap, 1985–86
Mixed media on wood veneers, 77 x 41 (195.6 x 104.1)
Purchase, with funds from The Mnuchin Foundation 86.36

Untitled, 1988
Graphite and waxed crayon on paper, 28 x 40 (71.1 x 101.6)
Purchase, with funds from the Drawing Committee in memory
of Victor Ganz 89.2

RICHARD ESTES (b. 1935)
Ansonia, 1977
Oil on canvas, 48 x 60 (121.9 x 152.4)
Purchase, with funds from Frances and Sydney Lewis 77.33

PAUL FIENE (1899–1949)
Bust of Grant Wood, c. 1942
Bronze, 13 x 7½ x 8 (33 x 19.1 x 20.3)
Gift of Mr. and Mrs. George D. Stoddard 81.33.1

R.M. FISCHER (b. 1947)
Max, 1983
Steel, limestone, brass, and electric lights, 86 x 33½ x 33½
(218.4 x 85.1 x 85.1)
Purchase, with funds from the Painting and Sculpture Committee
84.7

ERIC FISCHL (b. 1948)
A Visit To/A Visit From/The Island, 1983
Oil on canvas, two panels, 84 x 168 (213.4 x 426.7) overall
Purchase, with funds from the Louis and Bessie Adler Foundation,
Inc., Seymour M. Klein, President 83.17a-b

DAN FLAVIN (b. 1933)
Untitled (for Robert, with fond regards), 1977
Pink, yellow, and red fluorescent light, 96 x 96 (243.8 x 243.8)
Purchase, with funds from the Louis and Bessie Adler Foundation,
Inc., Seymour M. Klein, President, the Howard and Jean Lipman
Foundation, Inc., by exchange, and gift of Peter M. Brant, by
exchange 78.57

FRITZ GLARNER (1899–1972)
Tondo No. 54, 1960
Oil on masonite, 48 (121.9) diameter
Promised 50th Anniversary Gift of Richard S. Zeisler P.19.79

SIDNEY GORDIN (b. 1918)
April 1953, 1953
Painted steel, 64 x 47½ x 34½ (162.6 x 120.7 x 87.6)
Gift of Raymond J. Learsy 84.71.2

ARSHILE GORKY (1904–1948)
Nighttime, Enigma and Nostalgia, c. 1931–32
Ink on paper, 24 x 31 (61 x 78.7)
50th Anniversary Gift of Mr. and Mrs. Edwin A. Bergman 80.54

Study for *"Mechanics of Flying," Newark Airport Aviation Murals*,
c. 1936
Gouache on paper, 13¼ x 16½ (33.7 x 41.9) sight
50th Anniversary Gift of Alan H. Temple 80.16

Drawing, 1946
Graphite and colored crayon on paper, 19¹/₁₆ x 25¹/₁₆ (48.4 x 63.7)
50th Anniversary Gift of Edith and Lloyd Goodrich in honor of
Juliana Force 82.48

NANCY GRAVES (b. 1940)
Cantileve, 1983
Bronze wth polychrome patina, 98 x 68 x 54 (248.9 x 172.7 x 137.2)
Purchase, with funds from the Painting and Sculpture Committee
83.39

PHILIP GUSTON (1913–1980)
Study for *Conspirators*, 1930
Graphite, ink, colored pencil, and crayon on paper, 22½ x 14½
(57.2 x 36.8) irregular
Purchase, with funds from The Hearst Corporation and The
Norman and Rosita Winston Foundation, Inc. 82.20

Cabal, 1977
Oil on canvas, 68 x 116 (172.7 x 294.6)
50th Anniversary Gift of Mr. and Mrs. Raymond J. Learsy 81.38

Untitled, 1980
Ink on board, 20 x 30 (50.8 x 76.2)
Purchase, with funds from Martin and Agneta Gruss and Mr. and
Mrs. William A. Marsteller 81.6

DUANE HANSON (b. 1925)
Woman with Dog, 1977
Cast polyvinyl, polychromed in acrylic, with mixed media, life size
Purchase, with funds from Frances and Sydney Lewis 78.6

MARSDEN HARTLEY (1877–1943)
Landscape, New Mexico, 1919–20
Oil on canvas, 28 x 36 (71.1 x 91.4)
Purchase, with funds from Frances and Sydney Lewis 77.23

MICHAEL HEIZER (b. 1944)
Untitled, 1969
Photograph, graphite, and watercolor on paper, 39 x 30
(99.1 x 76.2)
Gift of Norman Dubrow 80.26.1

AL HELD (b. 1928)
South Southwest, 1973
Synthetic polymer paint on canvas, 96 x 144 (243.8 x 365.7)
Purchase 73.65

76 C-7, 1976
Colored pencil, graphite, crayon, and felt-tip pen on paper,
27 x 39^{15}/$_{16}$ (68.6 x 101.4)
Purchase, with funds from the Drawing Committee 86.2

EVA HESSE (1936–1970)
Untitled, 1966
Ink wash on ragboard, 9^{11}/$_{16}$ x 7 (24.6 x 17.8)
Purchase, with funds from David J. Supino in honor of his parents,
Muriel and Renato Supino 87.51

Untitled (Rope Piece), 1969–70
Latex over rope, string, and wire, two strands, dimensions variable
Purchase, with funds from Eli and Edythe L. Broad, the Mrs. Percy
Uris Purchase Fund, and the Painting and Sculpture Committee
88.17a-b

JENNY HOLZER (b. 1950)
Unex Sign #1, 1983
Spectrocolor machine with moving graphics, 30^1/$_2$ x 116^1/$_2$ x 11^5/$_8$
(77.5 x 295.9 x 29.5)
Purchase, with funds from the Louis and Bessie Adler Foundation,
Inc., Seymour M. Klein, President 84.8

EDWARD HOPPER (1882–1967)
A Woman in the Sun, 1961
Oil on canvas, 40 x 60 (101.6 x 152.4)
50th Anniversary Gift of Mr. and Mrs. Albert Hackett in honor of
Edith and Lloyd Goodrich 84.31
(not in exhibition)

EARLE HORTER (1881–1940)
The Chrysler Building Under Construction, 1931
Ink and watercolor on paper, 20^1/$_4$ x 14^3/$_4$ (51.4 x 37.5)
Purchase, with funds from Mrs. William A. Marsteller 78.17

BRYAN HUNT (b. 1947)
Step Falls, 1978
Bronze, 114 x 12 x 12 (289.6 x 30.5 x 30.5)
Purchase, with funds from Edward R. Downe, Jr. 78.68

Double Cantata, 1982
Lacquer on paper over wood, 7 x 62 x 7 (17.8 x 157.5 x 17.8)
Promised gift of Mr. and Mrs. M. Anthony Fisher P.1.83

Visitation, 1982
Crayon, graphite, and linseed oil on paper, 83^1/$_2$ x 34^3/$_8$
(212.1 x 87.3) sight
Purchase, with funds from the Wilfred P. and Rose J. Cohen
Purchase Fund 87.42

NEIL JENNEY (b. 1945)
Saw and Sawed, 1969
Acrylic on canvas, 58^1/$_2$ x 70^3/$_8$ (148.6 x 178.8) including frame
Gift of Philip Johnson 77.65

North America Abstracted, 1978–80
Oil on wood, 38 x 85^1/$_4$ x 5^1/$_4$ (96.5 x 216.5 x 13.3)
Purchase, with funds from the Burroughs Wellcome Purchase Fund,
the Wilfred P. and Rose J. Cohen Purchase Fund, and the Painting
and Sculpture Committee 83.19

BILL JENSEN (b. 1945)
Black Line Drawing, 1978
Graphite and charcoal on vellum, 24 x 19 (61 x 48.3)
Purchase, with funds from the Mr. and Mrs. M. Anthony Fisher
Purchase Fund 82.19

The Meadow, 1980–81
Oil on linen, 22 x 22 (55.9 x 55.9)
Purchase, with funds from the Wilfred P. and Rose J. Cohen
Purchase Fund 81.36

JESS (b. 1923)
Young People in Particular Will Find It, 1983
Collage on paper mounted on wood, 21 x 48^1/$_4$ (53.3 x 122.6)
Purchase, with funds from the Drawing Committee 86.17

JASPER JOHNS (b. 1930)
Three Flags, 1958
Encaustic on canvas, 30^7/$_8$ x 45^1/$_2$ x 5 (78.4 x 155.6 x 12.7)
50th Anniversary Gift of the Gilman Foundation, Inc., The Lauder
Foundation, A. Alfred Taubman, an anonymous donor, and
purchase 80.32

Studio II, 1966
Oil on canvas, 70^3/$_8$ x 125^1/$_4$ (178.8 x 318.1)
Partial and promised gift of the family of Victor Ganz in his memory
P.3.88

Racing Thoughts, 1983
Encaustic and collage on canvas, 48 x 75^1/$_8$ (121.9 x 190.8)
Purchase, with funds from the Burroughs Wellcome Purchase Fund,
Leo Castelli, the Wilfred P. and Rose J. Cohen Purchase Fund, the
Julia B. Engel Purchase Fund, the Equitable Life Assurance Society
of the United States Purchase Fund, the Sondra and Charles Gilman,
Jr. Foundation, Inc., S. Sidney Kahn, The Lauder Foundation,
Leonard and Evelyn Lauder Fund, the Sara Roby Foundation, and
the Painting and Sculpture Committee 84.6

Untitled, 1983
Monotype: sheet, 32 x 92¼ (81.3 x 234.3) sight; image, 30¼ x 90¼ (76.8 x 229.2)
Purchase, with funds from the Grace Belt Endowed Purchase Fund, the Wilfred P. and Rose J. Cohen Purchase Fund, the Equitable Life Assurance Society of the United States Purchase Fund, S. Sidney Kahn, The List Purchase Fund, Mr. and Mrs. William A. Marsteller, the Print Purchase Fund, and the Print Committee 84.28

Untitled, 1984
Charcoal on paper, 44 x 33³⁄₁₆ (111.8 x 84.3)
Purchase, with funds from the Burroughs Wellcome Purchase Fund, the Equitable Life Assurance Society of the United States Purchase Fund, the Mr. and Mrs. Thomas M. Evans Purchase Fund, and the Mrs. Percy Uris Purchase Fund 86.4

DONALD JUDD (b. 1928)
Untitled, 1965
Perforated steel, 8 x 120 x 66 (20.3 x 304.8 x 167.6)
50th Anniversary Gift of Toiny and Leo Castelli 79.77

Untitled, 1984
Aluminum with blue plexiglass over black plexiglass, six pieces, 19¹¹⁄₁₆ x 39³⁄₈ x 19¹¹⁄₁₆ (50 x 100 x 50) each
Purchase, with funds from the Brown Foundation, Inc. in memory of Margaret Root Brown 85.14a-f

ALEX KATZ (b. 1927)
The Red Smile, 1963
Oil on canvas, 78¾ x 114¾ (200 x 291.5)
Purchase, with funds from the Painting and Sculpture Committee 83.3

ELLSWORTH KELLY (b. 1923)
Blue Panel I, 1977
Oil on canvas, 105 x 56¾ (266.7 x 144.2)
50th Anniversary Gift of the Gilman Foundation, Inc. and Agnes Gund 79.30

Wall, 1979
Etching and aquatint: sheet, 31⁵⁄₈ x 28 (80.3 x 71.1); plate, 16¼ x 14 (41.3 x 35.6)
Purchase, with funds from the Print Purchase Fund 79.73

FRANZ KLINE (1910–1962)
Untitled, 1960
Ink on paper, 8½ x 10½ (21.6 x 26.7)
Purchase, with funds from Mr. and Mrs. Benjamin Weiss 78.53

JOSEPH KOSUTH (b. 1945)
"Titled (Art as Idea as Idea)," 1967
Photographic enlargement mounted on composition board, 48 x 48 (121.9 x 121.9)
Gift of Mr. Peter M. Brant 74.108

LEE KRASNER (1908–1984)
White Squares, c. 1948
Oil on canvas, 24 x 30 (61 x 76.2)
Gift of Mr. and Mrs. B.H. Friedman 75.1

The Seasons, 1957
Oil on canvas, 92¾ x 203¹¹⁄₁₆ (235.6 x 517.4)
Purchase, with funds from Frances and Sydney Lewis (by exchange), the Mrs. Percy Uris Purchase Fund, and the Painting and Sculpture Committee 87.7

GASTON LACHAISE (1882–1935)
Woman Arranging Hair, 1910–12
Bronze, 10¼ x 5¼ x 3½ (26 x 13.3 x 8.9)
Promised 50th Anniversary Gift of Dr. and Mrs. Barnett Malbin; the Lydia and Harry Lewis Winston Collection P.2.80

Woman with Arms Akimbo, 1910–12
Bronze, 11 x 4¾ x 4½ (27.9 x 12.1 x 11.4)
Promised 50th Anniversary Gift of Dr. and Mrs. Barnett Malbin; the Lydia and Harry Lewis Winston Collection P.3.80

Standing Figure, 1927
Bronze, 11¼ x 4¼ x 3¼ (28.6 x 10.8 x 8.3)
Gift of The Edith Gregor Halpert Foundation in memory of Edith Gregor Halpert 75.14

John Marin, 1928
Bronze, 12 x 9 x 9 (30.5 x 22.9 x 22.9)
50th Anniversary Gift of Seth and Gertrude W. Dennis 81.25

Draped Seated Nude, 1932–34
Graphite on paper, 24⅛ x 19 (61.3 x 48.3)
Purchase, with funds from an anonymous donor 87.52

Torso with Arms Raised, 1935
Bronze, 36¼ x 32¼ x 16½ (92.1 x 81.9 x 41.9)
50th Anniversary Gift of The Lachaise Foundation 80.8

ARMIN LANDECK (1905–1984)
Manhattan Vista, 1934
Drypoint: sheet, 12⅞ x 10¹¹⁄₁₆ (32.7 x 27.2); plate, 10⅛ x 8⁹⁄₁₆ (25.7 x 21.8)
Gift of Helen S. Tankersley 86.68.46

IBRAM LASSAW (b. 1913)
Sculpture in Steel, 1938
Steel, 18⅝ x 23⁹⁄₁₆ x 15 (47.3 x 59.8 x 38.1) including base
Purchase, with funds from the Painting and Sculpture Committee 86.11

SHERRIE LEVINE (b. 1947)
Untitled (Golden Knots: 1), 1988
Oil on plywood under plexiglass, 62⅝ x 50⁹⁄₁₆ x 3½ (159.1 x 128.4 x 8.9) including frame
Purchase, with funds from the Painting and Sculpture Committee 88.48a-b

SOL LeWITT (b. 1928)
A six-inch (15 cm) grid covering each of the four black walls. White lines to points on the grids. 1st wall: 24 lines from the center; 2nd wall: 12 lines from the midpoint of each of the sides; 3rd wall: 12 lines from each corner; 4th wall: 24 lines from the center, 12 lines from the midpoint of each of the sides, 12 lines from each corner, 1976
White crayon lines and black pencil grid on black walls, four walls, dimensions variable
Purchase, with funds from the Gilman Foundation, Inc. 78.1.1–4

Five Towers, 1986
Painted wood, eight units, 86⁹/₁₆ x 86⁹/₁₆ x 86⁹/₁₆ (219.9 x 219.9 x 219.9) overall
Purchase, with funds from the Louis and Bessie Adler Foundation, Inc., Seymour M. Klein, President, the John I.H. Baur Purchase Fund, the Grace Belt Endowed Purchase Fund, the Sondra and Charles Gilman, Jr. Foundation, Inc., The List Purchase Fund, and the Painting and Sculpture Committee 88.7a-h

ROY LICHTENSTEIN (b. 1923)
Still Life with Crystal Bowl, 1973
Oil and magna on canvas, 52 x 42 (132.1 x 106.7)
Purchase, with funds from Frances and Sydney Lewis 77.64

Gold Fish Bowl, 1977
Painted bronze with patina, 77½ x 25½ x 18¼ (196.9 x 64.8 x 46.4)
Purchase, with funds from the Howard and Jean Lipman Foundation, Inc. 77.66

Study for *Figures in Landscape*, 1977
Graphite and colored pencil with collage on paper, 22½ x 27¾ (57.2 x 70.5)
Purchase, with funds from the Drawing Committee 84.4

Moonscape, from the series *Landscapes*, 1985
Lithograph, woodcut, and serigraph: sheet, 37³/₁₆ x 55¼ (94.5 x 140.3); image, 34³/₁₆ x 52 ⁵/₁₆ (86.8 x 132.9)
Purchase, with funds from the Print Committee 86.7

JACQUES LIPCHITZ (1891–1973)
Marsden Hartley Sleeping, 1942
Bronze, 10¼ x 7¾ x 10 (26 x 19.7 x 25.4)
Gift of Benjamin Sonnenberg 76.41

LOUIS LOZOWICK (1892–1973)
Pittsburgh, 1922–23
Oil on canvas, 30 x 17 (76.2 x 43.2)
Gift of Louise and Joe Wissert 83.50

New York, c. 1923
Carbon pencil on paper, 12½ x 10 (31.8 x 25.4)
Purchase, with funds from the Richard and Dorothy Rodgers Fund 77.15

New York, 1925
Lithograph: sheet, 15⅛ x 11⅜ (38.4 x 28.9); image, 11⁹/₁₆ x 9 (29.4 x 22.9)
Purchase, with funds from the John I.H. Baur Purchase Fund 77.12

Subway Construction, 1931
Lithograph: sheet, 11 ⁵/₁₆ x 15⅞ (28.7 x 40.3); image, 6⅝ x 13¹/₁₆ (16.8 x 33.2)
Purchase, with funds from Philip Morris Incorporated 77.8

BRICE MARDEN (b. 1938)
Number One, 1981–84
Oil on canvas, three panels, 84 x 109 (213.4 x 276.9) overall
Purchase, with funds from the Julia B. Engel Purchase Fund 85.2a-c

JOHN MARIN (1870–1953)
Wave on Rock, 1937
Oil on canvas, 22¼ x 30 (57.8 x 76.2)
Purchase, with funds from Charles Simon and the Painting and Sculpture Committee 81.18

REGINALD MARSH (1898–1954)
Minsky's Chorus, 1935
Tempera on composition board, 29¼ x 35⅞ (75.6 x 91.1)
Partial and promised gift of Mr. and Mrs. Albert Hackett in honor of Edith and Lloyd Goodrich P.5.83

AGNES MARTIN (b. 1916)
Untitled #11, 1977
Graphite and gesso on canvas, 72 x 72 (182.9 x 182.9)
Gift of The American Art Foundation 77.44

JAN MATULKA (1890–1972)
Hopi Snake Dance, Number I, 1917–18
Crayon, watercolor, and graphite on paper, 15 x 12 (38.1 x 30.5) irregular
Gift of Gertrude W. Dennis 79.38

Hopi Snake Dance, Number II, 1917–18
Crayon, watercolor, and graphite on paper, 15 x 12 (38.1 x 30.5) irregular
Gift of Gertrude W. Dennis 79.39

New York Evening, 1925
Lithograph: sheet, 14⁷/₁₆ x 19 ¹/₁₂ (36.7 x 49.5); image, 13¼ x 16 (33.7 x 40.6)
Purchase 77.9

JOHN McLAUGHLIN (1898–1976)
Untitled (Geometric Abstraction), 1953
Oil on panel, 32 x 38 (81.3 x 96.5)
Promised gift of Beth and James DeWoody P.1.86

JOAN MITCHELL (b. 1926)
Clearing, 1973
Oil on canvas, triptych, 110¼ x 236 (280 x 599.4) overall
Purchase, with funds from Susan Morse Hilles in honor of John I.H. Baur 74.72

ROBERT MORRIS (b. 1931)
Untitled (L-Beams), 1965
Stainless steel, 96 x 96 x 24 (243.8 x 243.8 x 61)
Gift of Howard and Jean Lipman 76.29

ROBERT MOTHERWELL (b. 1915)
Three Figures Shot, 1944
Colored ink on paper, 11⅜ x 14½ (28.9 x 36.8)
Purchase, with funds from the Burroughs Wellcome Purchase Fund and the National Endowment for the Arts 81.31

WALTER MURCH (1907–1967)
Medley, c. 1950–51
Oil on canvas, 26⅝ x 20 (67.3 x 50.8)
Lawrence H. Bloedel Bequest 77.1.35

ELIZABETH MURRAY (b. 1940)
Children Meeting, 1978
Oil on canvas, 101 x 127 (256.5 x 322.6)
Purchase, with funds from the Louis and Bessie Adler Foundation, Inc., Seymour M. Klein, President 78.34

Shake, 1979
Charcoal on paper, 46½ x 38 (118.1 x 96.5)
Purchase, with funds from Joel and Anne Ehrenkranz 79.60

ELIE NADELMAN (1882–1946)
The Bird, c. 1904–07
Ink on paper, 25¼ x 19⅜ (64.1 x 49.2)
Purchase, with funds from Philip Morris Incorporated 76.4

Wounded Stag, c. 1915
Bronze, 12½ x 19⅞ x 9⅝ (31.8 x 50.5 x 24.5)
Gift of Mr. and Mrs. E. Jan Nadelman 78.109

Sur la Plage, 1916
Marble and bronze, 23 x 26¼ x 7½ (58.4 x 66.7 x 19.1)
including base
50th Anniversary Gift of the Sara Roby Foundation in honor of
Lloyd Goodrich 80.56

Dancing Figure, c. 1916–18
Bronze, 29½ x 12 x 11½ (74.9 x 30.5 x 29.2)
Promised gift of an anonymous donor P.7.75

Tango, c. 1919
Painted wood and gesso, three units, 35⅞ x 26 x 13⅞ (91.1 x 66 x
35.2) overall
Purchase, with funds from the Mr. and Mrs. Arthur G. Altschul
Purchase Fund, the Joan and Lester Avnet Purchase Fund, the Edgar
William and Bernice Chrysler Garbisch Purchase Fund, the Mrs.
Robert C. Graham Purchase Fund in honor of John I.H. Baur, the
Mrs. Percy Uris Purchase Fund, and the Henry Schnakenberg
Purchase Fund in honor of Juliana Force 88.1a–c

Standing Nude Figure (States I, II, and III), c. 1920
Drypoint with graphite.
State I: sheet, 10 ¹³⁄₁₆ x 4⁷⁄₁₆ (27.5 x 11.3)
irregular; image, 10¹⁄₁₆ x 3 (25.6 x 7.6); State II: sheet, 10⅞ x 4⅞
(27.6 x 12.4) irregular; image, 10 x 3 (25.4 x 7.6); State III: sheet,
10⅞ x 8⅜ (27.6 x 21.3); image, 9¹⁵⁄₁₆ x 3 (25.2 x 7.6)
Purchase, with funds from the Katherine Schmidt Shubert Purchase
Fund 87.61a–c

Head of a Woman with Hat, c. 1923–25
Graphite on tracing vellum, 16½ x 10¾ (41.9 x 27.3)
Purchase, with funds from the Lily Auchincloss Foundation,
Vivian Horan, The List Purchase Fund, the Neysa McMein Purchase
Award, Mr. and Mrs. William A. Marsteller, the Richard and
Dorothy Rodgers Fund, and the Drawing Committee 83.34

ALICE NEEL (1900–1984)
Andy Warhol, 1970
Oil on canvas, 60 x 40 (152.4 x 101.6)
Gift of Timothy Collins 80.52

LOUISE NEVELSON (1899–1988)
Black Cord, 1964
Painted wood, 104½ x 117¾ x 12¼ (265.4 x 299.1 x 31.1)
Promised 50th Anniversary Gift of Joel and Anne Ehrenkranz
P.15.79

BARNETT NEWMAN (1905–1970)
Untitled, 1961
Lithograph: sheet, 30 x 22¼ (76.2 x 56.6); image, 22⅝ x 16¼
(57.5 x 41.3)
Purchase, with funds from the Print Committee 84.57

Untitled Etching No. 1, 1969
Etching and aquatint: sheet, 22½ x 31⁹⁄₁₆ (57.2 x 80.2); plate,
14⁹⁄₁₆ x 23⁵⁄₁₆ (37 x 59.2)
Purchase, with funds from the Print Committee 88.15

JOHN NEWMAN (b. 1952)
Uprooted Symmetry (The Anchor), 1988
Aluminum with patina, 50⅛ x 60½ x 64 (127.3 x 153.7 x 162.6)
Purchase, with funds from the Louis and Bessie Adler Foundation,
Inc., Seymour M. Klein, President, and the Mrs. Percy Uris Purchase
Fund 88.32

ISAMU NOGUCHI (1904–1988)
Work Sheets for Sculpture, 1945
Graphite on paper with cutouts, 17 x 22 (43.2 x 55.9)
Purchase, with funds from the Howard and Jean Lipman
Foundation, Inc. 74.46

The Gunas, 1946
Marble, 73¼ x 26¼ x 25½ (186.1 x 66.7 x 64.8)
Purchase, with funds from the Howard and Jean Lipman
Foundation, Inc. 75.18

GEORGIA O'KEEFFE (1887–1986)
Drawing No. 8, 1915
Charcoal on paper mounted on cardboard, 24¼ x 18⅞ (61.6 x 47.9)
Purchase, with funds from the Mr. and Mrs. Arthur G. Altschul
Purchase Fund 85.52

Flower Abstraction, 1924
Oil on canvas, 48 x 30 (121.9 x 76.2)
50th Anniversary Gift of Sandra Payson 85.47

Black and White, 1930
Oil on canvas, 36 x 24 (91.4 x 61)
50th Anniversary Gift of Mr. and Mrs. R. Crosby Kemper 81.9

Summer Days, 1936
Oil on canvas, 36 x 30 (91.4 x 76.2)
Promised gift of Calvin Klein P.4.83

Black Place Green, 1949
Oil on canvas, 38 x 48 (96.5 x 121.9)
Promised 50th Anniversary Gift of Mr. and Mrs. Richard D.
Lombard P.17.79

Drawing IV, 1959
Charcoal on paper, 18½ x 24½ (47 x 62.2) sight
Gift of Chauncey L. Waddell in honor of John I.H. Baur 74.67

It Was Blue and Green, 1960
Oil on canvas, 30 x 40 (76.2 x 101.6)
Lawrence H. Bloedel Bequest 77.1.37

CLAES OLDENBURG (b. 1929)
The Black Girdle, 1961
Painted plaster, 46½ x 40 x 4 (118.1 x 101.6 x 10.2)
Gift of Howard and Jean Lipman 84.60.2

Soft Toilet, 1966
Vinyl filled with kapok, painted with liquitex, and wood, 52 x 32 x 30
(132.1 x 81.3 x 76.2)
50th Anniversary Gift of Mr. and Mrs. Victor W. Ganz 79.83

Proposal for a Cathedral in the Form of a Colossal Faucet,
Lake Union, Seattle, 1972
Watercolor, graphite, and colored pencil on paper, 29 x 22⅞
(73.7 x 58.1)
Purchase, with funds from Knoll International 80.35

NAM JUNE PAIK (b. 1932)
V-yramid, 1982
Forty televisions and videotape, 186¾ x 85 x 74 (474.3 x 215.9 x 188)
Purchase, with funds from the Lemberg Foundation, Inc. in honor of
Samuel Lemberg 82.11a-xx

ED PASCHKE (b. 1939)
Violencia, 1980
Oil on canvas, 74 x 96 (188 x 243.8)
Gift of Sherry and Alan Koppel in memory of Miriam and Herbert
Koppel 82.46

PHILIP PEARLSTEIN (b. 1924)
Female Model on Oriental Rug with Mirror, 1968
Oil on canvas, 60 x 72 (152.4 x 182.9)
50th Anniversary Gift of Mr. and Mrs. Leonard A. Lauder 84.69

JACKSON POLLOCK (1912–1956)
Untitled, c. 1933–39
Graphite and colored crayon on paper, 15 x 10 (38.1 x 25.4)
Purchase, with funds from the Julia B. Engel Purchase Fund and the
Drawing Committee 85.17

Untitled, c. 1939–42
Colored crayon and graphite on paper, 14 x 11 (35.6 x 27.9)
Purchase, with funds from the Julia B. Engel Purchase Fund and the
Drawing Committee 85.18

Untitled, 1944
Ink with gouache on paper, 13⅛ x 11⅛ (33.3 x 28.3)
Purchase, with funds from the Julia B. Engel Purchase Fund and the
Drawing Committee 85.20

FAIRFIELD PORTER (1907–1975)
The Screen Porch, 1964
Oil on canvas, 79½ x 79½ (201.9 x 201.9)
Lawrence H. Bloedel Bequest 77.1.41

RICHARD POUSETTE-DART (b. 1916)
Within the Room, 1942
Oil on canvas, 36 x 50 (91.4 x 152.4)
Promised 50th Anniversary Gift of the artist P.4.79

MAURICE PRENDERGAST (1859–1924)
Madison Square, c. 1901
Watercolor on paper, 15 x 16½ (38.1 x 41.9)
Joan Whitney Payson Bequest 76.14

Sailboat Pond, Central Park, c. 1902
Watercolor on paper, 19¼ x 22³⁄₁₆ (48.9 x 56.4)
50th Anniversary Gift of an anonymous donor 86.57

Summer's Day, 1916–18
Oil on canvas, 20¼ x 28¼ (51.4 x 71.8)
Lawrence H. Bloedel Bequest 77.1.43

MARTIN PURYEAR (b. 1941)
Sanctum, 1985
Wood, wire mesh, and tar, 76 x 109 x 87 (193 x 276.9 x 221)
Purchase, with funds from the Painting and Sculpture Committee
85.72

ROBERT RAUSCHENBERG (b. 1925)
Satellite, 1955
Oil, fabric, paper, and wood on canvas, with stuffed pheasant,
80 x 42½ (203.2 x 108)
Partial and promised gift of Claire B. Zeisler and purchase, with
funds from the Mrs. Percy Uris Purchase Fund P.2.86
(not in exhibition)

Bellini #1, 1986
Color photogravure: sheet and image, 58⅜ X 38¹⁄₁₆ (148.3 x 97.6)
Purchase, in honor of Charles Simon, with funds given by his friends
from Salomon Brothers on the occasion of his 75th birthday 87.38

Bellini #2, 1987
Color photogravure: sheet and image, 58½ x 37½ (148.6 x 95.2)
Purchase, in honor of Charles Simon, with funds given by his friends
from Salomon Brothers on the occasion of his 75th birthday 89.14

Bellini #4, 1988
Color photogravure: sheet and image, 60 x 38½ (152.4 x 97.8)
Purchase, in honor of Charles Simon, with funds given by his friends
from Salomon Brothers on the occasion of his 75th birthday 89.16

Bellini #5, 1989
Color photogravure: sheet and image, 58⅞ x 38 ⁵⁄₁₆ (149.5 x 97.3)
Purchase, in honor of Charles Simon, with funds given by his friends
from Salomon Brothers on the occasion of his 75th birthday 89.17

AD REINHARDT (1913–1967)
Number 30, 1938
Oil on canvas, 40½ x 42½ (102.9 x 108)
Promised gift of Rita Reinhardt P.31.77

Untitled (N.Y. World's Fair), 1939
Gouache on cardboard, 10 x 13¼ (25.4 x 33.7)
50th Anniversary Gift of Rita Reinhardt 79.55

Untitled (N.Y. World's Fair), 1939
Gouache on cardboard, 10 x 13 (25.4 x 33)
50th Anniversary Gift of Rita Reinhardt 79.56

Abstract Painting, Blue 1953, 1953
Oil on canvas, 50 x 28 (127 x 71.1)
Gift of Susan Morse Hilles 74.22

Abstract Painting, Number 33, 1963
Oil on canvas, 60 x 60 (152.4 x 152.4)
50th Anniversary Gift of Fred Mueller 80.33

Untitled, n.d.
Gouache on cardboard, 16 x 20 (40.6 x 50.8)
50th Anniversary Gift of Rita Reinhardt 79.58

JAMES ROSENQUIST (b. 1933)
Fahrenheit 1982 Degrees, 1982
Colored ink on frosted mylar, 33⅛ x 71½ (84.1 x 181.6)
Purchase, with funds from the John I.H. Baur Purchase Fund, the
Mr. and Mrs. M. Anthony Fisher Purchase Fund, and The Lauder
Foundation—Drawing Fund 82.35

THEODORE ROSZAK (1907–1981)
Metaphysical Structure, 1933
Crayon, gouache, and ink on paper, 23 x 16⁹⁄₁₆ (58.4 x 42.1)
Gift of the Theodore Roszak Estate 83.33.5

Bi-Polar in Red, 1940
Metal, plastic, and wood, 54 x 9 x 9 (137.2 x 22.9 x 22.9)
including base
Purchase, with funds from the Burroughs Wellcome Purchase Fund
and the National Endowment for the Arts 79.6

Star Burst, 1954
India ink and colored ink on paper, 43 ½ x 79 (110.5 x 200.7) irregular
Gift of Mrs. Theodore Roszak 83.33.10

SUSAN ROTHENBERG (b. 1945)
For the Light, 1978–79
Acrylic and Flashe on canvas, 105 x 87 (266.7 x 221)
Purchase, with funds from Peggy and Richard Danziger 79.23

MARK ROTHKO (1903–1970)
Agitation of the Archaic, 1944
Oil on canvas, 35 ⅜ x 54 ¼ (89.9 x 137.8)
Gift of The Mark Rothko Foundation, Inc. 85.43.1

Untitled, 1953
Mixed media on canvas, 106 x 50⅞ (269.2 x 129.2) irregular
Gift of The Mark Rothko Foundation, Inc. 85.43.2

EDWARD RUSCHA (b. 1937)
Large Trademark with Eight Spotlights, 1962
Oil on canvas, 66¾ x 133 ¼ (169.6 x 338.5)
Purchase, with funds from the Mrs. Percy Uris Purchase Fund 85.41

Motor, 1970
Gunpowder and pastel on paper, 23 x 29 (58.4 x 73.7)
Purchase, with funds from The Lauder Foundation—Drawing Fund
77.78

Several Monograms, 1986
Dry pigment and acrylic on paper, 59⁹⁄₁₆ x 40⅛ (151.3 x 101.9)
Purchase, with funds from the Drawing Committee 87.55

ROBERT RYMAN (b. 1930)
Carrier, 1979
Oil on cotton with metal brackets, 81 ½ x 78 (207 x 191.1)
Purchase, with funds from the National Endowment for the Arts
and the Painting and Sculpture Committee 80.40

KAY SAGE (1898–1963)
Constant Variation, 1958
Watercolor and collage on paper, 19¹⁄₁₆ x 26⅞ (48.4 x 68.3)
Gift of Flora Whitney Miller 86.70.2

DAVID SALLE (b. 1952)
Sextant in Dogtown, 1987
Oil and acrylic on canvas, 96³⁄₁₆ x 126 ¼ (244.3 x 320.7)
Purchase, with funds from the Painting and Sculpture Committee
88.8

LUCAS SAMARAS (b. 1936)
Box #41, 1965
Mixed media, 17⅛ x 13¾ x 38 (43.5 x 34.9 x 96.5) open
Gift of Howard and Jean Lipman 77.81

Box #42, 1965
Mixed media, 9⅜ x 14⅛ x 10⅛ (23.8 x 35.9 x 25.7)
Gift of Howard and Jean Lipman 74.97

Dinner #15, 1965
Mixed media, 8½ (21.6) x 12 (30.5) diameter
Gift of Howard and Jean Lipman 74.98

Transformation: Scissors, 1968
Mixed media, 51 ½ x 36 ½ x 36 ½ (130.8 x 92.7 x 92.7)
50th Anniversary Gift of Frances and Sydney Lewis 80.18

Chair Transformation Number 3, 1969–70
Acrylic on wood, 43 x 20 x 29¾ (109.2 x 50.8 x 75.6)
Promised 50th Anniversary Gift of Mr. and Mrs. Wilfred P. Cohen
P.1.80

Extra Large Drawing #2, 1975
Ink on paper, 30¼ x 22 (76.8 x 55.9)
Purchase, with funds from The Crawford Foundation 77.69

GEORGE SEGAL (b. 1924)
Walk, Don't Walk, 1976
Plaster, cement, metal, painted wood, and electric light,
104 x 72 x 72 (264.2 x 182.9 x 182.8)
Purchase, with funds from the Louis and Bessie Adler Foundation,
Inc., Seymour M. Klein, President, the Gilman Foundation, Inc.,
the Howard and Jean Lipman Foundation, Inc., and the National
Endowment for the Arts 79.4

RICHARD SERRA (b. 1939)
Left Corner Rectangles, 1979
Paint stick on linen, two parts, 147 x 107½ (373.4 x 273.1) each
50th Anniversary Gift of the Louis and Bessie Adler Foundation, Inc.,
Seymour M. Klein, President, and the Gilman Foundation, Inc. 80.2

JOEL SHAPIRO (b. 1941)
Untitled (House on Field), 1975–76
Bronze, 3 ½ x 28¾ x 21 ½ (8.9 x 73 x 54.6)
Purchase, with funds from Mrs. Oscar Kolin 76.22

Untitled, 1978
Painted wood, 4 ½ x 6 x 3 ⅛ (11.5 x 15.2 x 7.9)
Purchase, with funds from an anonymous donor 79.27

Untitled, 1980–81
Bronze, 52⅞ x 64 x 45 ½ (134.3 x 162.6 x 115.6)
Purchase, with funds from the Painting and Sculpture Committee
83.5

Untitled, 1987
Charcoal and chalk on paper, 53 ⅛ x 42⁹⁄₁₆ (134.9 x 108.1)
Purchase, with funds from Mrs. Nicholas Millhouse and the
Drawing Committee 88.21

CHARLES G. SHAW (1892–1974)
Plastic Polygon, 1938
Oil on wood, 38 ½ x 23 ½ (97.8 x 59.7)
Purchase, with funds from the Painting and Sculpture Committee
82.5

CINDY SHERMAN (b. 1954)
Untitled #146, 1985
Color photograph, 71⁹⁄₁₆ x 48⅛ (181.8 x 122.2)
Purchase, with funds from Eli and Edyth L. Broad 87.49

DAVID SMITH (1906–1965)
Untitled, 1946
Tempera on paper, 22 x 30¼ (55.9 x 76.8)
Purchase, with funds from The Lauder Foundation—Drawing Fund
79.45

Untitled, 1951
Ink and tempera on paper, 19¾ x 25¾ (50.2 x 65.4)
Promised 50th Anniversary Gift of an anonymous donor P.7.79

Don Quixote I, 1952
Lithograph: sheet, 21⅞ x 27⅞ (55.6 x 70.8) irregular; image,
17⅞ x 23¹⁄₁₆ (45.4 x 60.5)
Purchase, with funds from the Print Committee 84.13

Don Quixote II, 1952
Lithograph: sheet, 22⁵⁄₁₆ x 29¼ (56.7 x 74.3) irregular; image,
17⅞ x 23¹³⁄₁₆ (45.4 x 60.5)
Purchase, with funds from the Print Committee 84.12

Eng No. 6, 1952
Tempera and oil on paper, 29¾ x 42¼ (75.6 x 107.3)
Purchase, with funds from Agnes Gund and an anonymous donor
79.43

Running Daughter, 1956
Painted steel, 100½ x 36 x 17 (255.3 x 91.4 x 43.2)
50th Anniversary Gift of Mr. and Mrs. Oscar Kolin 81.42

Untitled, 1957
Egg ink on paper, 26¾ x 40 (68 x 101.6)
Purchase, with funds from an anonymous donor 79.42

TONY SMITH (1912–1980)
Die, (1962)
Steel, 72⅜ x 72⅜ x 72⅜ (183.8 x 183.8 x 183.8)
Purchase, with funds from the Louis and Bessie Adler Foundation,
Inc., James Block, the Sondra and Charles Gilman, Jr. Foundation,
Inc., Penny and Mike Winton, and the Painting and Sculpture
Committee 89.6

ROBERT SMITHSON (1938–1973)
Mud Flow, 1969
Crayon and felt-tip pen on paper, 17½ x 23¾ (44.5 x 60.3) sight
Gift of Norman Dubrow 77.99

SAUL STEINBERG (b. 1914)
Giant Table III, 1974
Mixed media on wood, 35⅝ x 83⅝ (90.5 x 212.4)
Promised gift of an anonymous donor P.28.80

FRANK STELLA (b. 1936)
Die Fahne Hoch, 1959
Enamel on canvas, 121½ x 73 (308.6 x 185.4)
Gift of Mr. and Mrs. Eugene M. Schwartz and purchase, with funds
from the John I.H. Baur Purchase Fund, the Charles and Anita Blatt
Fund, Peter M. Brant, B.H. Friedman, the Gilman Foundation, Inc.,
Susan Morse Hilles, The Lauder Foundation, Frances and Sydney
Lewis, the Albert A. List Fund, Philip Morris Incorporated, Sandra
Payson, Mr. and Mrs. Albrecht Saalfield, Mrs. Percy Uris, Warner
Communications Inc., and the National Endowment for the Arts
75.22

Silverstone, 1981
Mixed media on aluminum and fiberglass, 105½ x 122 x 22
(268 x 309.9 x 55.9)
Purchase, with funds from the Louis and Bessie Adler Foundation,
Inc., Seymour M. Klein, President, the Sondra and Charles
Gilman, Jr. Foundation, Inc., Mr. and Mrs. Robert M. Meltzer,
and the Painting and Sculpture Committee 81.26

Imola Three I, from the series *Circuits*, 1982
Engraving and etching with relief printing: image,
65¹³⁄₁₆ x 51⅛ (167.2 x 129.9) sight
Gift of Judge Steven D. Robinson 86.55.4

Swan Engraving I, from the series *Swan Engravings*, 1982
Etching: image, 65⅞ x 51½ (167.3 x 130.8) sight
Gift of Judge Steven D. Robinson 85.55.5

Swan Engraving II, from the series *Swan Engravings*, 1982
Etching with engraving: image, 65⅜ x 51⅞ (166.1 x 131.8) sight
Gift of Judge Steven D. Robinson 85.55.6

Swan Engraving III, from the series *Swan Engravings*, 1982
Etching with relief printing: image, 65⅜ x 52 sight (166.1 x 132.1)
Gift of Judge Steven D. Robinson 85.55.7

Talladega Five I, from the series *Circuits*, 1982
Relief print: image, 66¼ x 51⅜ (168.3 x 130.5) sight
Gift of Judge Steven D. Robinson 85.55.1

Pergusa Three (State I), from the series *Circuits*, 1983
Etching with relief printing: image, 66⁷⁄₁₆ x 52 sight (168.8 x 132.1)
Gift of Judge Steven D. Robinson 86.55.5

JOSEPH STELLA (1877–1946)
Boy with Bagpipe, 1910–12
Charcoal, pastel, and graphite on paper, 21¾ x 16⅜ (55.3 x 41.6)
50th Anniversary Gift of Lucille and Walter Fillin 86.59

Untitled, c. 1919
Oil and wire on glass, 13⁵⁄₁₆ x 8½ (33.8 x 21.6)
Daisy V. Shapiro Bequest 85.29

JOHN STORRS (1885–1956)
Forms in Space #1, c. 1924
Marble, 76¾ x 12⅝ x 8⅝ (195 x 32.1 x 21.9)
50th Anniversary Gift of Mr. and Mrs. B.H. Friedman in honor of
Gertrude Vanderbilt Whitney, Flora Whitney Miller, and Flora
Miller Biddle 84.37

MYRON STOUT (1908–1987)
Untitled, c. 1957–64
Charcoal on paper, 25 x 18⅞ (63.5 x 47.9)
Purchase, with funds from Martin and Agneta Gruss and the
National Endowment for the Arts 80.42

Untitled (Wind Borne Egg), 1959–80
Oil on canvas, 26 x 20 (66 x 50.8)
Purchase, with funds from the Mrs. Percy Uris Purchase Fund 85.42

Untitled, 1969
Graphite on paper, 7⅞ x 8 (20 x 20.3) sight
Promised gift of Abby and B.H. Friedman P.1.75

GEORGE SUGARMAN (b. 1912)
Inscape, 1964
Painted, laminated wood, nine parts, dimensions variable
Purchase, with funds from the Painting and Sculpture Committee
86.10 a-i

ALBERT SWINDEN (1899–1961)
Study for mural, *Williamsburg Housing Project*, c. 1936
Gouache on board, 11 x 21¾ (27.9 x 55.3)
Purchase, with funds from the John I.H. Baur Purchase Fund and the
M. Anthony Fisher Purchase Fund 81.1

ROBERT THERRIEN (b. 1947)
No Title, 1985
Tin on bronze, 34⅝ (88) x 16½ (41.9) diameter
Purchase, with funds from the Eli Broad Family Foundation 86.33

MARK TOBEY (1890–1976)
Battle of the Lights, 1956
Gouache and tempera on paper, 43½ x 35½ (110.5 x 90.2) sight
Promised gift of Lydia Winston Malbin in honor of Walter Fillin
P.2.87
(not in exhibition)

BRADLEY WALKER TOMLIN (1899–1953)
Number 2—1950, 1950
Oil on canvas, 54 x 42 (137.2 x 106.7)
Gift of Mr. and Mrs. David Rockefeller in honor of John I.H. Baur
81.8

RICHARD TUTTLE (b. 1941)
Drift III, 1965
Painted wood, 24¼ x 52¾ x 1¼ (61.6 x 134 x 3.2)
Purchase, with funds from Mr. and Mrs. William A. Marsteller and
the Painting and Sculpture Committee 83.18

Fountain, 1965
Painted plywood, 1 x 40 x 39 (2.5 x 101.6 x 99.1)
50th Anniversary Gift of Richard Brown Baker 79.76

CY TWOMBLY (b. 1928)
Untitled, 1964
Graphite, colored pencil, and crayon on paper, 27½ x 39⅜
(69.9 x 100)
Purchase, with funds from the Drawing Committee 84.21

Untitled (Stones Are Our Food to Gorky), 1982–84
Oil pastel, crayon, and graphite on paper, 44½ x 30⅛ (113 x 76.5)
Gift of the artist 84.30

ABRAHAM WALKOWITZ (1880–1965)
Cityscape, c. 1915
Oil on canvas, 25 x 18 (63.5 x 45.7)
Purchase, with funds from Philip Morris Incorporated 76.11

ANDY WARHOL (1925–1987)
Ginger Rogers, 1962
Graphite on paper, 23¾ x 18 (60.3 x 45.7)
Purchase, with funds from The Lauder Foundation—Drawing Fund
79.29

Ethel Scull 36 Times, 1963
Synthetic polymer paint silkscreened on canvas, thirty-six panels,
79¼ x 143¼ (202.6 x 363.9) overall
Gift of Ethel Redner Scull 86.61a-jj

Mao Tse-Tung, 1972
Portfolio of ten serigraphs: sheet and image, 36 x 36
(91.4 x 91.4) each
Gift of Mr. and Mrs. Peter M. Brant 74.96.1—10

MAX WEBER (1881–1961)
Forest Scene, 1911
Watercolor and graphite on paper, 12½ x 8 (31.8 x 20.3)
Purchase, with funds from the Felicia Meyer Marsh Purchase Fund
and an anonymous donor 81.7

H. C. WESTERMANN (1922–1981)
The Evil New War God, 1958
Brass, partly chrome-plated, 16¼ x 9¾ x 10¼ (42.6 x 24.8 x 26.1)
Promised gift of Howard and Jean Lipman P.62.80
(not in exhibition)

The Sweetest Flower, 1978
Watercolor on paper, 22⅛ x 31 (56.2 x 78.7)
Purchase, with funds from The Lauder Foundation—Drawing Fund
78.102

WILLIAM T. WILEY (b. 1937)
Nothing Conforms, 1978
Watercolor on paper, 29½ x 22½ (74.9 x 57.2)
Purchase, with funds from the Neysa McMein Purchase Award 79.25

CHRISTOPHER WILMARTH (1943–1987)
Clearing #1 of Nine Clearings for a Standing Man, 1973
Glass and steel, 80 x 60 x 3½ (203.2 x 152.4 x 8.9)
Gift of the artist in Salute to a Man of Honor 78.108

JACKIE WINSOR (b. 1941)
Bound Logs, 1972–73
Wood and hemp, 114 x 29 x 18 (289.6 x 73.7 x 45.7)
Purchase, with funds from the Howard and Jean Lipman
Foundation, Inc. 74.53

TERRY WINTERS (b. 1949)
Good Government, 1984
Oil on linen, 101¼ x 136¼ (257.2 x 346.1)
Purchase, with funds from The Mnuchin Foundation and the
Painting and Sculpture Committee 85.15

Untitled, 1985
Charcoal and oil paint stick on paper, 41⁹⁄₁₆ x 29⅝ (105.6 x 75.2)
Purchase, with funds from the Drawing Committee 88.6

GRANT WOOD (1892–1942)
Study for *Breaking the Prairie*, 1935–39
Colored pencil, chalk, and graphite on paper, triptych, 22¼ x 80¼
(57.8 x 203.8) overall
Gift of Mr. and Mrs. George D. Stoddard 81.33.2a-c

WILLIAM ZORACH (1889–1966)
Two Figures, 1929
Crayon on paper, 29¼ x 18¼ (74.3 x 46.36) image
Gift of the artist's children in honor of John I.H. Baur 74.69

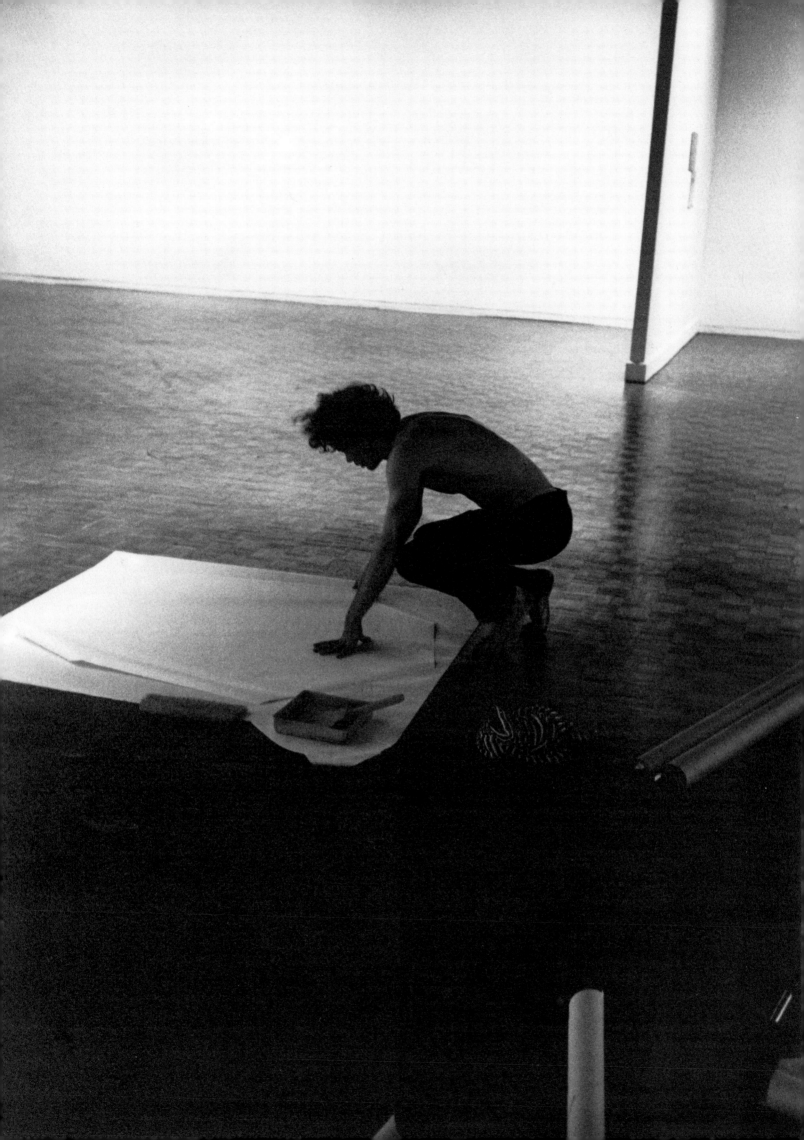

EXHIBITION HISTORIES

A museum such as the Whitney Museum of American Art, devoted primarily to the work of living artists, gains its place in the history of art through commitments to artists made at a time when the staff does not have the benefit of historical perspective. These judgments, voiced through exhibitions and acquisitions, play a primary role in American art history as it is formed.

To confirm the role the Whitney Museum has played in American art of this century, we have compiled a record of the association of the artists in this exhibition with the Museum. Most have been represented in Annuals, Biennials, group and one-artist exhibitions prior to our acquisition of their work. Listed below are the years of their participation in one-artist exhibitions as well as in Annuals or Biennials since the Museum opened in November 1931. The first Biennial took place in November 1932; in 1937, the program was reorganized into Annuals, alternately of painting and sculpture; in 1973, the Biennial system was reinstated.

Unless otherwise indicated, all exhibitions were organized by the Whitney Museum of American Art. For exhibitions at Whitney Museum branches (Downtown, Equitable, Fairfield County, Philip Morris), the name of the branch appears in parentheses.

Richard Tuttle preparing a work for his 1975 Whitney Museum Exhibition.

JOSEF ALBERS
Annual/Biennial Exhibitions: 1950, 1953, 1954, 1955, 1956, 1957, 1958, 1961, 1962, 1963, 1965, 1966, 1967

RICHARD ARTSCHWAGER
One-Artist Exhibitions: 1988 (traveled)
Annual/Biennial Exhibitions: 1966, 1968, 1970, 1972, 1983, 1987

MILTON AVERY
One-Artist Exhibitions: 1960 (organized by the American Federation of Arts), 1982 (traveled), 1982 (Fairfield County; traveled)
Annual/Biennial Exhibitions: 1932, 1936, 1943, 1944, 1945, 1947, 1952, 1953, 1956, 1957, 1958, 1961, 1963

JOHN BALDESSARI
Annual/Biennial Exhibitions: 1969, 1973, 1977, 1979, 1983, 1985

JENNIFER BARTLETT
Annual/Biennial Exhibitions: 1977, 1979, 1981

WILLIAM BAZIOTES
Annual/Biennial Exhibitions: 1945, 1946, 1947, 1948, 1949, 1950, 1951, 1952, 1953, 1954, 1955, 1956, 1957, 1958, 1959, 1961

GEORGE BELLOWS
No exhibitions

THOMAS HART BENTON
One-Artist Exhibitions: 1932
Annual/Biennial Exhibitions: 1934, 1936, 1940, 1941, 1942, 1943, 1945, 1948

CHARLES BIEDERMAN
Annual/Biennial Exhibitions: 1964, 1965

OSCAR BLUEMNER
Annual/Biennial Exhibitions: 1932

ILYA BOLOTOWSKY
Annual/Biennial Exhibitions: 1950, 1952, 1953, 1955, 1957, 1959, 1961, 1963, 1965, 1966, 1967, 1972

JONATHAN BOROFSKY
One-Artist Exhibitions: 1984 (organized with the Philadelphia Museum of Art; traveled)
Annual/Biennial Exhibitions: 1979, 1981, 1983

LOUISE BOURGEOIS
Annual/Biennial Exhibitions: 1945, 1946, 1947, 1948, 1951, 1953, 1954, 1955, 1956, 1960, 1962, 1968, 1970, 1973, 1983, 1987

ROGER BROWN
Annual/Biennial Exhibitions: 1973, 1979

BYRON BROWNE
Annual/Biennial Exhibitions: 1938, 1940, 1946, 1947, 1948, 1949, 1950, 1952, 1953, 1955, 1956

CHARLES BURCHFIELD
One-Artist Exhibitions: 1956 (traveled), 1980
Annual/Biennial Exhibitions: 1933, 1936, 1938, 1939, 1940, 1941, 1942, 1943, 1945, 1946, 1947, 1948, 1949, 1950, 1951, 1952, 1954, 1955, 1956, 1958, 1959, 1960, 1961, 1963, 1965

ALEXANDER CALDER
One-Artist Exhibitions: 1971, 1972, 1976 (traveled), 1981, 1984, 1987
Annual/Biennial Exhibitions: 1942, 1943, 1945, 1946, 1949, 1951, 1952, 1953, 1954, 1955, 1956, 1958, 1960, 1962, 1964, 1966, 1968, 1970

FEDERICO CASTELLON
Annual/Biennial Exhibitions: 1938, 1939, 1940, 1941 1942, 1943, 1946, 1947, 1948, 1949, 1950, 1952, 1966

JOHN CHAMBERLAIN
Annual/Biennial Exhibitions: 1964, 1966, 1968, 1970, 1973, 1987

CHUCK CLOSE
One-Artist Exhibitions: 1981 (organized by the Walker Art Center, Minneapolis)
Annual/Biennial Exhibitions: 1969, 1972, 1977, 1979

GEORGE CONDO
Annual/Biennial Exhibitions: 1987

HOWARD COOK
Annual/Biennial Exhibitions: 1933, 1936, 1939, 1941, 1942, 1943, 1945, 1946, 1950, 1951

JOSEPH CORNELL
Annual/Biennial Exhibitions: 1953, 1954, 1955, 1956, 1957, 1958, 1960, 1962, 1964, 1966

RALSTON CRAWFORD
One-Artist Exhibitions: 1973, 1985 (traveled), 1986 (Fairfield County)
Annual/Biennial Exhibitions: 1944, 1945, 1946, 1947, 1948, 1952, 1953, 1955, 1958, 1961, 1963, 1965, 1967

FRANCIS CRISS
Annual/Biennial Exhibitions: 1933, 1934, 1936, 1937, 1938, 1940, 1942, 1951, 1952

ROBERT CUMMING
One-Artist Exhibitions: 1986
Annual/Biennial Exhibitions: 1977, 1981

JAMES H. DAUGHERTY No exhibitions

STUART DAVIS
One-Artist Exhibitions: 1957 (organized with the Walker Art Center, Minneapolis; traveled), 1965 (organized by the National Collection of Fine Arts, Washington, D.C.; traveled), 1980, 1986 (Philip Morris)
Annual/Biennial Exhibitions: 1932, 1933, 1936, 1937, 1938, 1940, 1941, 1942, 1943, 1945, 1946, 1947, 1948, 1951, 1952, 1953, 1955, 1956, 1957, 1958, 1961, 1963

WILLEM DE KOONING
One-Artist Exhibitions: 1983 (traveled)
Annual/Biennial Exhibitions: 1948, 1949, 1950, 1951, 1952, 1953, 1954, 1956, 1959, 1963, 1965, 1967, 1969, 1972, 1981, 1987

CHARLES DEMUTH
One-Artist Exhibitions: 1937, 1987 (traveled)
Annual/Biennial Exhibitions: 1932, 1933, 1934

RICHARD DIEBENKORN
One-Artist Exhibitions: 1977 (organized by the Albright-Knox Art Gallery, Buffalo)
Annual/Biennial Exhibitions: 1955, 1958, 1961, 1963, 1965, 1967, 1969, 1972, 1981

BURGOYNE DILLER
Annual/Biennial Exhibitions: 1955, 1962, 1964

JIM DINE
One-Artist Exhibitions: 1970
Annual/Biennial Exhibitions: 1965, 1966, 1967, 1973

MARK DI SUVERO
One-Artist Exhibitions: 1975
Annual/Biennial Exhibitions: 1966, 1968, 1970

ARTHUR G. DOVE
One-Artist Exhibitions: 1958 (organized by the Art Galleries of the University of California, Los Angeles), 1975 (organized by the San Francisco Museum of Art)
Annual/Biennial Exhibitions: 1932, 1934, 1936, 1940, 1944, 1945, 1946

CARROLL DUNHAM No exhibitions

RICHARD ESTES
Annual/Biennial Exhibitions: 1972, 1977

PAUL FIENE
Annual/Biennial Exhibitions: 1933, 1936, 1938, 1940, 1941, 1942, 1943, 1945, 1946, 1947, 1948, 1949

R.M. FISCHER
One-Artist Exhibitions: 1984
Annual/Biennial Exhibitions: 1983, 1987

ERIC FISCHL
One-Artist Exhibitions: 1986 (organized by the Mendel Art Gallery, Saskatoon, Canada)
Annual/Biennial Exhibitions: 1983, 1985

DAN FLAVIN
Annual/Biennial Exhibitions: 1970

FRITZ GLARNER
Annual/Biennial Exhibitions: 1951, 1952, 1953, 1955, 1956, 1957, 1958, 1963, 1965, 1966

SIDNEY GORDIN
Annual/Biennial Exhibitions: 1952, 1953, 1954, 1956, 1957, 1958, 1960, 1962

ARSHILE GORKY
One-Artist Exhibitions: 1951 (traveled), 1962
Annual/Biennial Exhibitions: 1936, 1937, 1940, 1943, 1945, 1946, 1947, 1948

NANCY GRAVES
One-Artist Exhibitions: 1969
Annual/Biennial Exhibitions: 1970, 1972, 1973, 1983

PHILIP GUSTON
One-Artist Exhibitions: 1981 (organized by the San Francisco Museum of Modern Art)
Annual/Biennial Exhibitions: 1938, 1940, 1942, 1943, 1944, 1945, 1946, 1947, 1948, 1950, 1951, 1952, 1953, 1955, 1956, 1957, 1958, 1961, 1962, 1963, 1966, 1979

DUANE HANSON
One-Artist Exhibitions: 1978 (organized by the Edwin A. Ulrich Museum of Art, Wichita State University)
Annual/Biennial Exhibitions: 1970, 1973, 1977, 1981

MARSDEN HARTLEY
One-Artist Exhibitions: 1962 (organized by the American Federation of Arts), 1980 (traveled)
Annual/Biennial Exhibitions: 1932, 1934, 1936, 1937, 1938, 1940, 1942

MICHAEL HEIZER
One-Artist Exhibitions: 1985 (organized by The Museum of Contemporary Art, Los Angeles)
Annual/Biennial Exhibitions: 1968, 1969, 1977

AL HELD
One-Artist Exhibitions: 1974
Annual/Biennial Exhibitions: 1963, 1965, 1967, 1969, 1972, 1973, 1981

EVE HESSE
Annual/Biennial Exhibitions: 1968

JENNY HOLZER
Annual/Biennial Exhibitions: 1983, 1985

EDWARD HOPPER
One-Artist Exhibitions: 1940, 1950 (traveled), 1964 (traveled), 1971 (traveled), 1972, 1974 (Downtown), 1979 (traveled), 1980 (traveled), 1986 (Fairfield County; traveled)
Annual/Biennial Exhibitions: 1932, 1933, 1934, 1936, 1937, 1938, 1939, 1940, 1941, 1942, 1943, 1945, 1946, 1947, 1948, 1951, 1952, 1953, 1954, 1955, 1956, 1958, 1959, 1961, 1963, 1965

EARLE HORTER
Annual/Biennial Exhibitions: 1933, 1936, 1937, 1938, 1939, 1940

BRYAN HUNT
Annual/Biennial Exhibitions: 1979, 1981, 1985

NEIL JENNEY
Annual/Biennial Exhibitions: 1969, 1973, 1981, 1987

BILL JENSEN
Annual/Biennial Exhibitions: 1981

JESS
No exhibitions

JASPER JOHNS
One-Artist Exhibitions: 1977 (traveled), 1978 (traveled), 1980, 1982, 1982 (Fairfield County)
Annual/Biennial Exhibitions: 1959, 1961, 1962, 1963, 1965, 1966, 1967, 1969, 1972, 1973, 1983, 1985

DONALD JUDD
One-Artist Exhibitions: 1968, 1988 (traveled)
Annual/Biennial Exhibitions: 1966, 1968, 1970, 1973, 1985

ALEX KATZ
One-Artist Exhibitions: 1974 (traveled), 1986
Annual/Biennial Exhibitions: 1967, 1972, 1973, 1979

ELLSWORTH KELLY
One-Artist Exhibitions: 1982 (traveled)
Annual/Biennial Exhibitions: 1959, 1960, 1961, 1962, 1963, 1965, 1966, 1967, 1968, 1969, 1973, 1981

FRANZ KLINE
One-Artist Exhibitions: 1968 (traveled)
Annual/Biennial Exhibitions: 1952, 1953, 1955, 1956, 1957, 1958, 1959, 1960, 1961

JOSEPH KOSUTH
Annual/Biennial Exhibitions: 1969, 1987

LEE KRASNER
One-Artist Exhibitions: 1973
Annual/Biennial Exhibitions: 1956, 1957, 1973

GASTON LACHAISE
One-Artist Exhibitions: 1964, 1980
Annual/Biennial Exhibitions: 1933, 1936

ARMIN LANDECK
No exhibitions

IBRAM LASSAW
Annual/Biennial Exhibitions: 1936, 1946, 1947, 1948, 1949, 1950, 1951, 1952, 1953, 1954, 1956, 1957, 1958, 1960, 1962, 1964, 1966

SHERRIE LEVINE
Annual/Biennial Exhibitions: 1985, 1989

SOL LeWITT
Annual/Biennial Exhibitions: 1979, 1987

ROY LICHTENSTEIN
One-Artist Exhibitions: 1981 (organized by The Saint Louis Art Museum), 1981 (Downtown)
Annual/Biennial Exhibitions: 1965, 1966, 1967, 1968, 1969, 1972, 1973, 1979

JACQUES LIPCHITZ
Annual/Biennial Exhibitions: 1946, 1947, 1948, 1949, 1950, 1951, 1954, 1956, 1957, 1958, 1960, 1964, 1966

LOUIS LOZOWICK
One-Artist Exhibitions: 1972
Annual/Biennial Exhibitions: 1933, 1936, 1938, 1939, 1940, 1941, 1942

BRICE MARDEN
Annual/Biennial Exhibitions: 1969, 1977, 1979, 1989

JOHN MARIN
One-Artist Exhibitions: 1956 (organized by the Art Galleries, University of California, Los Angeles), 1971 (organized by the Los Angeles County Museum of Art)
Annual/Biennial Exhibitions: 1933, 1936, 1942, 1943, 1944, 1945, 1946, 1947, 1948, 1949, 1950, 1951, 1952, 1953

REGINALD MARSH
One-Artist Exhibitions: 1955 (traveled), 1979, 1983 (Philip Morris; traveled)
Annual/Biennial Exhibitions: 1932, 1933, 1934, 1936, 1937, 1938, 1939, 1940, 1941, 1942, 1943, 1945, 1946, 1947, 1948, 1949, 1950, 1951, 1952, 1953, 1954

AGNES MARTIN
Annual/Biennial Exhibitions: 1963, 1965, 1967, 1977

JAN MATULKA
One-Artist Exhibitions: 1979 (traveled)
Annual/Biennial Exhibitions: 1932, 1933, 1934, 1936, 1940, 1944

JOHN McLAUGHLIN
One-Artist Exhibitions: 1974

JOAN MITCHELL
One-Artist Exhibitions: 1974
Annual/Biennial Exhibitions: 1957, 1959, 1961, 1965, 1967, 1973, 1983

ROBERT MORRIS
Annual/Biennial Exhibitions: 1966, 1968, 1970, 1973

ROBERT MOTHERWELL
One-Artist Exhibitions: 1951, 1968
Annual/Biennial Exhibitions: 1945, 1946, 1947, 1948, 1949, 1950, 1951, 1952, 1953, 1954, 1956, 1957, 1958, 1959, 1961, 1963, 1965, 1966, 1967, 1969, 1973

WALTER MURCH
One-Artist Exhibitions: 1986 (Philip Morris)
Annual/Biennial Exhibitions: 1948, 1949, 1950, 1951, 1953, 1955, 1956, 1957, 1959, 1961, 1963, 1965, 1967

ELIZABETH MURRAY
One-Artist Exhibitions: 1988 (organized by the Dallas Museum of Art)
Annual/Biennial Exhibitions: 1972, 1973, 1977, 1979, 1981, 1985

ELIE NADELMAN
One-Artist Exhibitions: 1975 (traveled)

ALICE NEEL
One-Artist Exhibitions: 1974
Annual/Biennial Exhibitions: 1972

LOUISE NEVELSON
One-Artist Exhibitions: 1967 (traveled), 1970, 1980, 1987 (Fairfield County)
Annual/Biennial Exhibitions: 1947, 1950, 1953, 1956, 1957, 1960, 1962, 1964, 1966, 1968, 1973

BARNETT NEWMAN
Annual/Biennial Exhibitions: 1959, 1963, 1965, 1966, 1967, 1968, 1969

JOHN NEWMAN
Annual/Biennial Exhibitions: 1985

ISAMU NOGUCHI
One-Artist Exhibitions: 1968, 1980
Annual/Biennial Exhibitions: 1939, 1940, 1945, 1946, 1947, 1948, 1949, 1950, 1951, 1952, 1955, 1956, 1958, 1960, 1962, 1964, 1966, 1970

GEORGIA O'KEEFFE
One-Artist Exhibitions: 1970 (traveled), 1981
Annual/Biennial Exhibitions: 1932, 1934, 1943, 1945, 1946, 1948, 1949, 1950, 1953, 1955, 1956, 1957, 1958, 1959, 1961, 1963, 1965, 1967, 1972

CLAES OLDENBURG
One-Artist Exhibitions: 1978 (organized by the Museum of Contemporary Art, Chicago)
Annual/Biennial Exhibitions: 1964, 1966, 1968, 1970

NAM JUNE PAIK
One-Artist Exhibitions: 1982 (traveled)
Annual/Biennial Exhibitions: 1977, 1981, 1983, 1987, 1989

ED PASCHKE
Annual/Biennial Exhibitions: 1973, 1981, 1985

PHILIP PEARLSTEIN
Annual/Biennial Exhibitions: 1955, 1956, 1958, 1962, 1967, 1969, 1972, 1973, 1979

JACKSON POLLOCK
One-Artist Exhibitions: 1970 (organized by the Maxwell Galleries, San Francisco)
Annual/Biennial Exhibitions: 1946, 1947, 1948, 1949, 1950, 1951, 1952, 1953, 1954

FAIRFIELD PORTER
One-Artist Exhibitions: 1984 (organized by the Museum of Fine Arts, Boston), 1984 (Fairfield County)
Annual/Biennial Exhibitions: 1959, 1961, 1963, 1965, 1967

RICHARD POUSETTE-DART
One-Artist Exhibitions: 1963, 1974
Annual/Biennial Exhibitions: 1949, 1950, 1951, 1953, 1955, 1956, 1957, 1958, 1959, 1961, 1963, 1965, 1967, 1969, 1972, 1973

MAURICE PRENDERGAST
One-Artist Exhibitions: 1934, 1961 (organized by the Museum of Fine Arts, Boston), 1980, 1987 (Philip Morris; organized by the Terra Museum of American Art, Chicago)

MARTIN PURYEAR
Annual/Biennial Exhibitions: 1979, 1981, 1989

ROBERT RAUSCHENBERG
One-Artist Exhibitions: 1968
Annual/Biennial Exhibitions: 1962, 1963, 1965, 1966, 1969, 1973

AD REINHARDT
One-Artist Exhibitions: 1980
Annual/Biennial Exhibitions: 1947, 1948, 1950, 1951, 1952, 1953, 1955, 1956, 1957, 1958, 1959, 1961, 1965

JAMES ROSENQUIST
One-Artist Exhibitions: 1972, 1986 (organized by The Denver Art Museum)
Annual/Biennial Exhibitions: 1963, 1966, 1967, 1969, 1981

THEODORE ROSZAK
One-Artist Exhibitions: 1956 (organized with the Walker Art Center, Minneapolis), 1984
Annual/Biennial Exhibitions: 1932, 1936, 1937, 1938, 1941, 1942, 1943, 1945, 1946, 1947, 1948, 1949, 1950, 1951, 1952, 1953, 1954, 1955, 1956, 1957, 1958, 1960, 1962, 1964, 1966, 1968

SUSAN ROTHENBERG
Annual/Biennial Exhibitions: 1979, 1983, 1985

MARK ROTHKO
Annual/Biennial Exhibitions: 1945, 1946, 1947, 1948, 1949, 1950

EDWARD RUSCHA
One-Artist Exhibitions: 1982 (organized by the San Francisco Museum of Modern Art)
Annual/Biennial Exhibitions: 1967, 1969, 1987

ROBERT RYMAN
Annual/Biennial Exhibitions: 1977, 1987

KAY SAGE
Annual/Biennial Exhibitions: 1946, 1947, 1948, 1949, 1950, 1951, 1952, 1953, 1955, 1956, 1957, 1958, 1962

DAVID SALLE
One-Artist Exhibitions: 1987 (organized by the Institute of Contemporary Art, University of Pennsylvania, Philadelphia)
Annual/Biennial Exhibitions: 1983, 1985

LUCAS SAMARAS
One-Artist Exhibitions: 1972
Annual/Biennial Exhibitions: 1966, 1968, 1970, 1979

GEORGE SEGAL
One-Artist Exhibitions: 1979 (organized by the Walker Art Center, Minneapolis)
Annual/Biennial Exhibitions: 1959, 1964, 1968, 1970

RICHARD SERRA
Annual/Biennial Exhibitions: 1968, 1970, 1973, 1977, 1979, 1981

JOEL SHAPIRO
One-Artist Exhibitions: 1983 (traveled)
Annual/Biennial Exhibitions: 1970, 1977, 1979, 1981, 1989

CHARLES G. SHAW
Annual/Biennial Exhibitions: 1945, 1947, 1953, 1956, 1963

CINDY SHERMAN
One-Artist Exhibitions: 1987 (organized with the Akron Art Museum)
Annual/Biennial Exhibitions: 1983, 1985

DAVID SMITH
One-Artist Exhibitions: 1979 (traveled)
Annual/Biennial Exhibitions: 1941, 1942, 1945, 1946, 1947, 1948, 1949, 1950, 1951, 1952, 1953, 1954, 1955, 1956, 1958, 1960, 1962, 1964

TONY SMITH
Annual/Biennial Exhibitions: 1966, 1970, 1973

ROBERT SMITHSON
One-Artist Exhibitions: 1982 (organized by the Herbert F. Johnson Museum of Art, Cornell University, Ithaca)
Annual/Biennial Exhibitions: 1966, 1968, 1970, 1973

SAUL STEINBERG
One-Artist Exhibitions: 1978 (traveled)

FRANK STELLA
One-Artist Exhibitions: 1983 (organized by The University of Michigan Museum of Art, Ann Arbor, and the American Federation of Arts)
Annual/Biennial Exhibitions: 1963, 1965, 1967, 1969, 1972, 1973, 1979, 1983

JOSEPH STELLA
One-Artist Exhibitions: 1963
Annual/Biennial Exhibitions: 1932, 1936, 1940, 1946

JOHN STORRS
One-Artist Exhibitions: 1986
Annual/Biennial Exhibitions: 1933

MYRON STOUT
One-Artist Exhibitions: 1980

GEORGE SUGARMAN
One-Artist Exhibitions: 1985
Annual/Biennial Exhibitions: 1960, 1968, 1970, 1973

ALBERT SWINDEN No exhibitions

ROBERT THERRIEN
Annual/Biennial Exhibitions: 1985

MARK TOBEY
One-Artist Exhibitions: 1951, 1971
Annual/Biennial Exhibitions: 1947, 1949, 1951, 1952, 1953, 1954, 1955, 1956, 1957, 1958, 1959, 1961, 1962, 1965, 1967

BRADLEY WALKER TOMLIN
One-Artist Exhibitions: 1957 (organized with the Art Galleries of the University of California, Los Angeles)
Annual/Biennial Exhibitions: 1932, 1940, 1942, 1943, 1944, 1945, 1946, 1947, 1948, 1949, 1950, 1952

RICHARD TUTTLE
One-Artist Exhibitions: 1975 (traveled)
Annual/Biennial Exhibitions: 1977, 1987

CY TWOMBLY
One-Artist Exhibitions: 1979
Annual/Biennial Exhibitions: 1967, 1969, 1972, 1973

ABRAHAM WALKOWITZ
Annual/Biennial Exhibitions: 1932, 1934, 1936, 1938, 1941, 1945, 1947, 1949, 1951

ANDY WARHOL
One-Artist Exhibitions: 1971, 1979, 1980, 1988 (films)
Annual/Biennial Exhibitions: 1967, 1969

MAX WEBER
One-Artist Exhibitions: 1949 (traveled)
Annual/Biennial Exhibitions: 1932, 1933, 1934, 1936, 1937, 1938, 1939, 1940, 1941, 1942, 1943, 1944, 1945, 1946, 1947, 1950, 1951, 1953, 1955, 1956, 1957, 1958, 1959

H.C. WESTERMANN
One-Artist Exhibitions: 1978 (traveled)
Annual/Biennial Exhibitions: 1964, 1968, 1970, 1973, 1977, 1979

WILLIAM T. WILEY
Annual/Biennial Exhibitions: 1967, 1969, 1970, 1973, 1983

CHRISTOPHER WILMARTH
Annual/Biennial Exhibitions: 1968, 1970, 1973, 1979

JACKIE WINSOR
Annual/Biennial Exhibitions: 1970, 1973, 1977, 1979, 1983

TERRY WINTERS
Annual/Biennial Exhibitions: 1985, 1987

GRANT WOOD
One-Artist Exhibitions: 1983 (organized by the Minneapolis Institute of Arts)
Annual/Biennial Exhibitions: 1932, 1933, 1934, 1936, 1938, 1940, 1941

WILLIAM ZORACH
One-Artist Exhibitions: 1959 (traveled)
Annual/Biennial Exhibitions: 1933, 1936, 1938, 1939, 1940, 1941, 1942, 1943, 1945, 1946, 1947, 1948, 1949, 1950, 1951, 1952, 1954, 1955, 1956, 1957, 1958, 1960, 1962, 1964, 1966

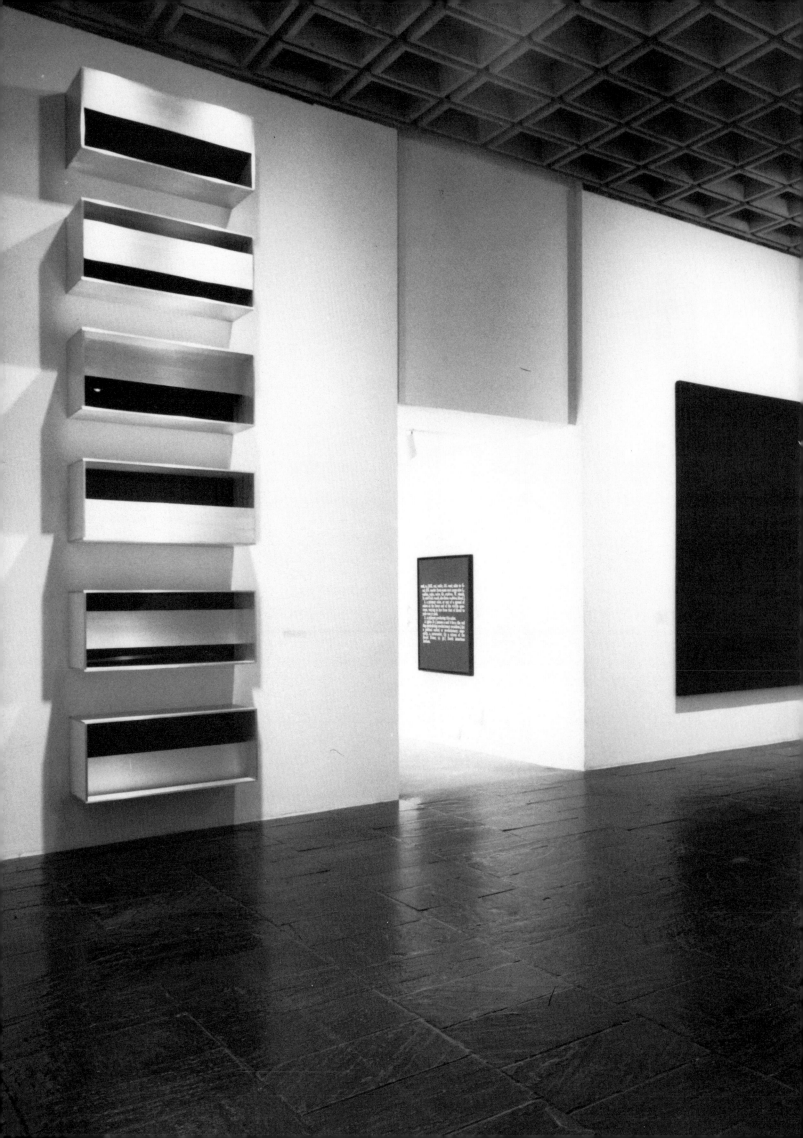

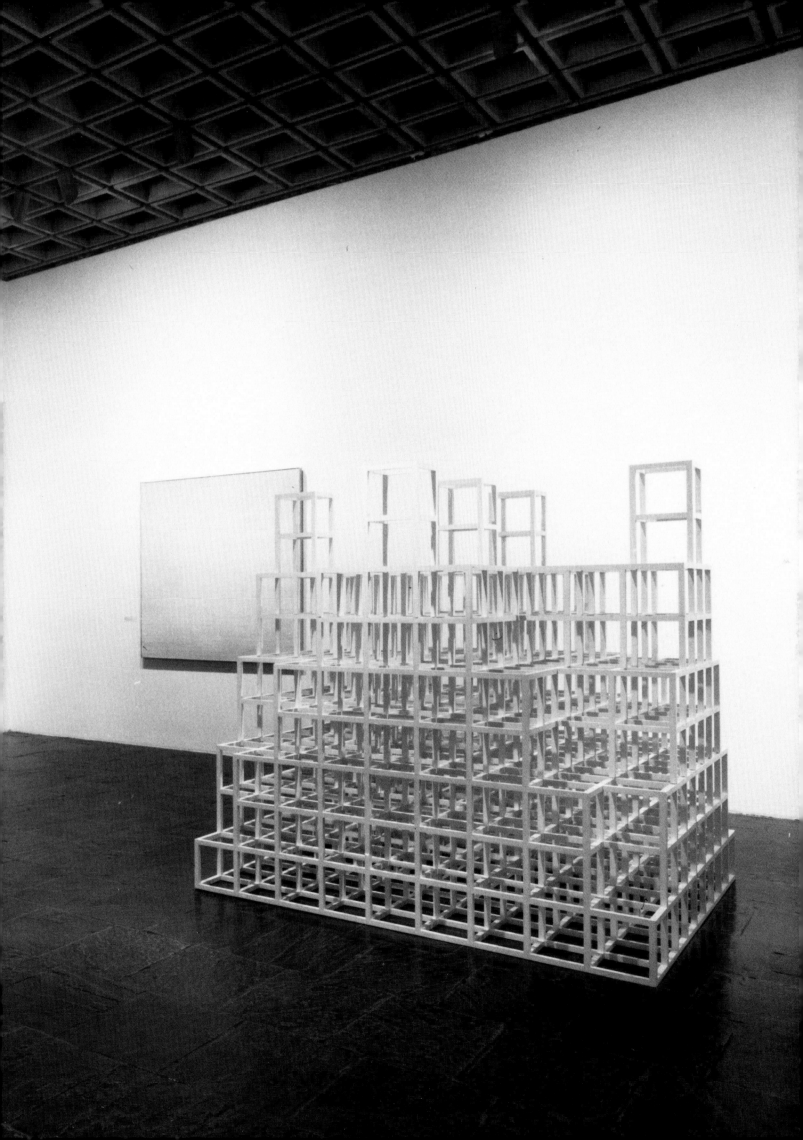

DESIGN
Anita Meyer, plus design, inc.

TYPESETTING
Monotype Composition Company

PRINTING
Meridian Printing

This publication was organized at the Whitney Museum of
American Art by Doris Palca, Head, Publications and Sales;
Sheila Schwartz, Editor; Andrew Perchuk, Associate Editor;
Ellen Rafferty Sorge, Production Coordinator; and Aprile Gallant,
Assistant. Photography was coordinated by Anita Duquette,
Manager, Rights and Reproductions.

Overleaf
Installation view, clockwise from left: Donald Judd, *Untitled*;
Joseph Kosuth, *"Titled (Art as Idea as Idea)"*; Frank Stella, *Die
Fahne Hoch*; Robert Ryman, *Carrier*; Sol LeWitt, *Five Towers*.

Opposite
Installation view, clockwise from left: Jasper Johns, *Three Flags*;
Alex Katz, *The Red Smile*; George Segal, *Walk, Don't Walk*.

Endleaf
Installation view of works by Burgoyne Diller, Ad Reinhardt,
Charles Biederman, Josef Albers, and (center) Sidney Gordin.

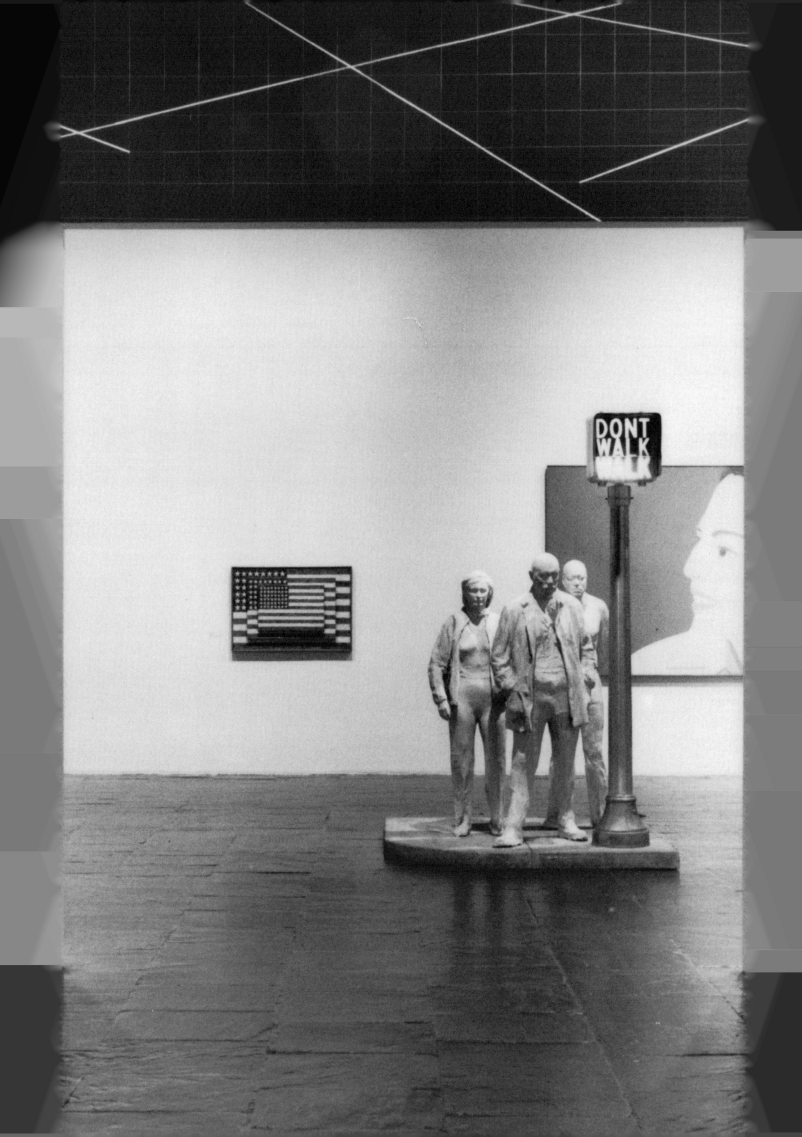